GOLD

The Earth series traces the historical significance and cultural history of natural phenomena. Written by experts who are passionate about their subject, titles in the series bring together science, art, literature, mythology, religion and popular culture, exploring and explaining the planet we inhabit in new and exciting ways.

Series editor: Daniel Allen

Gold

Rebecca Zorach and
Michael W. Phillips Jr

REAKTION BOOKS

Published by Reaktion Books Ltd
Unit 32, Waterside
44–48 Wharf Road
London N1 7UX, UK
www.reaktionbooks.co.uk

First published 2016

Printed and bound in China by 1010 Printing International Ltd

A catalogue record for this book is available from the British Library

ISBN 978 1 78023 577 6

CONTENTS

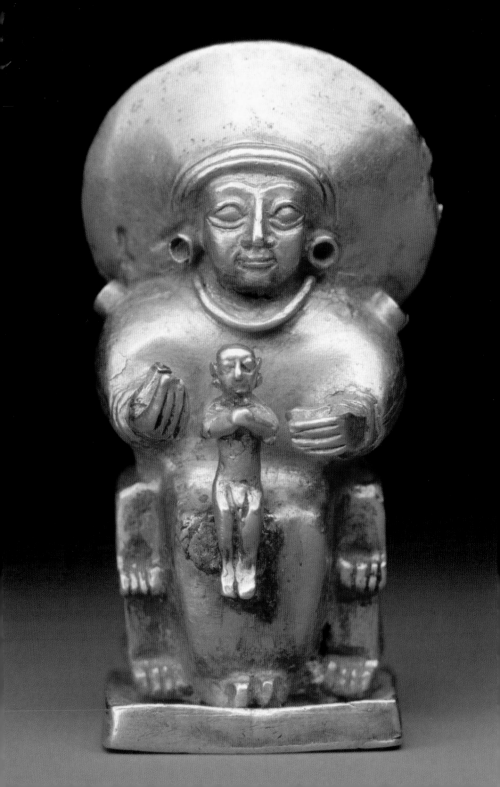

Introduction: In Search of Gold

Gold has beguiled humankind from the earliest days of civilization. The most malleable of metals, and one of the most brilliant, it was fashioned early on into artful forms. Often found relatively unadulterated, it did not require sophisticated smelting techniques. Its softness rendered it largely useless for making tools (though modern science has found many uses for it): thus most of its earliest uses were decorative.

The 'uselessness' of gold, and not its inherent beauty or nobility, may also have been what prompted its use as currency. Its relationship to value – why it became such a highly prized medium for money – is, perhaps, an unanswerable question. Did early human civilizations use gold for money because of qualities they prized in it or do we *attribute* precious qualities to it, fetishistically, because ancient convention, for reasons now obscured, decrees that we use it for money? It is also notable that throughout history gold has been used to represent the antithesis of true value – in critiques of wealth and idolatry – almost as much as it has compelled admiration. The questions posed by the human desire for gold are central questions about value itself – and about meaning.

Gold is an element, one of the heavy metals. Unlike lighter elements, gold cannot be created by fusion within stars. Scientists now believe the gold in the universe likely came from collisions between dying stars (supernovas).[1] When the earth was formed, most of its gold – possibly as much as 1.6 quadrillion tons – sank into the planet's core, with subsequent surface deposits (all the gold that is humanly accessible)

Seated goddess with a child, Hittite Empire, central Anatolia, *c.* 14th–13th century BCE.

7

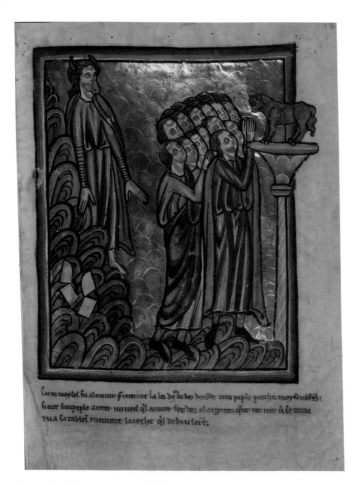

The Israelites worship the Golden Calf, by the English illuminator William de Brailes, *c*. 1250, ink, pigment and gold on parchment.

Cum moyfes fi almum firemue la les de lacdes derdes cui peple peulje moyfernefes: fi uur furpeple aurre unuoel of aueur foo'oos, efargenur: djur coo niir fi le cozza nua farablel mauure lauoebe ol debru fer̃t;

deposited by meteorites.[2] The meteorite collisions that produced the gold humans mine took place a very long time ago. Gold deposits in the Witwatersrand region of South Africa – the origin of 40 per cent of the gold ever mined from the earth – are dated to 3 billion years old, 1.5 billion years younger than the earth. Compared to these events, any human encounter with the metal is quite recent. But humans have used gold since the dawn of our own history. It is found on every continent, and was among the first metals prehistoric peoples mined and used.

Primary deposits of gold are found as particles or in veins lodged in minerals like basalt and granite and in rock formations

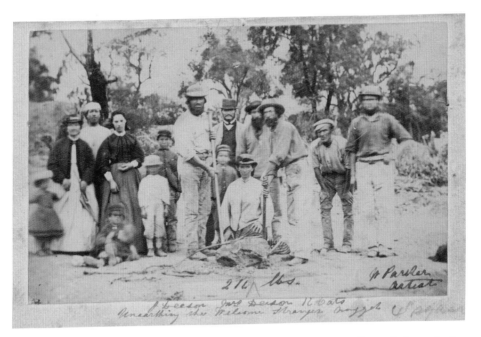

Miners and their wives posing with the finders of the Welcome Stranger Nugget, Richard Oates, John Deason and his wife, albumen silver carte-de-visite photograph, 1869.

called 'turbidites' (sedimentary rock layers formed through the action of ancient oceans). The combination of gold and the rock that hosts it is called an 'ore'; the gold contained in the rock is also called 'lode gold'. Often, gold is found together with quartz and iron pyrite (also known as 'fool's gold'), and typically as a natural alloy with silver or copper. Nuggets of pure gold may be the result of the activity of bacteria. Scientists have studied two in particular, *Delftia acidovorans* and *Cupriavidus metallidurans*, which have a genetic resistance to the toxicity of heavy metals. They have been shown to dissolve gold into nanoparticles that can travel through sediment and may collect as nuggets.[3]

The shiny nuggets we associate with the discovery of gold are typically found in 'placer' deposits, dense concentrations of particles of gold eroded from rocks and deposited in the banks of rivers and streams. (*Placer* is a Spanish word for a sandbank.) The biggest nuggets, however, have been found in underground mines. The one that is probably the biggest ever found (at a refined weight of 71.018 kg), the 'Welcome Stranger', was found in Australia in 1858 and melted down in London in 1859. The

Woodcut image of dowsing, from Agricola, *De re metallica* (1556).

Canaã nugget, found in Para, Brazil, in 1983, may have been part of a nugget even larger than the Welcome Stranger, and is today the largest nugget in existence, containing 52.332 kg of gold.

Gold-seekers have used some extraordinary techniques to discover hidden gold deposits, from dowsing (using specially shaped sticks to try to identify magnetic impulses from buried gold) to gold-dreaming (treasure hunters in nineteenth-century Ireland reported success upon following information given to them in dreams), to the modern use of botanical indicators (horsetail, for example, can assimilate large quantities of gold and serves as an indicator of high soil concentrations of the metal).[4] But historically most attempts to extract gold have originated with a chance find of a flake or nugget in a body of water, as in the case of James W. Marshall's discovery of gold – in the tailrace or sluice of a sawmill he was building – which sparked the California Gold Rush. Indeed, the earliest gold-seekers of the chalcolithic period likely used placer mining techniques one would recognize from a film about the California Gold Rush

Indians panning
for gold in the early
colonial period, from
Gonzalo Fernández
de Oviedo y Valdés,
Corónica de las Indias
(1547), woodcut.

– rinsing gravel with water to uncover gold flakes and nuggets.
'Panning' for gold is a version of this technique: sifting gravel in
a large pan filled with water until the gold, which is denser than
other substances, settles to the bottom. On a larger scale, one
can shovel gravel into 'sluice boxes' or 'rockers'; on an even larger
scale, one can use pressurized jets of water to dislodge rock or
sediment and wash the slurry into sluice boxes.

If you took all the gold ever mined by humans, you would
have a cube that measured more than 20 metres (65 feet) on
each side and weighed 176,000 tonnes.[5] Gold ores under the
earth's surface are extracted through tunnelling or open-pit
mining. Though placer mining likely came first, human beings
have been digging pits to mine the earth for a very long time. In
southern Georgia mining activities date to the fourth millen-
nium BCE, the very beginning of the Bronze Age. The Egyptians
mined underground gold in Nubia beginning around 1300 BCE,
developing a sophisticated operation; the diversity and com-
plexity of ancient Egyptian hieroglyphs for gold demonstrate
divisions by colour, degree of purity and geographic origins.

The Romans may have learned their mining techniques
from the Egyptians. They mined throughout their empire, as
far north as Dolaucothi in Wales, a location that shows archae-
ological evidence for mining dating from the Bronze Age,
and as far west as Las Médulas in the province of León in

northwestern Spain, where aerial laser technology has recently pointed to a far greater extent of mining activity than was previously thought to have existed. The prolific Roman writer Pliny the Elder describes a method known as 'hushing', introduced by the Romans, which uses floods of water, often from displaced streambeds, to uncover mineral deposits. Roman methods were so advanced that they could undermine hills, which would collapse and wash away, revealing their gold deposits. The Romans used hushing from the first century BCE until the end of the empire. Although Georgius Agricola does not mention it in his fifteenth-century *De re metallica*, it was used intermittently from the sixteenth to the early twentieth centuries, most prominently to mine for gold in Africa.

The California Gold Rush of the 1840s and '50s saw the development of 'hydraulicking', in which jets of water are shot at alluvial deposits in hillsides and riverbanks – sometimes washing entire hillsides away. This earth had to go somewhere, and it did: it built up in lowlands, redirecting rivers and causing devastating floods. Downstream farmers successfully sued to stop the practice in 1884, but California allowed it again after 1893, albeit with more rules about containing the run-off.

All this effort to extract the precious metal depends on the demand for it, which has existed for a very long time indeed. Stories of the quest for gold go back millennia. The most prominent example is that of Jason and the Argonauts (illustrated on page sixteen), recounted by Apollonius of Rhodes, among others, in his *Argonautica*. Jason's father Aeson was the rightful king of Iolcos, but his half-brother Pelias usurped the throne. Hoping to get rid of his troublesome nephew, Pelias sent Jason to Aea to fetch the skin of a golden-fleeced flying ram. This was some sheep: the son of Poseidon, it was the flying ruminant that was carrying Helle when she fell off and drowned in what is now known as the Hellespont. It was sacrificed to Poseidon and became the constellation Aries. Its skin was hung in a grove and protected by a dragon until Jason showed up to snatch it away.

Since time immemorial, people have tried to rationalize the tall tales of their ancestors, and the Golden Fleece is no

James May Ford,
*Portrait of a Boy with
Gold Mining Toys*,
1854, hand-coloured
daguerreotype.

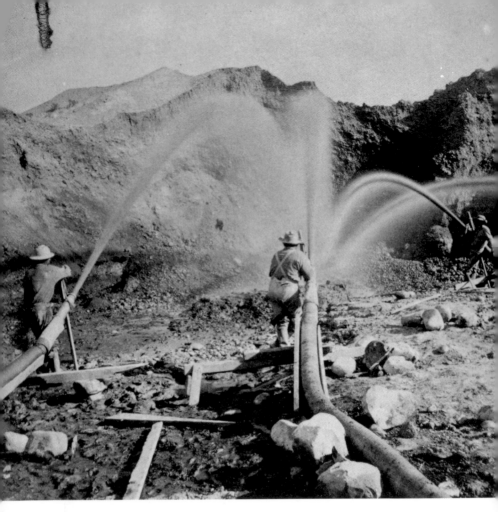

exception. Strabo, writing in the first century CE, proposed an explanation that is still considered plausible: the region around Colchis (the land at the eastern end of the Black Sea where earlier writers had decided Aea was located) was rich in gold, and 'It is said that in their country gold is carried down by the mountain torrents, and that the barbarians obtain it by means of perforated troughs and fleecy skins, and that this is the origin of the myth of the golden fleece.'[6] In fact, people were still using fleece to pan for gold into the Soviet era.

This rationalization of legend is known as euhemerism, after Euhemerus, a fourth-century BCE Greek mythographer who saw mythology as 'history in disguise'. It's a reasonable

Hydraulic mining near French Corral, Nevada County, late 19th century.

effort – it is fairly unlikely that a flying, talking golden ram actually existed once upon a time. However, the archaeologist Otar Lordkipanidze, in a survey of different 'historical' explanations for the Golden Fleece legend, draws a line in the sand: 'I shall venture to doubt that the miraculous ram, which according to Greek mythology could fly and speak and for whose fleece such a perilous expedition, celebrated in Greek literature, was undertaken, was "liver-damaged"', referring to a scholar's suggestion that the legend was referring to jaundiced livestock.[7] Whether the story relates to specific techniques for finding gold, it certainly attests to the desire for it.

The search for El Dorado (and other fictitious places)

More recent times have witnessed stories nearly as far-fetched as this one that excite the fantasies of explorers, kings and commoners alike. The seductive myth of El Dorado is one of the most famous. As V. S. Naipaul put it in *The Loss of El Dorado*, 'The legend of El Dorado, narrative within narrative, witness within witness, had become like the finest fiction, indistinguishable from truth.' This South American city of gold, which led thousands of European explorers to their deaths, did not start life as a city at all. El Dorado was probably a person, 'the gilded man'. Once a year during a religious festival, members of the Zipa group of the Muisca tribe coated their king in a natural adhesive and covered him in gold dust. He then ritually jumped into Lake Guatavita near Bacata (present-day Bogotá, Colombia). A later account, from Juan Rodríguez Freyle's picaresque history *El Carnero*, has it that the gilded king merely threw great amounts of gold into the lake 'to make offerings and sacrifices to the demon which they worshipped as their god and lord'.[8] The 'Muisca raft', the particularly impressive work of Muisca goldsmithery, which we will learn more about in Chapter Five, illustrates the dunking ceremony – with its golden chieftain surrounded by an entourage of golden courtiers.

Spanish conquistadors heard these tantalizing stories – one man, Diego de Ordaz's lieutenant Martinez, claimed to have

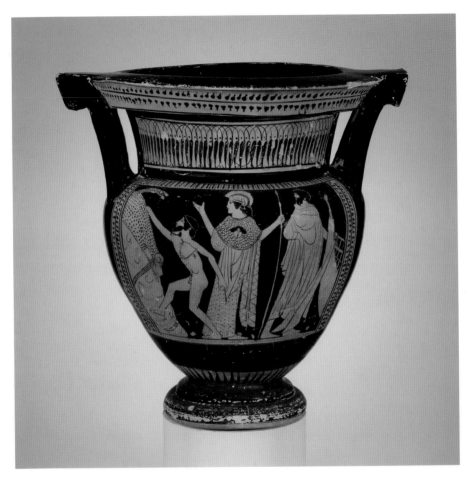

met El Dorado in 1531 – but when the Spanish conquered the Muisca in 1539, they found no gilded man or fabulous treasures. That failure was not enough to squelch the rumours, and as the decades passed the legend grew. El Dorado became a city, not a person, and newly conquered peoples were happy to tell the conquistadors that yes, there is a land of fabulous wealth – always just a little farther into the jungle.

Enter Sir Walter Raleigh, the dashing poet-explorer, popularizer of tobacco, founder of doomed Roanoke and friend (perhaps lover) of Elizabeth I of England. He came into possession of a Spanish account of Manoa, a golden city in Guiana

Jason about to seize the golden fleece. Red-figure terracotta column-krater (a bowl to mix wine and water) from c. 470–460 BCE.

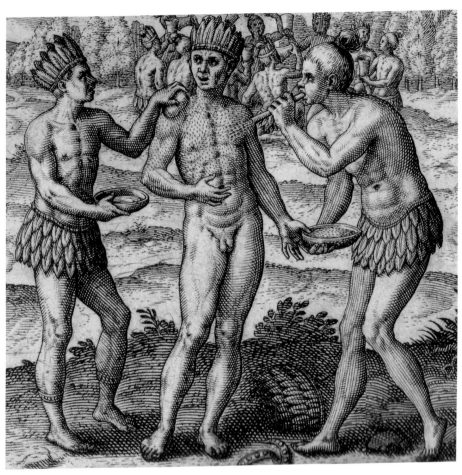

Detail from Theodor de Bry, *The Golden Man*, 1599, engraving.

on the Orinoco River that he decided must be El Dorado. He journeyed there in 1595 but failed to find Manoa – or much in the way of gold. This initial setback only whetted his appetite for adventure. He returned to England and wrote *The Discovery of Guiana*, a sometimes fanciful, always hyperbolic account of his travels. It also contained words of wisdom that Raleigh himself would have been smart to follow: 'In all that ever I observed in the course of worldly things, I ever found that men's fortunes are oftener made by their tongues than by their virtues, and more men's fortunes overthrown thereby also, than by their vices.'[9]

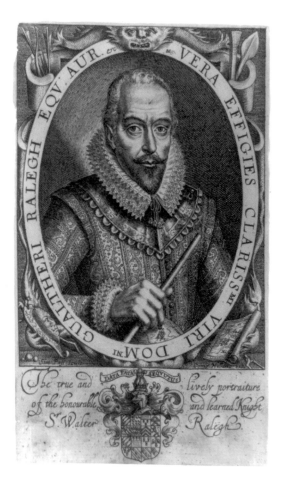

Simon de Passe,
*The True and Lively
Portraiture of the
Honourable and Learned
Knight Sir Walter
Ralegh*, 1617, engraving.

According to the historian Joyce Lorimer, Raleigh's first draft described in great detail the gold ornaments and fabulous clothing worn by native Guianans, but had very little to say about the possibility of mining for the precious metal. His backers, worried that investors would not come forward without assurances of *future* gold, convinced Raleigh to play up the riches that could be taken from the Guianan ground. In many cases, it was just a matter of changing a word or two, such as when his 'beliefs' about the presence of gold turned into 'knowledge'.[10] The changes he made to the manuscript worked, at least well enough to raise money for another trip. He sent his

assistant Lawrence Kemys back to Guiana. Kemys arrived to find that the Spanish had founded a settlement, Santo Tomé, close to the putative location of the mines. Fearing an ambush if he were to make his presence known to the Spaniards, he returned empty-handed. Undaunted, Raleigh sent a Dutchman named Adriaen Cabeliau in 1597, but he also failed to produce any lucre.

By this time detractors were openly calling Raleigh a liar. The ore he had brought back from South America was worthless; naysayers were baldly accusing him of never having gone to Guiana; and subsequent voyages had failed to bolster his claims. His patroness Elizabeth I died in 1603, and he was imprisoned that same year in the Tower of London for allegedly plotting against her successor James I.

But his fortunes began to change. In 1610 his biggest enemy, Sir Robert Cecil – Secretary of State, spymaster for King James, and the man responsible for having Raleigh locked up – died. England's treasury was empty and war with Spain was imminent. Raleigh seized the opportunity. He suddenly remembered that he had in fact seen gold mines, and knew exactly where they were. He brandished letters from a mysterious Spanish informant that conveniently bolstered his story. The worthless ore that he had brought back, when re-tested by a friendly (and generously rewarded) mineralogist, turned out to be rich in gold. James I released him from the Tower in 1616, and by 1617 Raleigh had outfitted another trip to Guiana. The one condition was that he not cause any trouble with the Spanish.

It was this condition, finally, that caused the adventurer's downfall. He was prohibited from personally leading the expedition, so his lieutenant Kemys headed down the Orinoco. What happened next is unclear: the result was a skirmish with the Spanish at Santo Tomé that left Raleigh's eldest son Walter dead and Kemys in command of the town. Unable to negotiate a settlement with the angry Spanish forces surrounding him, Kemys ordered the town looted and burned. After he explained to Raleigh what had happened, he shot and then, when that was not fatal, stabbed himself to death. When the heartbroken Raleigh returned to England

empty-handed, having caused an international incident that almost sparked yet another war with Spain, James I ordered his execution. Although offered several chances to escape, the explorer refused. He was beheaded at Westminster on 29 October 1618.

Jérôme David, after Claude Vignon, *Portrait of Atahualpa* (*Atabalipa Rex Peruviae*), 1610–47, engraving.

Sir Walter was far from being the first person to have lost his head over gold, and he would not be the last. Many a fruitless quest has been pursued over the gleaming metal. Throughout human history, the idea of gold – its imagined presence in a faraway place more than its actual existence – has had fantastic powers of attraction, powers that have usually had more unintended than intended consequences. Adventurers seeking gold have, more often than not, failed. But gold has been used to rationalize all kinds of other territorial activities and claims, whether the exploration of unknown territories or the seizure of lands where gold has been newly found. Driving exploration and conquest, gold has had an enormous impact on large-scale movements of population, perhaps even more than its monetary value would suggest.

The Americas have been the source of many tales of fabulous cities – and, of course, actual fabulous cities, like those of the Aztec and Inca empires. Perhaps the greatest single example of this wealth is found in the person of Atahualpa, the last king of the Inca empire. When Francisco Pizarro captured him in 1532, the king offered to pay a unique ransom: he would fill a large room with approximately 85 cubic metres (3,000 cubic ft) of gold if Pizarro would let him live. It took Indian goldsmiths working with nine forges almost a month to melt down the treasure – a devastating loss for our knowledge of the workmanship of Inca artisans. In the end the ransom didn't even work: after holding him for several months, Pizarro had the emperor executed. His only concession was to have Atahualpa garrotted instead of burned at the stake, as Inca religion held that the soul would not go to the afterlife if the body were burned.

At around the same time, the Spanish conquistador Francisco Vázquez de Coronado explored northern Mexico

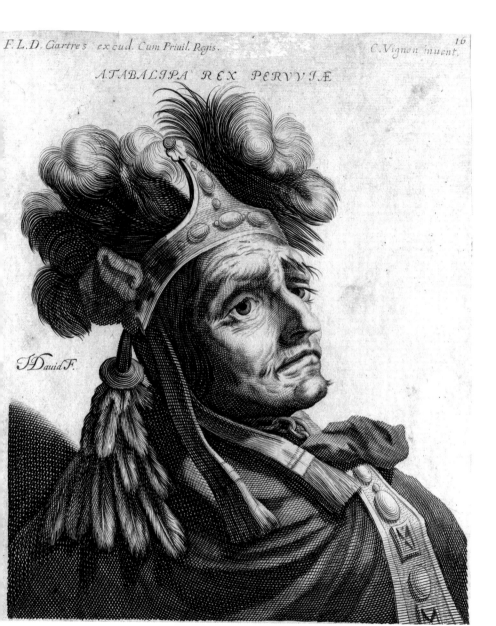

F.L.D. Gartres *excud. Cum Priuil. Regis.* C. Vignon *inuent.*

ATABALIPA REX PERVVIÆ

J.Dauid F.

looking for the mythical Seven Cities of Gold. The four sur-
vivors of the doomed Narváez expedition – the only men who
lived to tell the tale from among the 600 Spaniards who sailed
to Florida in a vain attempt to colonize the peninsula in 1528 –
reported that, during their eight-year odyssey, they had heard
rumours of cities full of fabulous riches. A Franciscan friar who
was sent to investigate reported that he had seen, at a distance,
one of the seven cities: Cibola, which he said rivalled in size
and wealth Tenochtitlan, the capital city of the Aztecs. Coro-
nado was dispatched to gather the gold, but when he arrived in
present-day New Mexico, he found that Cibola was actually a
settlement of Zuni farmers living in adobe pueblos. Undeterred,
Coronado occupied the area and used it as a military base.

Then he heard of a place called Quivira far to the east,
where the chief drank from golden cups hanging from trees.
Guided by a native nicknamed 'the Turk' (because the Span-
iards thought he looked Turkish), Coronado set off across the
Great Plains, eventually realizing when he reached present-day
Kansas that he had been misled. The Turk admitted as much:
according to Coronado,

> the people at Cicuye had asked him to lead them off on the
> plains and lose them, so that the horses would die when
> their provisions gave out, and they would be so weak if
> they ever returned that they would be killed without any
> trouble, and thus they could take revenge for what had
> been done to them.

Coronado had the Turk strangled, but the revenge was com-
plete, at least for a time – Coronado never found his cities
of gold, and the Spanish would abandon the southwest for
another generation.[11]

Mapping Egypt's gold

Within the lore about the search for gold, we often find the
well-worn trope of buried treasure, pirate booty that you can

find if you have the right antique map. There is, however, no evidence that any pirate ever concealed the location of his treasure under a large X on a coded map. The closest example is Captain Kidd, who in 1699 did bury some gold on Long Island. But he didn't make a map, and despite what 200 years of treasure hunters will tell you, it was all recovered and sent to England as evidence in his trial. We can blame Robert Louis Stevenson for popularizing the fictional treasure map in his 1883 novel *Treasure Island*.

This is not to say that treasure maps have never existed. Indeed, among the Dead Sea Scrolls is the Copper Scroll (called that because it was etched on copper instead of written on parchment or papyrus), which dates from the first century CE and appears to give readers directions on how to find enormous caches of gold and silver. However, the directions are not very specific, and the loot remains undiscovered.[12]

An even older map is the Turin Papyrus, created around 1160 BCE by a scribe of the Egyptian pharaoh Rameses IV. The map, which now exists in several fragments, is about 208 cm (82 in.) long by 41 cm (16 in.) tall. It currently resides in the Egyptian Museum in Turin, and attests to the long history of gold exploration in Africa. Certainly, before Europeans ever lusted after the fabled golden cities of the Americas, they dreamed of African gold. And long before Europeans dreamed of African gold, other Africans did. From the dawn of history, the gold of Africa has attracted the attention of traders and invaders. At least since the dawn of cartography, that is, for the Turin Papyrus is the oldest existing geological map (meaning that it shows types and locations of geologic features such as rock outcroppings). It is surprisingly modern in its detail. It shows us, among other things, the location of a gold mine in the Eastern Desert, the barren area between the Eastern Nile and the Red Sea. It informs us that the gold-mining settlement at Bir Umm Fawakhir (Well of the Mother of Pottery) consisted of four houses, a temple of the god Amun, a statue of King Sety I, a reservoir and a well. It even notes that the valley was full of tamarisk trees.[13]

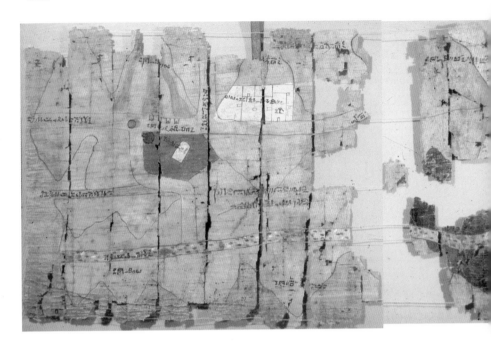

Most of Egypt's gold, however, came from Nubia, an area of eastern Africa corresponding to present-day southern Egypt and northern Sudan. (The name Nubia came late in history, possibly from the Egyptian word *nub*, meaning gold, but more likely from the Nobatae, an African group that settled the area around 300 CE.) In ancient Nubia gold mining was so important to the economy that royalty wore jewellery made of pierced nuggets of unworked alluvial gold, apparently touting the material's local origins.[14] Nubia's millennia-long history is intertwined with and often inseparable from that of its more famous northern neighbour Egypt, as much of what we know of its history is from Egyptian sources. Over the centuries, Egypt and Nubia traded, made war and conducted diplomacy with one another. Their royalty intermarried, and Nubian dynasties even ruled over all of Egypt during the Middle Kingdom period.

Nubia is defined by the series of six rapids, or cataracts, along the southern course of the Nile between the point at Khartoum where its tributaries join and the point at Aswan

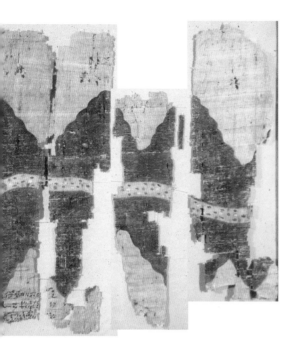

Map of the gold
mines in the Sinai on
a papyrus fragment,
from the 20th Dynasty
(12th–11th century BCE),
New Kingdom, Egypt.

Qumran Copper Scroll,
1st century CE.

where it exits the forbidding sandstone and granite of Nubia and flows through Egypt's vast, fertile floodplain. The land was the home of some major kingdoms that interacted with more familiar Egyptian kingdoms. The Kerma Kingdom corresponded roughly with the Egyptian Middle Kingdom. The Kingdom of Kush, once a colony of the New Kingdom of Egypt, became independent when that kingdom collapsed, and in the eighth century BCE Kush conquered Egypt and founded the Twenty-fifth dynasty. When the Kushite dynasty was expelled in 656 BCE, its rulers retreated south; this latter phase of the Kingdom of Kush is also called the Kingdom of Meroë or the Meroitic Kingdom, after its second capital at Meroë.

In the religion of ancient Egypt gold was a divine and indestructible metal associated with the sun; the very skin of the gods was thought to be golden. Egyptians did not use it as money – there were coinlike objects made of gold as early as 2700 BCE, but they were used as gifts, not currency. Instead pharaohs prized it for ritual and religious uses such as funerary objects – Tutankhamun's solid-gold sarcophagus being the most famous example.

Starting in the Egyptian Old Kingdom (c. 2685–2150 BCE), a newly centralized and powerful Egypt wanted Nubian commodities, especially gold but also ivory and the bekhen-stone used for statuary, and pharaohs began making military incursions to secure them. Control of Nubia's gold rested mostly in the hands of Egyptian rulers for the next millennium, but Nubia took advantage of power vacuums, such as the occasional Intermediate Periods, to retake Nubian areas and even conquer Egypt. By around 800 BCE at the beginning of the Kush-founded Twenty-fifth Dynasty, the gold-mining industry in Nubia collapsed, perhaps because it was impossible to retrieve any more gold from the mines using the technology at hand. Ptolemaic rule brought new mining techniques from Greece, but by this time attacks by nomadic peoples made it impossible to look for new sources of gold. After the Muslim conquest around 700 CE, there was quite a bit of placer mining in the area, but even that ceased by 1350.

During the European Middle Ages there was no direct trade between Europe and Africa. Muslims in the Middle East served as intermediaries, and the military force of the Moors of North Africa ensured that Europeans who wanted African commodities, including most of the gold that made its way to Europe, would have to stick to established trade routes. Europeans heard rumours through traders that the gold they were getting from the Arabs came from a race of black people south of the Western Nile, but not even the Islamic rulers of North Africa knew exactly where the gold was coming from: the celebrated Arab geographers al-Biruni of the tenth century CE, al-Idrisi of the twelfth century and Ibn Said of the thirteenth century simply left the land south of the Nile blank.[15]

Eventually, the rumours accumulated more details. The *Catalan Atlas*, made in 1375 for Charles v of France, depicts the Malian emperor Mansa Musa holding an enormous gold nugget and refers to him as 'the richest and most noble lord of all this region on account of the abundance of gold which is gathered in his kingdom'. Musa could hardly have avoided attracting the attention of the entire world with his pilgrimage to Mecca in 1324. Reportedly bringing with him a retinue of attendants that included 500 slaves, each carrying a 1.8-kg (4-lb) golden staff, he also was said to have distributed so much gold dust that the Egyptian historian al-Maqrizi claims he caused a depreciation in the value of the gold dinar that lasted twelve years.

Among the Europeans whose interest was piqued by stories of African gold was Prince Henry the Navigator of Portugal (1394–1460). Henry – the man most responsible for the Age of Exploration – was, like many of his royal contemporaries, a big spender and was constantly in debt. The historian P. E. Russell attributes this to keeping up with the Joneses – or the Burgundians and Castillians: a shortage of gold in Europe, rampant inflation and a labour shortage in Portugal, and a lengthy period of peace that removed any chance for gaining wealth and fame on the battlefield combined to make it difficult for the nobles of Portugal to live as they thought nobility should. Henry

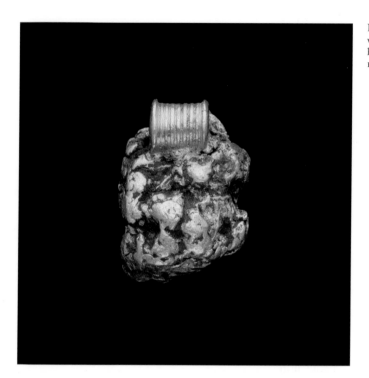

Nubian gold nugget
with coiled suspension
loop at the top, 700–500
BCE (see page 24).

maintained a large household of knights and squires and other
hangers-on, and he was in debt for most of his life. As one of
his captains, Diogo Gomes, remarked, Henry wanted African
gold 'to sustain the nobles of his household'.[16]

In 1415 he captured Ceuta, opposite Gibraltar, and over the
next several decades the Portuguese under Henry explored and
settled West Africa, breaking the Arab monopoly on European
trade with Africa and making Portugal, for a time, the rich-
est nation on earth. By the early 1470s Portuguese traders were
sending back shiploads of gold dust to Lisbon. In 1482 they
built their first settlement in the area that would become known
as the Gold Coast, in present-day Ghana.

As the name suggests, this region of Africa was the source
of a great deal of gold. During the Middle Ages Muslim traders
travelled from North Africa to the region with wool, salt, glass,
copper, steel and other commodities that they traded for slaves
and gold. Abu 'Ubayd al-Bakri, a geographer from Andalusia

Mansa Musa, emperor of the Mali empire, in the *Catalan Atlas* by the cartographer Abraham Cresques, 1375, ink, pigment, gold and silver on parchment over wood panel.

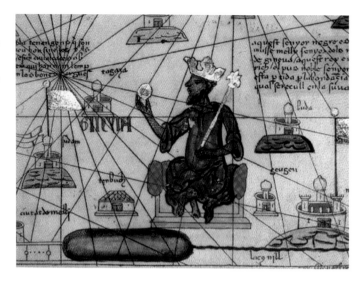

who visited the Ghana Empire in the eleventh century CE, described the king 'adorned in jewelry and a golden headdress', and sitting 'in a pavilion around which stood ten horses in gold trappings. Behind the throne were ten pages holding shields and gold-hilted swords.'[17]

Anticipating the imminent discovery of gold ore, the Portuguese called their fort São Jorge da Mina de Ouro (St George of the Gold Mine). The name proved to be unwarranted, as there were no gold mines near the coast where they built. However, their effort was not wasted – the Portuguese used the fort as a gold-buying outpost, and plenty of African gold flowed from this location into Portuguese coffers. But in the end, they found a more lucrative source of treasure. The kingdom's New World colonies, it turned out, were perfect for growing sugar cane. What they lacked was the cheap labour needed to do the work. Their foothold in Africa gave them the brutal solution. As Prince Henry's biographer P. E. Russell says, 'it was soon found that black gold – slaves – was the most attractive cargo Guinea had to offer.'[18]

Thomas More, in his book *Utopia* (1516), decries the greed and rampant commercialism that accompanied the influx of gold from the Americas and Africa. He reports that

every household has two slaves who are bound with golden chains. Perhaps he was familiar with Herodotus, who in his *Histories* suggests that gold was so plentiful in Ethiopia that they used golden chains to fetter their slaves?[19] And could he have foreseen the moment, two centuries later, when the Prussian kingdom sold its settlements in present-day Ghana to the Netherlands for, among other things, six slaves bound in chains of gold?

Why gold?

Is there anything inherent in gold as a material that explains its lasting popularity with humans? Why do we travel so far and go to so much trouble to get it? As an element, gold has a characteristic atomic profile – atomic number 79. Its one naturally occurring isotope is also its one stable isotope, with 79 protons, 79 electrons and 118 neutrons. In the periodic table of elements, where it is classed with the transition metals, it carries the symbol Au – from the Latin word for gold, 'aurum'. The way gold atoms bond to one another is called metallic bonding, and this helps to account for many of the properties of gold. The way metallic bonding works is often described using a concept called the 'sea of electrons'. According to this model, gold cations (positively charged ions formed by the nucleus of the atom and its inner rings of electrons) bond together in a crystalline structure while allowing the other electrons to become 'delocalized', freed from their specific atoms and 'swimming' in a 'sea' of other electrons. The molecular structure is held together tightly because the electrons are attracted to multiple surrounding nuclei. This form of bond is thought to account for the malleability and ductility of metals. The sea of mobile electrons explains the high conductivity of metals. In the case of transition metals, extra electrons provided to the sea account for a high melting point. The density and mobility of the electron sea is what gives metals their special lustre when light bounces off them. The unreactive nature of gold also derives from the strength of the bonds between gold atoms – it does not easily

release these bonds to react with other elements. This is why gold does not tarnish.

The reason why gold is yellow has to do with the theory of relativity proposed by Albert Einstein. Without relativity, gold might be expected to look more like silver: shiny but relatively colourless. But gold attracts its electrons more strongly, with 79 protons in its nucleus (as opposed to 47 for silver). Because of the relatively stronger attraction, its electrons must move much faster than silver's in order to withstand the pull of the nucleus and stay in orbit. They thus achieve a speed that is more than half the speed of light, and this produces what scientists call 'relativistic effects': their orbitals (the routes the electrons travel around the nucleus) are deformed by their speed. Electrons that would be expected to absorb light in the ultraviolet (hence invisible) spectrum shift down to absorb in the blue (visible) end of the spectrum, reflecting the light of the rest of the spectrum, which combines to produce gold's yellow colour.

Slight differences in colour are produced by alloying with other metals, but that yellow gleam is characteristic of pure gold, what jewellers refer to as 'twenty-four carat gold'. When gold is alloyed with other metals, we describe the proportion of gold by weight in the resulting metal using a unit called the 'carat', which is ¼₄ of the total. Eighteen-carat gold is three-quarters gold (eighteen out of 24). The word 'carat' and its variants came into European languages from the Arabic *qīrāt* (قيراط), which came from Greek *kerátion* (κεράτιον), little horn, used for the carob seed, a unit of weight.

None of this really answers the question, *why* gold? We know that it is pretty and shiny – its properties as a metal may account for its uses in adornment. Associations with purity and perfection may derive from the fact that it does not rust or tarnish, and thus appears incorruptible. For artisanal purposes, its ductility – it can be beaten to a thinness of ¹⁄₂₈₂,₀₀₀ inch, and drawn into fine threads – has long been prized. But this very ductility, as we noted at the outset, means that it is too soft and malleable to be used for tools. Even as money, it has to be alloyed with something else to be hard enough to withstand use.

Useless but suitable as a container for value, gold also seems, throughout history, to have possessed qualities that (in the eye of the beholder, at least) transcended the material world.

This book is not a comprehensive history of gold. Rather, it explores the various roles gold has played in history and the human imagination. In fact, gold has played so many roles that it is difficult to fasten the metal itself in one's sights. In the course of the book, we trace these tensions as we delve into gold's history as a substance of desire. This book proceeds by dividing the variety of uses to which gold has been put, and the realms of inquiry it has inspired and shaped, into the six follow-ing chapters, examining wearable gold, religious gold, gold as currency, the science of gold, gold as a material for artists, and the many dangers associated with gold in myth and in reality.

In the next chapter, we explore the use of gold for human adornment. For all the developments that have changed the extraction of gold, we still use most of this shiny yellow metal in the same way the earliest humans used it – we wear it.

1 Wearable Gold

In October 1972 Raycho Marinov was digging a utility ditch with his tractor outside the eastern Bulgarian town of Varna when he turned up some unusual metallic objects. He picked up a few, squirrelled them away in a shoebox and kept them for a week until his day off, when he brought them to his former history teacher. Only then, in brushing off the dirt that coated them, did they realize that the objects were made of pure gold.

Among the accidental finds of 'buried treasure', this was one of the most dramatic. Another impressive one occurred in 2014, when a California couple out for a walk in their back yard chanced upon $10 million in 1890s coins. In 1990 on the island of Java, workers digging an irrigation ditch were shocked when their picks uncovered three terracotta jars containing several thousand gold and silver objects, likely the treasure room of part of the royal family buried by a volcanic eruption in the tenth century CE. (The treasure trove also included the earliest evidence of a currency system in Java.[1]) And in 1992 a farmer in Suffolk, England who was searching for a missing hammer got the surprise of his life: his metal detector alerted him to what turned out to be a wooden chest full of Roman gold and silver coins and jewellery that was likely buried in the fourth century CE, when Roman rule was collapsing in Britain and the Anglo-Saxons were making their first raids on the island.

While these were spectacular finds, the objects Marinov uncovered were about five millennia older than the Roman hoard: what he had stumbled upon was a Copper Age gravesite that would come to be known as the Varna Necropolis. Its

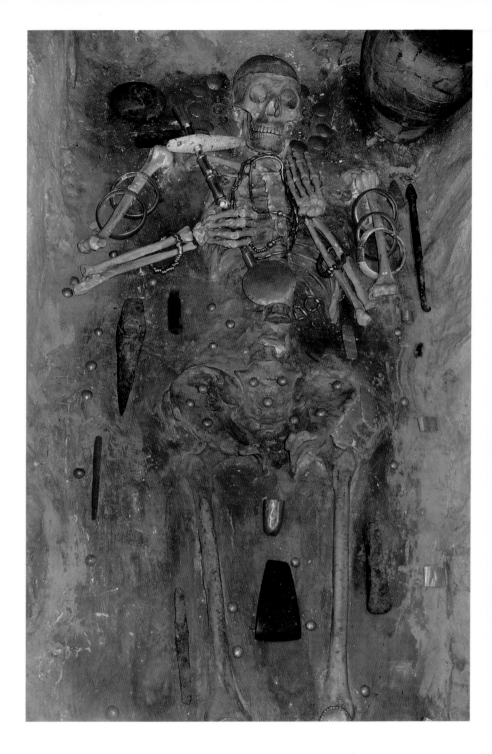

earliest graves date to around 4600 BCE.[2] While some early pieces of worked gold have been found at other sites – gold objects may have been produced in Anatolia (modern-day Turkey) at a similarly early date – Varna possesses the largest and most sophisticated cache of gold objects yet found from this earliest period of human goldworking. It also presents the earliest evidence of human beings wearing gold for adornment – wearing it, that is, after death.

The oldest graves of the Varna Necropolis (dated by famil-iar types of pottery and other artefacts found in them) yielded hammered gold ornaments that could be sewn onto clothing or worn directly on the body: chest plates, armbands, finger rings and earrings, beads, diadems for the forehead, appliqués to be attached to garments and other forms of bodily adornment, decorated with geometric and figural (generally zoomorphic, meaning animal-shaped) designs. This gold was not mined, but likely came from local surface deposits and the earth and gravel of riverbeds. The artisans who created the designs employed the techniques of engraving (cutting lines with a sharp tool) and repoussé work (hammering from the reverse of a sheet of gold in order to ornament it with relief designs).

Humans have made use of gold in many ways, but coin-age and adornment are the two most substantial and consistent uses. The archaeological record – at Varna and elsewhere – suggests that adornment came first, and it continues to be one of gold's most widespread uses. Today the world consumption of newly mined gold is divided about evenly into use as jew-ellery and as a financial investment – with 10 per cent being used in industry, including dental uses.[3] Throughout history people all over the world have decked themselves out in gold. Forms of wearable gold include crowns, earrings, nose-rings, diadems and other facial decorations, necklaces, bracelets and armbands, pectoral plates and finger-rings. Before the arrival of Europeans the indigenous peoples of the Americas used it primarily for bodily adornment, and not at all for coinage, despite having access to large quantities. In many cultures gold might be understood as one material within an array of types

A grave in the Varna Necropolis, Bulgaria, with the world's oldest gold jewellery yet discovered, *c.* 4600 BCE.

of brilliant materials – other metals, mica, crystals, gems – associated with light, the sun and the divine. The wearing of gold may have indicated beliefs about the metal's talismanic properties – protecting or perfecting the body, making it more desirable or imposing – in the same way that people believed eating and drinking from golden vessels ensured they would not be poisoned. In monetary systems that use gold, its display, of course, carries additional meanings. In contemporary culture it is 'bling', a word which has extended its reach beyond its original hip-hop context. It's a way of showing off one's wealth. But gold jewellery historically has not only been about display, but about holding value close to the body. As humans developed the ability to encase the body entirely in gold, whether that meant using numerous pieces of gold jewellery in royal and imperial courts or gold lamé in the movies, it could also carry an aura of otherworldliness.

Gold for the dead

On the basis of objects like those found at Varna, it is tempting to imagine the use of gold adornments by the living as well as the dead. But as a gravesite from a culture that left no written records, the necropolis provides little information about whether people wore gold while they were alive. What we know is that some specific individuals were adorned with gold in death. Scholars believe that the abundance of gold in certain graves – but not in others – reflects the social status of their occupants while alive.[4] Varna's gold would thus provide evidence of the early development of social hierarchy based on gender and rank. The grave of an elder 'elite male' found there contains a gold penis covering along with numerous other gold ornaments, while, for example, the only gold in other graves might be a pair of earrings or a ring or amulet, along with some stone tools and clay vessels.[5] Male and female bodies also seem to have been buried in different positions that might mark status differences. But while most people were buried with a relatively simple array of goods, the most lavishly endowed 'graves' were

not those of human beings at all. They were, instead, symbolic burials of gold-adorned effigies whose social status is difficult to define: we may resort to the assumption that more gold equals higher status, but that does not actually tell us much. Gold could not have been a self-evident marker of status the very first time it was used as adornment: its relationship to social status had to be developed. And whether the establishment of a goldworking industry preceded or followed the desire to mark status remains in question. We should be cautious about projecting backward values that derive from a monetary system in which gold constitutes an absolute form of value.

So why were some of the dead dressed in gold and others not? The idea of a gold 'skin' for the dead came to be a frequent practice in many of the ancient cultures that clustered around the eastern Mediterranean. (The Varna culture, referred to as Gumelnita, was located on the Black Sea and had trade relations with other eastern Mediterranean cultures, as evidenced by the presence of shells and other artefacts from the Mediterranean.) In pharaonic Egypt gold was equated with the skin of the gods, and in particular that of Ra, the sun god. Pharaohs were considered divine: one inscription describes a pharaoh as 'a mountain of gold that brightens all the lands'.[6] Royal mummies were bedecked with golden masks and other adornments – bracelets, pectorals, sandals, ornamental weapons and their scabbards – to guarantee their immortal status, and in the lavish tomb of Tutankhamun, the pharaoh's remains were placed in a coffin of solid gold.

The innermost coffin of the king, from the tomb of Tutankhamun, New Kingdom (*c.* 1370–52 BCE), gold inlaid with semi-precious stones.

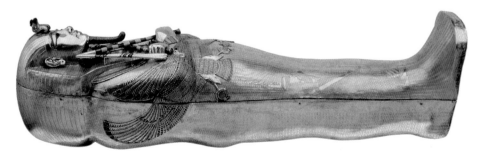

Impressive gold funerary masks from the second millen-
nium BCE were also found at Mycenae in Greece. The most
spectacular, the so-called 'Mask of Agamemnon' unearthed
by the famous German amateur archaeologist Heinrich
Schliemann, has become an iconic gold object that may, how-
ever, be a forgery planted by Schliemann, who was no stranger
to questionable methods and claims.[7] Schliemann's label for
the mask (like his claim of the discovery of what he called
'Priam's Treasure' at a location that may or may not be Troy)
was certainly inaccurate. But the site does boast plenty of gold
objects, including gold funerary masks, whose authenticity is
not in question. Golden burials were not unique to sedentary
cultures, but were also practised by nomadic tribes: a Scythian
nobleman, the 'Golden Man', was buried in a nearly complete
suit of gold in what is now southeastern Kazakhstan in the
fourth or fifth century BCE. The Jesuit missionary Bernabé
Cobo reported that the Inca similarly placed silver and gold
'in [the] mouth, hands, and bosom, or other places' of deceased
individuals.[8] Burying gold with the dead implies that peo-
ple need it more in the afterlife than they do while alive, or
suggests a ceremonial use of gold that outstrips its economic
value, or both. In this regard medieval France had it both ways,
endowing the honoured dead ceremonially with golden cloth
but then keeping it for the living: the golden funeral canopies
draped over dead kings were repeatedly the object of heated
disputes between pallbearers and the monks of the church of
St Denis where the kings were buried – each group thought
the cloth was theirs by right.[9]

As we suggested above, one of the key features of the Varna
site is the presence of 'symbolic graves' in which the 'dead' are
anthropomorphic figures of clay or stone, not human remains at
all. Many of these figures are clothed in gold much more thor-
oughly and richly than the human remains in graves. Whether
they refer to an actual individual or not is a mystery. The prac-
tice might relate to something mentioned in the Sumerian *Epic
of Gilgamesh*, where Gilgamesh orders a statue made depicting
his dead friend Enkidu: 'of lapis lazuli is your chest, of gold your

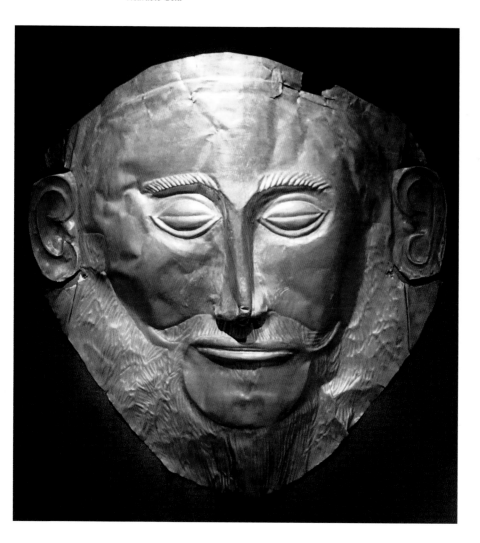

Mask of Agamemnon, hammered gold, *c.* 1550–1500 BCE(?).

body!"[10] In these cases we can understand the use of gold to establish honour that effectively marks social status even as its central purpose is religious. We will consider the use of gold for practices of worship in the next chapter. For now, as we explore the idea of gold for dress and adornment, the Varna graves can tell us that adornment of the dead was a key feature of the earliest human use of gold.

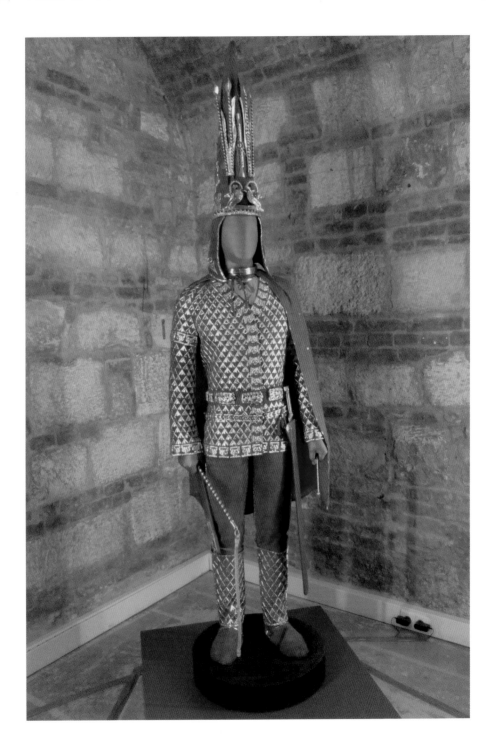

Gold for the living

How did living people wear gold in the distant past? This is harder to tell. Few of the many gold objects that were in use by the living in the Americas survived the Conquest and its aftermath. The encounter of these two cultures was also an encounter of two radically different systems of valuation where gold was concerned. In the Americas it was used for adornment and carried symbolic social and religious value, but melted down, it was not valuable in a raw economic sense. For Europeans it was quite the contrary. Almost every single seized gold object the conquistadors took back with them to Europe was, sooner or later, melted down. In part this fate was the result of the brute force of economics. It also reflected European anxieties about what they saw as dangerous pagan idolatry – a motivation that is hard to separate from the conquerors' intentional destruction of local cultural memory. Disrespect for the aesthetic value of pre-Columbian objects did not end with the Conquest; in the mid-nineteenth century, the Bank of England was still, every year, liquidating ancient American gold objects worth thousands of pounds.[11]

While the ancient American gold we can now see on display in museums (such as the Museo del Oro del Banco de la República in Bogotá, Colombia) was, therefore, almost entirely found more recently in tombs, gold was also worn by the living. Spanish accounts make this clear, and so do the objects themselves. Mixtec artisans – who worked for the Aztecs, producing some of the very finest gold adornments in the Americas – crafted breastplates, masks, headdresses, face ornaments and earpieces and other kinds of adornments with great care, to withstand the movements of a living body. As André Emmerich put it, 'Mixtec ornaments . . . for all their delicate preciousness . . . are never too fragile for their intended use.'[12]

For most people in the modern world, gold as a material to wear is most closely associated with much simpler adornments – rings and, in particular, wedding bands. The exchange of rings in marriage ceremonies seems to have derived from ancient

Reconstruction of a 5th-century BCE warrior costume made of thousands of pieces of gold. Scythian 'Golden Man', in Almaty, Kazakhstan.

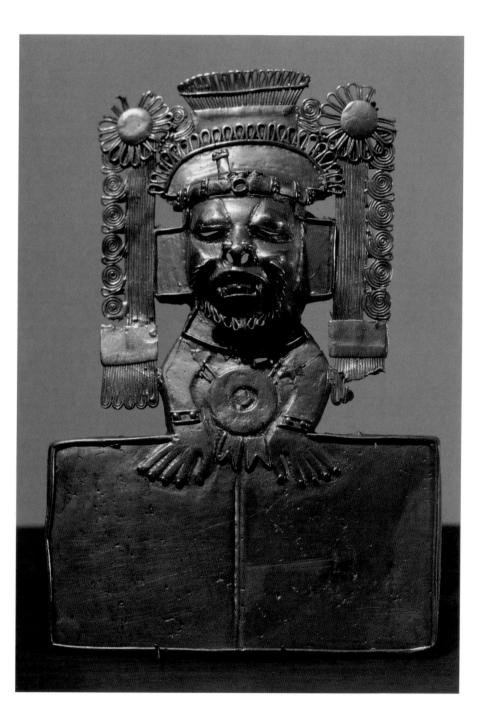

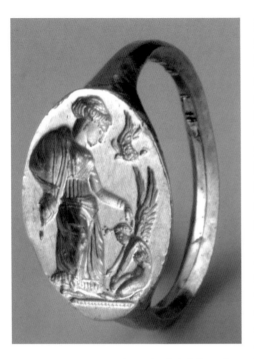

Gold ring with Aphrodite and Eros on the intaglio, 400–370 BCE.

A golden Mixtec pectoral made by lost-wax casting, depicting the Aztec god Xiuhtecuhtli, *c.* 1500 CE.

Roman practices, but the wearing of rings is even older. In the third millennium BCE goldsmiths in Egypt and in the Sumerian culture of Mesopotamia (modern Iraq) developed sophisticated techniques of annealing (heating metal to enhance its ductility for hammering), wire-making, soldering and casting. It was in this period that rings (for the living as well as the dead) became a key product of the goldsmith's art.

These rings had functional value. Even when they are found (as they are, often abundantly) in graves, we can tell they did not simply adorn the dead because documents and wear on the actual objects show they were used for practical purposes by the living. A chief function of rings was as seals, known today as 'signet' rings. In its simplest form the seal consisted of a flat, widened piece of the band, engraved with images or words and known as the 'intaglio', allowing the bearer to fix his or her identity officially in wax or clay to a document or other object. Other rings carried gems that were themselves engraved ('intaglio gems') and served as the seal. These rings served as markers of identity and particularly of identity within a social life comprised of agreements and exchanges. They may also have been used to indicate religious devotion, as when particular gods are illustrated on the intaglio, or as amulets possessing magical properties. In some cases, the engraved gem of a ring was carved in a scarab shape, with a rounded upper side expressing the humped shape and wings of the scarab beetle and a hidden, engraved flat side designed to rotate in the setting. Thus the seal or amuletic text could be worn hidden from view but touching the body, and rotated to allow for the image to be stamped in clay or wax.

43

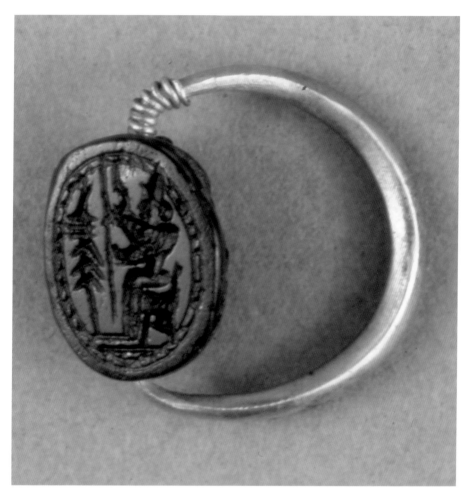

Rings were made of many different metals, and their use in connection with personal identity was widespread in ancient Egyptian, Greek and Roman society. Clearly gold was the preferred material, one that was also used for other amuletic purposes (for example, thin sheets of gold were inscribed with magic spells, rolled up and kept in special containers). Many of the amuletic ring types are associated with love and fertility, which suggests the key function of rings that developed in Roman times and came to be closely associated with the gold ring as cultural symbol: that is, its role in marriage.

A Phoenician scarab signet ring made of gold and jasper, showing a figure seated on a throne, 8th–3rd century BCE.

The exchange of rings as part of marriage ceremonies seems to have developed from Roman betrothal practices; later, in the European Middle Ages, the custom of giving rings not only for betrothal but for the marriage itself emerged. Pliny complained in the first century CE that gold rings had replaced plain iron bands for these ceremonies, which involved an exchange of rings marking the promise to wed. He wrote rather hyperbolically that 'the worst crime against man's life was committed by the person who first put gold on his fingers.'[13] To him, this excessive luxury marked the decadence into which imperial Rome had fallen. (About a century after Pliny, the Christian writer Tertullian complained that the only gold women used to know – in contrast to the excessive luxury seen in the adornments of his time – was the nuptial band.[14])

Today we generally think of marriage as an enduring bond created between more or less equal and loving partners. This view is not entirely novel; it has coexisted for a very long time with the more typical view of marriage as an alliance of families and an arrangement for the disposition of wealth. In the latter understanding, which held true historically in Western Europe until the modern period, the bride is essentially one more piece of property. (Indeed, some have argued that the use of a ring in marriage proceedings derives ultimately from the chains in which the bride was led to her husband's abode.) This did not mean that women had no role to play other than childbearing. Some Roman betrothal rings contained the image or shape of a key, signifying the bride's future role of protecting the husband's household and possessions. Gold rings thus straddle the divide between marriage as a personal bond and marriage as an economic arrangement. The ring marks a connection, the agreement between two individuals (one that might derive from the older function of the ring as a guarantor of personal identity), even an expression of love. But it also, particularly when the material is precious, speaks of the economic function of marriage exchange.

Cloth of gold

A ring made of gold is unobtrusive when compared to the lavish bodily adornments of European courts of the early modern period, from the fifteenth to the eighteenth century CE. Glittering spectacle was a way of expressing power and establishing fame (like the parade of celebrities at today's Academy Award ceremonies). In a time before television, in which printers produced editions of books numbering in the low thousands and pamphlets and broadsides might not be much more, rulers communicated their authority to their subjects in person. In coronations, weddings and ceremonial 'entries' into cities royalty paraded with an extensive entourage of nobles, servants and subjects, many of them clad in gold (which they were not otherwise allowed to wear) for the occasion. The Renaissance kings of France wore golden spurs in their *sacre* (the religious anointing that accompanied coronation) that are now part of the treasury of the royal church of St-Denis. European royalty are not the only rulers in history to clothe their bodies so lavishly in gold, but their performances are especially well documented. Books published to record these events provide obsessive accounts of the differences between costume of each rank and profession (a little like the coverage of the Academy Awards, in fact), demonstrating the importance of fine-grained distinctions – at least to the books' authors, for we do not know how legible these differences were to the typical viewer.

But certainly, the golden raiment of aristocrats was intended to make clear their difference from the common person. The *Siete Partidas*, the thirteenth-century law code of Castile, makes the case for the wearing of gold by rulers in particularly concrete ways. The code explains that luxury garments make immediately visible the status and uniqueness of the wearer and facilitate the ruler's recognition by subjects.[15] Again, without mass media, the faces of rulers were not necessarily familiar. Interestingly it was also a Spaniard, Gonzalo Fernández de Oviedo, who observed of New World (specifically Panamanian) chiefs that 'it was the custom in those parts for the chiefs and important men

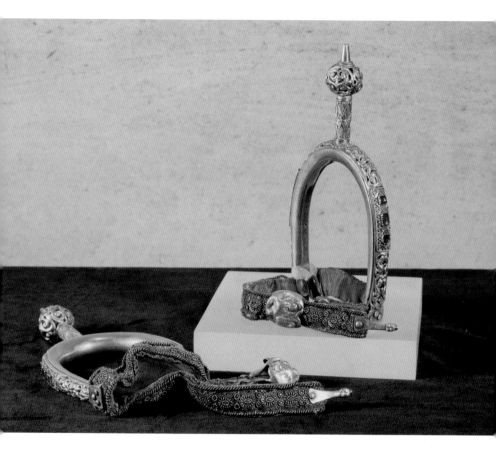

The golden spurs of St-Denis, 12th century, with 16th- and 19th-century additions. Gold, copper, garnet, fabric.

to bring to battle some gold jewel on their chests or head or arms in order to be known to their own men and also by their enemies."[16] Golden brilliance might not only suggest difference but even construct a kind of divine status for chiefs or rulers. It is easy to assume that gold might have this function in the case of early civilizations (for example, the association of gold with the pharaohs of Egypt reflects the divine status of both), but it seems a little more surprising in the case of Europeans who were ostensibly monotheistic. The resurgence of interest in pagan antiquity in early modern Europe, however, seems to have brought with it new resources for royal mythmakers: a seventeenth-century French treatise on royal marriage refers casually to kings and queens of France as 'demigods'.[17]

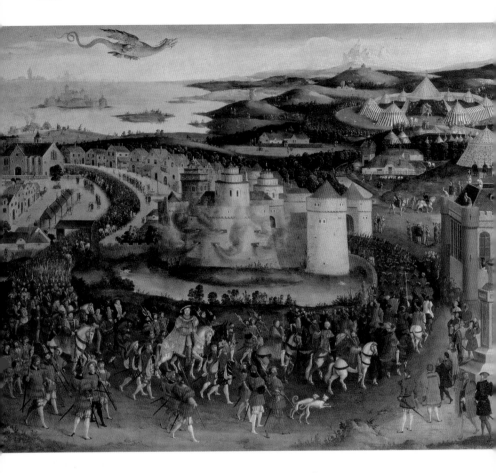

When the English king Henry VIII ceremonially encoun-
tered the French king Francis I on a field near Calais in 1520,
so much gold was worn that the event was dubbed 'the Field
of the Cloth of Gold'. Pavilions were draped in gold. The kings
and their entourages wore cloths of gold, gold chains and gold
belts; steeds sported gold spangles, tassels and bells.[18] Lesser
nobles were temporarily allowed finer cloths than usual in order
to enhance the spectacle. Liveried servants, far too low-rank-
ing to wear such fabric on their own account, wore gold as
extensions of the magnificence of the royal personage.

By that time, in the early sixteenth century, cloth of gold
was being produced in the French city of Tours, but the cities

British School (formerly
attributed to Hans
Holbein the Younger),
Field of the Cloth of Gold,
1545, oil on canvas.

in Europe most famous for their cloth of gold were the Italian centres of silk production (Lucca, Venice, Florence and Milan) that emerged after the Crusades. The gold thread that was the basis for cloth of gold was formed around threads of silk, which, though it had been produced in Europe for almost a millennium by this time, was still associated with its origins in China. Silk in general and golden textiles in particular were still associated with the aura of Eastern brilliance; patterned textiles made in Europe still mimicked Persian and Chinese models (Europeans distinguished only with difficulty among the different 'easts'), and some types of cloth still bear names that speak of their Middle Eastern places of origin, like damask, from Damascus, or baldaquin, from Baghdad.

The story of how gold cloth made its way to Europe involves a bit of intrigue. First, it is worth pointing out that gold, while valued in China, did not hold the special status there that it had in Europe; as precious materials, jade and bronze were more highly prized. Rather than the golden funerary apparel we saw in the ancient Mediterranean, Han dynasty emperors were interred in jade suits – sewn together, however, with gold thread! This thread was made by wrapping hammered gold foil around a core of silk. The same foil was used to adorn wooden, bronze and ceramic objects. Along with its use in sewing funerary suits, gold thread was used for embroidery and to create gold-woven silks (that is, cloth woven with a combination of plain silk thread and gold thread). Beginning in the second century BCE, trade along the Silk Road brought Chinese commodities including silk and gold thread to western Asia, Alexandria and Syria. Sassanid

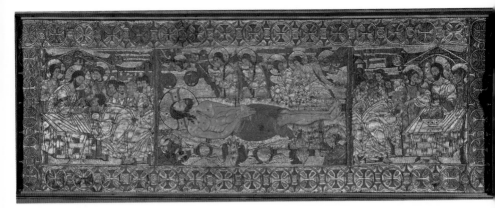

Persia in particular became especially famous for its polychrome and gold-woven silks.[19]

Chinese producers jealously guarded their knowledge of silkworm cultivation to maintain a monopoly on silk and its production techniques, of which gold thread was just a subset. Until the sixth century CE, Europeans not only lacked the necessary raw materials – silkworms and mulberry trees – necessary to spin silk thread, but thought it came from India, not China. Impetus to establish local silk farming in Europe came when the Sassanid Empire, situated in a pivotal location along the trade route, flexed its muscles in the waning years of the Roman Empire, and the imperial weaving workshops in the eastern Roman capital of Constantinople found it increasingly difficult to get enough raw silk to meet both local demand and the demand of western lands. It was at that point that two Byzantine (or possibly Persian Christian) monks travelled to China and while there managed to observe silk cultivation. According to the Byzantine chronicler Procopius, they reported on their discoveries to the emperor Justinian I and received his support to make another trip.[20] On that journey they managed to smuggle out of China the makings of a silk industry: young silkworms and small, potted mulberry plants that they managed to keep alive on the long journey back.

The weaving of golden fabrics and the use of gold thread in embroidery flourished in the Byzantine Empire, as the state

The Deposition, from the Thessaloniki Epitaph, *14th century. Embroidery, gold wire on purple silk cloth. This lavish altar frontal demonstrates the Byzantines' continued interest in gold-embroidered cloth many centuries after they acquired the technique.*

workshops supplied not only their own emperors and church dignitaries but the Western European tribes that succeeded the Roman Empire. These industries also flourished in Persia, Baghdad and Islamic Iberia. Along with gold-wrapped silk and plain gold wire, another type of gold yarn for weaving was made in the Islamic world by wrapping gilt vellum (thin strips of sheepskin) around wool. Characteristic Islamic designs for gold brocade became popular in Christian Europe and can be seen in numerous late medieval religious paintings, such as the sixteenth-century portrait of Edward IV on the next page.

Responding to the demand for luxury cloths, European goldsmiths in the twelfth century perfected the process of gilding silver thread, which allowed for the extensive production of 'cloth of gold' from silver-gilt thread, and more recently had established the technique of drawing gold wire to the necessary thinness for use in textiles. The single surviving sixteenth-century 'banc d'orfèvre' or 'goldsmith's bench' made for wire-drawing (shown on pages 54–5) is a luxury object in its own right. At 4.4 metres (14.4 feet), its length demonstrates well its function of pulling a stubby piece of gold wire into a very long, thin one.

These developments enabled European royalty to perform their magnificence all the more hyperbolically. But they also facilitated the wearing of luxury textiles by those of less elevated stations – those to whom it was forbidden by a system of law on the consumption of luxury items, which we now refer to as sumptuary laws. The regulation of cloth of gold (along with cloth of silver, silk and other materials used in clothing) was a key feature of medieval sumptuary laws. These laws restricting the personal display of wealth began to be enacted in the thirteenth century and developed over the years into a system of fine distinctions by rank that inspected dress down to minor details. (In seventeenth-century France, for example, regulations dictated the width of embroidery on the edge of a velvet cloak – no more than a finger's width – alongside prohibitions on gold buttons and the gilding of coaches.[21]) Sumptuary laws often present themselves as a defence of morality in a

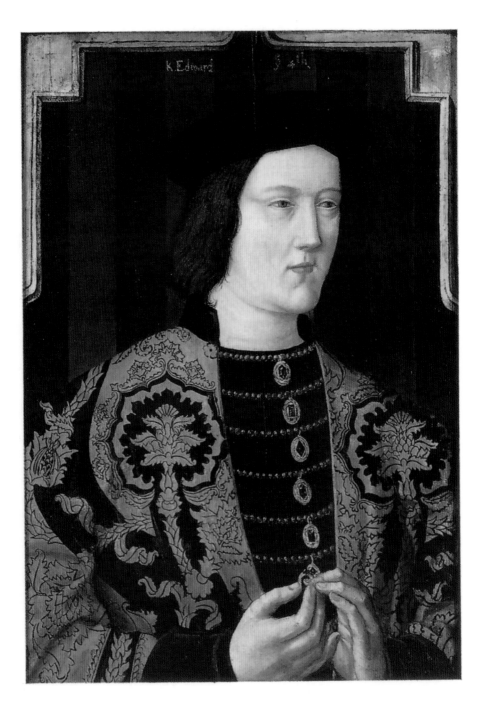

disordered world. Historians have tended to view these claims cynically, interpreting such laws as a strategy for maintaining social distinction in feudal societies. But the golden age of sumptuary laws in Europe was not the 'feudal' Middle Ages, it was the early modern period, when many of the distinctions of rank were becoming less grounded in economic realities. As a matter of policy, when types of expenditure are broken down by income, we have a clue that a sumptuary regulation was intended by royalty to maintain a certain level of ready cash among subjects, especially richer subjects who could be taxed to help support costly wars. Some laws specifically protected local industries from foreign incursions. Generally they responded to social mobility, and especially to the increasing anonymity of urban life. Sumptuary laws dealing with dress enforced the visual recognizability of rank, gender and profession. Legal systems also required particular distinguishing marks to be worn by Jews, the poor and foreigners, and differentiated the status of women (as nubile, married, widowed or prostitutes).

Sumptuary laws, however, seem rarely to have worked very well at their ostensible function. They were routinely disregarded; indeed, publishing them may have even served to provide the information that allowed them to be flouted, teaching members of 'lower' social ranks just what their material aspirations should look like and thus spurring consumption.[22] As Michel de Montaigne put it, 'to enact, that none but princes shall eat turbot, shall wear velvet, or gold lace, and to interdict these things to the people, what is it but to bring them into a greater esteem and to set everyone agog to eat, and wear them?'[23] Could these laws in fact have been designed with the understanding that they would be broken, with the more cynical goal of supporting the development of luxury industries?

In special events like the Field of the Cloth of Gold, the king allowed exceptions to the normal sumptuary regulations; displays of wealth that might otherwise be forbidden were accepted, even encouraged, as part of the overall royal spectacle. Contemporary commentators charged that all the

Unknown, Anglo-Flemish School, portrait of Edward IV Plantagenet, *c.* 1520.

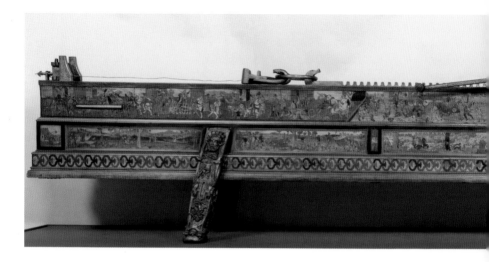

courtiers were bankrupting themselves as they competed to wear the most dazzling outfits. In their comments we can hear echoes of the language of sumptuary laws, directed, however, not at social climbers in particular but at society as a whole and its systems of value. The chronicler Martin du Bellay, for example, complained that attendees were 'wearing their forests, their mills, and their fields on their backs'.[24] He meant that they were misusing their property and the associated natural resources that constituted their real wealth. John Fisher, bishop of Rochester, preached a sermon in which he pointed out that all the finery was not only earthly but earthy: silk was made 'from the entrails of worms'; the dyes that coloured it came from 'right vile creatures'; and gold was nothing but earth.[25]

Other worlds

Throughout the history of human uses of gold, one key technique for goldsmiths has been to 'clothe' objects of all sorts in gold by gilding them. Gold works well as a surface adornment, for it is readily hammered into thin sheets that can be used for gilding. Metalworkers gild silver in many cultures (and the resulting objects are called silver-gilt) but Chinese goldsmiths gilded wooden, stone, clay and bronze objects. As we saw

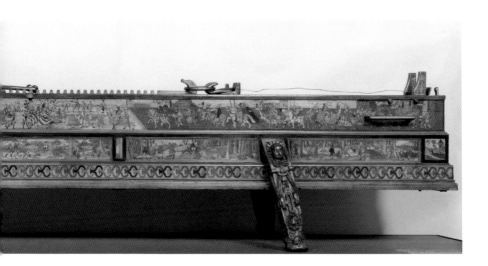

Leonhard Danner
(1497–1585), workbench
of a goldsmith, made
in Dresden for August
the Great, Elector of
Saxony (1526–1586),
c. 1565, carved and
inlaid wood.

above, silver-gilt thread was an important development in the production of cloth of gold in the European Renaissance. Adding gold to the surface of other materials allows for the more economical use of the precious metal, whether for functional objects, jewellery or textiles. Gilding also, however, carries with it some additional moral objections that echo those we have heard above. 'Gilding the lily' suggests excess, perhaps an affront to natural beauty, while the 'Gilded Age' of late nineteenth-century America was a term coined to suggest that the period's outward displays of wealth masked the widening gap between rich and poor, the development of urban ghettos, the hardening of legal racism and other social problems with a thin veneer of gold. It should come as no surprise that the Gilded Age also spawned a critical theory of consumption, Thorstein Veblen's *The Theory of the Leisure Class*. For Renaissance kings, the wearing of gold, while a display of status and magnificence, was still a means of *saving* as much as it was *spending*. Gold jewellery and cloth could readily be melted down for their material value; the artisans who made them were so poorly paid that the labour cost was essentially expendable. But nineteenth-century couturiers made a high art form out of crafting glittering costumes for the newly wealthy, whose ever-changing wardrobes defined 'conspicuous consumption', the term coined by Veblen.

55

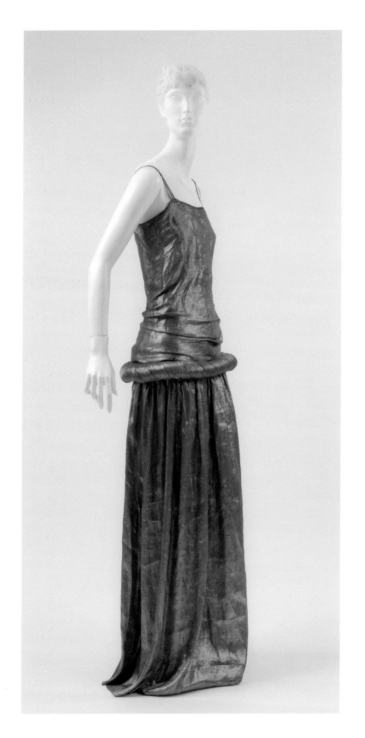

Paul Poiret, 'Irudrée'
gown made of gold and
silk, 1922.

Their creations also inherited the Orientalism of earlier European views of gold. For example, the haute couture designer Paul Poiret created gold lamé party costumes based on Asian and Middle Eastern motifs – notably, this also allowed him, at the turn of the twentieth century, to champion a straighter, looser silhouette for women, dispensing with corsets; it would be popularized with the flapper look in the 1920s. His contemporary Mariano Fortuny was also known for exotic use of gold lamé.[26] Marcel Proust described a Fortuny gown 'overrun, like Venice, with Arab ornamentation, like the Venetian palaces hidden like sultan's wives behind a screen of pierced stone ... [it] transformed itself into malleable gold by virtue of those same transformations which, before an advancing gondola, change into dazzling metal the azure of the Grand Canal'.[27]

During the Great Depression of the 1930s, Hollywood developed a taste for gold lamé gowns worn for their sheer glamour. Crystal Allen, the vixen played by Joan Crawford in *The Women* (1939), suggests a hint of scandal with her midriff-baring gold evening gown. In 1939's *Midnight* Claudette Colbert is a down-on-her-luck American showgirl stranded in Paris with a gold lamé evening gown and little else. After masquerading as a hapless tourist, Joan Bennett reveals her true colours as an American heiress in glorious gold lamé in *Artists and Models Abroad* (1938). Ironically the gold colour of this lamé was not visible to viewers. Gold lamé was used in black-and-white films because it photographed well, producing a flowing, liquid sheen, but viewers (who were, after all, living through the Great Depression) had to content themselves with imagined luxury. Then, in the 1940s, the government rationed fabric for movie studios and designers took a break from precious metal fabrics.

In the post-war period, gold was back, and Technicolor allowed it to glow with its characteristic yellow sheen. Gold represented both glamour and exoticism in the costume that Elizabeth Taylor wore in *Cleopatra* (1963). Made of 24-carat gold thread, the gown cost $130,000 (in 1963 dollars) to make.[28] The film was a massive flop. One certainly cannot attribute its failure to the appearance of Taylor's gown, but one might

wonder whether Technicolor made the gold costume look excessive or even a little trashy. Could this be the reason that one of the key costume design uses of gold in post-war film wasn't for luxury but for science fiction – for spacesuits and, especially, for the costumes and skin of aliens and androids? Maria, Fritz Lang's original film robot *Metropolis* (1927), was gold, though like the gold lamé screen goddesses of the 1930s she appeared in black and white. More recently, gold clothed the Romulans of the original *Star Trek*; Ornella Muti's Princess Aura in *Flash Gordon*; Joanna Cassidy's Zhora in *Blade Runner*; and, perhaps, most famously, C-3PO in *Star Wars*.

The gold at Varna and other ancient sites indicates its association not just with power and wealth but with the afterlife: one kind of alternate reality. In using it to express glamour, exoticism and futuristic or alien worlds, Hollywood has clothed characters in gold to suggest otherworldliness of other kinds. In retrospect gold can appear vulgar or campy. Even in its own time, classic Hollywood glitter oscillated between a beguiling transport into the celestial realm of the 'star' and a vulgar-seeming attachment to material riches. But that very vulgarity can also be a way to transgress norms and counter histories of oppression. In hip-hop culture, 'bling' (whether real or

Elizabeth Taylor in *Cleopatra* (1963).

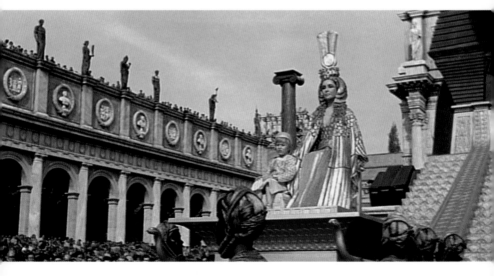

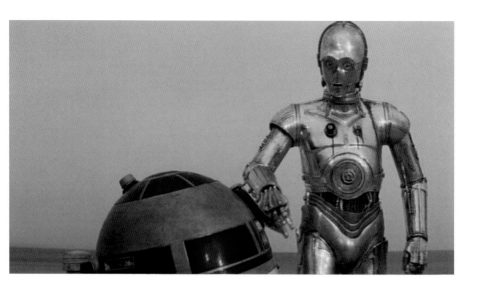

fake) can serve as a form of 'guerrilla capitalism', enabling artists to construct their self-image through an excess of shine.[29] In the next chapter, we address the confluence of material and spiritual power that gold represents in religious and political contexts. As much as people try, these functions are hard to separate from one another.

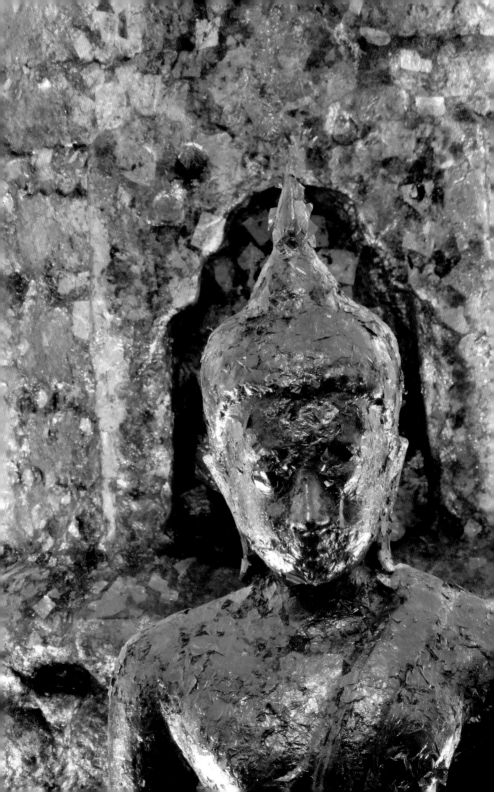

2 Gold, Religion and Power

The use of gold in worship is an ancient practice that has continued into modern times. In present-day Thai Buddhism, devotees 'make merit' by buying small squares of gold foil – the proceeds help to maintain the temple – and applying them to Buddha statues. This often takes place in annual temple fairs colloquially known as *ngarn pid thong phra*, the 'festival to put gold on the Buddha [statues]'.[1] At these and other occasions, the faithful apply gold leaf to Buddha statues and to other sacred objects (including the Buddha's footprint). Some worshippers choose to place their gold leaf on the statue's body in a spot corresponding to an illness they wish to have healed. This uneven application of gold leaf produces striking visual effects as pieces of gold foil accumulate in areas of greater intensity or sometimes come partly unstuck and sway in the wind. To an outsider these surfaces give the appearance of ancient gilding that has worn off through the centuries; to devotees they are signs not of decay but of the statues' continuing life.

Making merit is a personal, spiritual act. By performing good deeds, devotees accumulate merit that they can carry with them to their next incarnation as they seek the purified state of nirvana. But making merit can also be a social act, visible to the community. The idea that some merit-makers are more concerned with what their neighbours think than they are with their spiritual life is a root assumption of a Thai phrase, *bpìt tong lăng prá*. This means to do a good deed secretly, without expecting thanks: 'to gild the back of the Buddha', the part that is not seen. Running alongside the sacred uses of gold has been, of

Statue of the Buddha, covered in gold foil. Wat Saket (Golden Mount) Bangkok.

course – and for a very long time – its economic function. And thus the use of gold for religious purposes – especially its public use, as in this Thai example – seems to risk running counter to the purpose of giving honour to the deity, as if the donor is claiming honour by ostentatiously showing off the wealth she can afford to give up.

Gold is associated with a shining, otherworldly character attributed to the gods in the religions of many different cultures. It is sometimes a very bodily association: in the ancient Americas, for example, the Aztecs described gold as the 'excrement of the gods', while the Inca thought of it as the 'sweat of the sun'. In ancient Egypt gold was considered, somewhat more decorously, the blood or flesh of the gods (in particular the gods Ra and Osiris and the goddess Hathor – who was sometimes equated with gold itself).[2] In Hindu texts gold derives from the shattered body of the god Viśvarūpa, is emitted from the heat of Prajāpati and serves to generate Brahmā (from a 'golden egg' produced by the union of water and the seed of Agni, the fire god); the god Siva (Shiva) is said to be fluid gold. In the Rāmāyana, gold (and all the metals) are generated in the earth's body through the seed of Agni.[3] As a substance, thus, gold often has a divine character of its own, and this makes it, so the thinking goes, an appropriate way to give honour to deities. Objects and implements associated with sacrificial rituals in ancient Indian religion were frequently made of gold. Gold adorns the exterior of many houses of worship in South and Southeast Asia: the towering golden stupa of Shwedagon Pagoda, a Buddhist temple in Rangoon; the Golden Rock or Kyaiktiyo Pagoda, a temple perched atop a gilded boulder (also in Burma); and the Harmandir Sahib (Golden Temple) in Amritsar in India, an important Sikh temple. The richest temple in the world, Padmanabhaswamy Temple, is also in India, in Thiruvanathapuram, Kerala state, but its gold artefacts (valued in the billions of u.s. dollars) are hidden inside. Gold glimmers likewise on other temple interiors around the world: the mosaics of Hagia Sophia in Istanbul, made from golden *tesserae* (tiny square tiles), and the monumental, gold leaf-encased Altar of

Shwedagon Pagoda, Yangon (formerly Rangoon), Myanmar, 6th century CE.

The Harmandir Sahib, commonly known as the Golden Temple, Amritsar, India, 16th–17th century CE.

Kings in the Cathedral of Mexico City. Little material evidence remains of golden Inca temples ravaged by the Spanish, but the temple of the sun, Coricancha (Golden Enclosure), perhaps the most dazzling temple ever built, is said to have been clothed in sheets of gold inside and out and filled with golden ornaments.

Alongside sites like Coricancha, the Inca kings also possessed gold and silver regalia, such as sceptres, spears and halberds, that expressed their divine origins; the ruling elites were considered the offspring of the sun and moon.[4] Egyptian temples and tombs of Egyptian kings often had bas-reliefs and cladding in gold leaf, and the royal dead were equipped with golden grave goods and their cases decorated in gold. In Christian Europe the golden crown jewels of monarchs often incorporated crosses that established the relationship between spiritual and political power. Similar stories of sacred golden regalia exist for other elites whose power was held to be divinely ordained and who sometimes held priestly functions. According to Herodotus, the Scythians believed that golden instruments (a cup, an axe, a yoke and a plough) had fallen from heaven to indicate the heavenly ordination of their rulers.[5] Herodotus

Close-up showing Christ on the Byzantine Deesis mosaic in the Hagia Sophia, Istanbul, Turkey. Gold and glass mosaic, 9th century (before 867 CE).

Detail of the Altar of Kings, Metropolitan Cathedral in Mexico City.

could not have known about the real events that brought gold to the Ordos culture of Inner Mongolia, but his story sounds like a mythical embroidering of them. These pastoral people of the Eurasian steppes – indeed part of the larger group known as Scythians to the Greeks – herded livestock and made strikingly beautiful adornments in tin-encrusted bronze, which they prized above other materials. But in the fourth century BCE nomadic peoples who practised mounted warfare and apparently valued gold disrupted their way of life; quickly the pastoral people took up horseback riding and a nomadic existence, and established a hierarchy of metals with gold at the top. They did not produce golden objects, though – the dazzling belt buckles and bridle accoutrements with which they festooned their horses were manufactured in China specifically for export to their northern neighbours. Sixteen centuries later, the descendants of those newly mounted warriors conquered the descendants of the Chinese exporters when Kublai Khan conquered China and founded the Yuan Dynasty.[6]

Like the Scythian royal implements, the Asante Golden Stool, a symbol of the nationhood of the Asante of west Africa, was also believed to have fallen from heaven. Asante is part of modern Ghana, part of the region formerly known

The Asantehene, the Asante king, and the Golden Stool, Accra, Gold Coast, British West Africa, December 1946.

to Europeans as the Gold Coast. The stool – *Sika Dwa Kofi*, the 'golden stool born on Friday' – is held to have fallen into the lap of the first Asante king, Osei Tutu, in 1701. On it are a number of bells: one to call people together, two that announce the arrival of the stool when it is carried in procession, and a series of human-shaped bells that symbolize defeated enemies of the Asante kings.[7] For the Asante, gold was and is a key element in court display. Other golden artefacts worn by the Asante king and courtiers include rings, beads, caps and ceremonial sword ornaments. Slaves or servants charged with cleansing the king's soul of the moral effects of state violence wear the *akrafokonmu* (soul washer's disc). The king's spokesman carries the *kyeame poma* (a 'linguist's staff' with a golden finial). Another sign of gold's important symbolic status in the Asante kingdom comes in objects not made of gold at all: gold weights, generally made of brass, that attained elaborate ornamental and representational forms beginning in the seventeenth century.

Soul Disc Pendant (*akrafokonmu*, 'soul washer's disc'), Ghana, 19th century. Cast gold, hammered.

The golden stool has such sacred status that even the king does not sit on it, and when it is (rarely) seen it is displayed on a European-style chair of its own. When the colonial governor Sir Frederick Hodgson, installed in what was at the time one of Britain's newest colonies, haughtily demanded to sit on the stool in 1900, the Asante rebelled at the affront, besieging the British at Kumasi in the War of the Golden Stool (notably, a war that pitted two queens against one another: Queen Victoria and Queen Mother Yaa Asantewaa). Although the Asante eventually lost control of their territory to the British, they kept the stool, and it is still used as a symbol of traditional Asante power in Ghana.

In a secular vein, rulers throughout history have also possessed the prerogative of awarding golden tokens, such as rings,

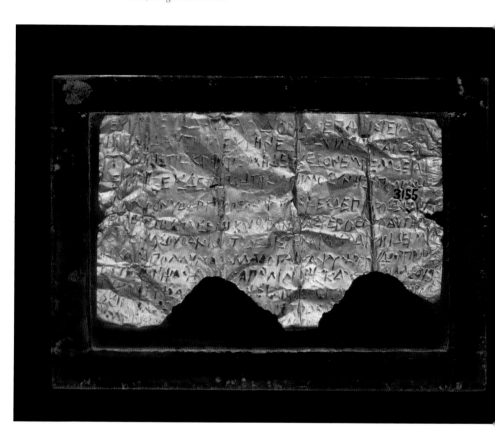

Gold tablet with an Orphic inscription, 3rd–2nd century BCE Greece.

cups or medals, to their favourites and servitors; this practice underlies the idea of the 'gold medal' as a contest prize, which developed in early modern Europe and blossomed around 1900 into the system of inscribed metallic medals (gold, silver, bronze) used in the modern Olympic Games.

Written in gold

One special use of gold in religious contexts is as a surface for writing or a substance with which to write. Joseph Smith, the founder of the Mormon church, claimed to have received from an angel named Moroni the 'golden plates' on which he found the text that he translated and published as the *Book of Mormon* in 1830. In the ancient Mediterranean, people prepared

inscribed thin sheets of gold, called *lamellae* or Orphic gold tablets, to use as 'passports' on their journey to the next life after death. They were sometimes cut to particular shapes and rolled as a phylactery (a magical amulet), inscribed with words of comfort and admonition to the deceased, giving guidance on what they will see as they proceed on their journey to the netherworld. Some seem to have been used by the living, with magical intent: for protection, for victory or as love charms. Some individuals in many early European cultures had gold coins placed on their tongues or accompanying their bodies in burial – in Greece this was called 'Charon's obol', the coin necessary to pay the ferryman for passage across the River Styx. In more modest contexts these 'coins' were actually thin gold leaf impressed with images of human or mythological figures.

Whether or not the sacred value of gold preceded its use as currency in any given culture, many cultures face the problem of establishing a relationship between the divine and the worldly significance of gold. Gold has often held a paradoxical place in religious practice. Is it an inherently noble metal or is its value a purely human convention, like money itself? Is it a good way of giving honour to God or does its materiality distract from its spiritual force? Along with its economic character, the very 'dazzlingness' of gold might make it suspect from certain moral perspectives.

The Hebrew Bible (known to Christians as the Old Testament) contains some of the most vivid accounts of the uses of gold in worship, and in that context gold occupies a decidedly ambivalent place. Gold first appears in a negative light, as the material of the Golden Calf (see page eight). In Exodus, as Moses is scaling Mount Sinai to receive the tablets of the Law – the Ten Commandments – the Israelites tire of waiting, and ask Moses' brother Aaron to make gods for them:

> Aaron answered them, 'Take off the gold earrings that your wives, your sons and your daughters are wearing, and bring them to me.' So all the people took off their earrings and brought them to Aaron. He took what they handed him and

made it into an idol cast in the shape of a calf, fashioning it with a tool. Then they said, 'These are your gods, Israel, who brought you up out of Egypt.' (32:2–4)

The making of the Golden Calf directly contravenes several of the commandments: the first identifying statement 'I am the Lord thy God who brought you out of Egypt'; the prohibition on worshipping other gods; and the prohibition on making graven images. Whether it is altogether fair that the Israelites are punished for breaking commandments they don't know about yet is certainly a question! But in the intention attached to the making of the idol, the account also resonates with later arguments about idolatry in European religious debates. Although the lines quoted above make clear that the calf is Aaron's handiwork, when Moses later asks Aaron how the idol came to be, he says 'they gave me the gold, and I threw it into the fire, and out came this calf!' One might wonder whether Aaron has actually forgotten his own act of making, or is just ashamed and trying to hide it. This parallels the concern – one that recurs over the centuries – that human beings make religious images only to forget or conceal the fact that these objects are made by human hands. To attribute divine presence to human artefacts, to worship them, is the key act of idolatry. A corollary often mentioned in biblical critiques of idolatry is the idea that idolaters render themselves *like* the substances they worship – humans become thing-like when they attribute liveness to dead matter.

This characteristic is not particular to gold or even to precious metal – wood is often mentioned, perhaps because the word for wood in Greek, *hule*, was also a general word for matter. But gold has a particular place in biblical discussions of idolatry. The idea of idols as 'made of silver and gold' appears in the Psalms and the books of Hosea and Isaiah. In the Acts of the Apostles, in the New Testament, Paul echoes these earlier statements: 'we should not think that the divine being is like gold or silver or stone – an image made by human design and skill.' And yet the Bible also provides fodder for thinking about gold as

Master of the Munich Boccaccio, Construction of the Temple of Jerusalem by King Solomon's order, 15th century CE, pigment and gold on parchment.

an especially good way to honour God or to represent heavenly things. Moses broke the tablets of the law in vexation over the Israelites' worship of the Golden Calf, but those same broken tablets came to rest in a sanctuary – the Holy of Holies – which King Solomon supposedly furnished with gold objects and covered completely in gold. According to the Bible, King David, his father, gave him 100,000 talents of gold to do so. A talent was a unit of weight, and we don't know exactly how much gold it represented, but since one talent of silver could pay the crew of a trireme for a month, we can guess that 100,000 talents of gold was worth quite a lot. Along with Solomon's temple, the New Jerusalem in John's vision in Revelation – unquestionably a heavenly place – is a city built and paved with pure gold.

Thus biblical texts provided fodder for thinking about gold in both negative and positive lights. And Christian theology – as it was formulated under the Roman Empire and beyond, in medieval Europe and Byzantium – likewise both embraced the

material world and expressed hostility toward it. In Western Europe Christianity began as a hidden cult practised by people of modest means and became the Roman Empire's official state religion; the emperor Constantine's conversion to Christianity in 312 brought to the church the trappings of imperial splendour. From this point on, as Christian churches were built as permanent and public structures, they were gilt on the exterior or adorned on the interior with glittering gold foil and mosaics set with golden tesserae.[8] In the fourth century CE these 'gold' mosaic pieces (made with a thin sheet of gold encased in glass) began to be used en masse as the background in pictorial church apses and other locations to create the impression of a solid gold ground.[9]

As we have seen, gold as material substance expressed otherworldly splendour but sometimes seemed to be in conflict with it. Interpreters of the Bible who explained the meaning of gold in the ancient texts generally emphasized symbolic interpretations: gold implied moral excellence rather than luxury.[10]

Mosaic of the Chapel of St Zeno in the Church of Santa Prassede, 9th century CE, Rome, Italy.

Writing in the early years of Christianity, St Jerome criticized the fashion for luxury Gospel manuscripts made with purple parchment written in gold (a practice known as chrysography), suggesting in the preface to his translation of the Book of Job that some people cared more for the luxury of a book than for the correctness of its texts. In one of his letters he writes, 'Parchments are dyed purple, gold is melted for lettering, manuscripts are decked with jewels: and Christ lies at their door naked and dying.'[11] Jerome's critique did not stop wealthy patrons from commissioning luxurious books written and illustrated in gold ink and gold leaf. The Codex Palatinus and Sinope Gospels are Latin and Greek examples of fine vellum dyed purple and then inscribed in gold.

In Islam as well, prohibitions on the use of gold script and other embellishments for the Qur'an coexisted with richly illuminated examples that seem to directly contradict the rules.[12] Gold is attested eight times in the Qur'an itself, four referring to the pleasures and luxuries that believers will have in paradise. Qur'an 43:71 says that golden platters in paradise contain 'whatever the souls desire' – but prohibitions on gold accessories mean that drinking from silver and golden cups in this life will make you feel the fire of hell in your stomach. It may have been in imitation of Christian practices that Islamic manuscript illuminators made such examples as the 'Blue Qur'an', written in Tunisia in the late ninth or early tenth century CE in gold on vellum that was dyed with indigo. In the earliest mosques gold lettering composed of mosaic tesserae was used for holy inscriptions. The script known as Kufic, which arose at the turn of the eighth century for handwritten texts of the Qur'an, developed from this gold mosaic lettering.[13] A lavish example of a manuscript copy of the Qur'an written in gold Kufic script, which appears opposite, displays its luxuriousness by including only a few words per page. Gold could also provide the ground on which to write, as in a Qur'an manuscript from the Seljuk empire (page 76) written in black Kufic letters on gold ground.

Gold calligraphy in Islamic manuscripts was routinely used as a highlight – for the names of God, or for chapter

Qur'an folio in gold Kufic script, *c.* 9th–10th century CE, gold and ink on parchment.

headings. But sometimes gold served an illustrative function in manuscript painting, representing prophetic fire or divine essence, as in the mystical episode of the prophet Muhammad's ascension to heaven. The story was retold many times. In the Miraculous Journey of Muhammad, the *Mirâj Nâmeh*, the prophet is transported by the angel Gabriel from the mosque at Mecca to the 'Far-off Mosque' of Jerusalem. He reaches the heavens and finally contemplates the divine at the Throne of God. In manuscripts the episode was often illustrated with gold to indicate the prophetic flame that envelops Muhammad and the elements of celestial scenery that he encounters. The Bibliothèque nationale de France in Paris possesses an especially lavish fifteenth-century manuscript of the *Mirâj Nâmeh* written in Uighur script in a royal Timurid workshop. It travelled to France after being acquired in 1673 in Constantinople by Antoine Galland, the translator of the *Thousand and One Nights*. On the page that represents Muhammad's encounter with divine essence, he is engulfed in rivulets of golden flame.

Folio from a Qur'an manuscript, *c.* 1180, Seljuk empire (eastern Iran or present-day Afghanistan), ink, opaque watercolour and gold on paper.

The episode was a popular one in manuscript illumination. The same episode appears in the *Book of Wisdom* attributed to Iskandar (Alexander) in a luxurious sixteenth-century Safavid Persian illuminated manuscript of Jami's *Haft Awrang*. Here Muhammad's face is covered in a white veil, a convention of respect, and he rides his human steed surrounded by tongues of golden flame and attended by angels.

Gold was widely used in medieval manuscripts in Europe as well. Charlemagne and his successors carried on

The Prophet Muhammad praying before the Gates of Hell. From *Mirâj Nâmeh*, by Mîr Haydar, produced in the royal workshop of the Timurid dynasty in Herat, Afghanistan, 1436, pigment, ink and gold on paper, owned by the Bibliothèque Nationale de France.

St Mark the Evangelist, from the Gospels of Saint-Médard de Soissons, 9th century CE.

The Miraj of the Prophet. Folio from *Haft Awrang* (Seven Thrones) by the Persian poet Jami (1414–1492), probably written in the Safavid period, 1556–65, opaque watercolour, ink and gold on paper.

the tradition of lavish gospel books written in gold, such as the Gospels of Saint-Médard de Soissons, written in gold on vellum dyed purple in the early ninth century CE. But gold came to be quite a routine form of adornment for manuscripts in the later Middle Ages. Technically, for a manuscript to be considered 'illuminated', it must have gold or silver decoration. Originally artists painted with powdered gold mixed with a painting medium so that it could be applied with a

brush (as with other pigments). This 'shell gold' – stored, like other pigments, in mussel shells – was made by grinding gold with salt or honey so that it crumbled into a powder, rather than just forming a thin sheet of gold leaf, as pounded gold by itself would tend to do. Beginning in the twelfth century, illuminators began using gold leaf applied to selected spots on the page. It was used for lettering (particularly for headings or *nomina sacra*, holy names), in borders and ornamental designs, and within representational images as a background or a highlight. The use of gold in manuscript production boomed after around 1200 CE; the supply of gold in Europe increased with an expanding West African gold trade and the sack of Constantinople in 1204 by European crusaders.[14] In addition the growth of a book industry in urban settings in the later Middle Ages contributed to the use of gold leaf. Professional illuminators who worked in specialized workshops were better equipped to use gold leaf – which is difficult to manipulate and requires a workspace completely sheltered from wind – than monastic scribes who often worked in cubicles adjoining open-air cloisters. One of the most popular types of books made by these professional illuminators was the Book of Hours. These were private prayer books commissioned by wealthy patrons or made on spec for the market, and regularly sported gold illumination. An example that harks back to the earlier fashion for chrysography on purple vellum is the 'Black Hours' in the collection of the Morgan Library in New York, a manuscript written in gold and silver on black-dyed vellum.

'Black Hours', an edition of the Book of Hours written and illuminated on stained or painted black vellum with golden text. Bruges, Belgium, *c.* 1470.

Stones and bones

As Christian thinking developed over time, the extent to which material things could serve as a vehicle for access to the divine

was, in particular, a subject for debate. From the neo-Platonic perspective that inspired many medieval theologians, the cosmos constituted a hierarchy emanating from the divine, of which the material world served as a more or less distant manifestation. The neo-Platonic writer Proclus, who wrote in the fifth century CE, used gold as an example; as the classicist Peter Struck describes it,

> One ray, or chain, leaves the transcendent heights of the One and manifests itself, very near its source, as the traditional Greek god Apollo. When this same ray continues downward and enters the realm of Nous, it brings into being the Platonic Form of the sun . . . Next, as it enters the outer limits of the material level, the beam brings into being the actual physical sun that we see in the sky. The beam does not stop there, however, but continues down to the lower substrata of material reality, into the plant level, where it manifests the heliotrope, and to the mineral level, where it appears as gold.[15]

This way of thinking allowed gold to be seen, depending on one's perspective, as a mineral (one of the lowest of the low among substances), or as linked in a tight chain to the very highest manifestations of divinity – or both. To be sure, gold was prominently mentioned in the Bible in the holiest contexts. Gold in churches recreated Solomon's temple and

provided the faithful with a shimmering, seductive vision of the heavenly Jerusalem. Abbot Suger, in describing the work he oversaw on the twelfth-century Basilica of St-Denis, the first church built in the Gothic style, repeatedly emphasizes the brilliant golden ornamentation of the church in its vessels, crosses, tapestries, gilt inscriptions, wall paintings and altars. In particular gold serves as an especially appropriate substance for housing the Eucharist and the remains of the saints. Its glitter brings the saints, he says, 'to the visitors' glances in more glorious and conspicuous manner'. The living, he proposes, 'should deem it worth our effort to cover the most sacred ashes of those whose venerable spirits, radiant as the sun, attend upon Almighty God with the most precious material we possibly can: with refined gold and a profusion of hyacinths, emeralds and other precious stones'.[16]

Suger points to a key religious use of gold: as the material of reliquaries that hold the bodily remains, or relics, of holy figures, clothing them in brilliant light. The largest Christian reliquary in Europe, the Shrine of the Three Kings in Cologne cathedral, is made of gold. This reliquary, measuring more than 2 metres (6 feet) long, was created by Nicholas of Verdun in the twelfth century to house relics of the Magi. The Magi were also responsible for a relic that was itself made of gold: a gold *solidus* coin from the fifth-century rule of the Byzantine emperor Zeno was worshiped in Milan as a *ducato dei tre magi*, that is, a ducat of the Three Magi, ostensibly among the offerings of gold that the Magi brought to the infant Jesus.[17] But most relics were bones and other bodily fragments, material evidence of the physical lives of saints. In fact they represented them in a more than merely symbolic way. They *were* the saints, still present (living, even) among the faithful. And yet these aged, dirty, broken bits of bone – whether genuine or not – were often quite unimpressive to look at. Luxuriously fashioned reliquaries redressed this concern by lending the beauty of gold and other precious materials to express how important these objects actually were and to suggest the shining purity of the saint. Indeed this function was quite explicitly understood by

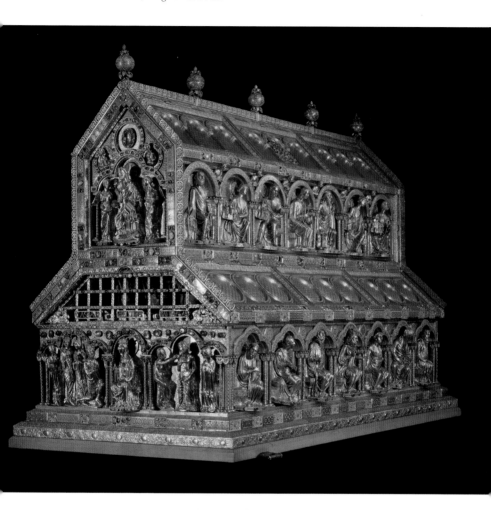

Nicholas of Verdun
(*c.* 1150–1205), Shrine of
the Three Kings, begun
1181. Gold, enamel,
precious stones, cameos,
antique gems.

proponents of relics. Thiofrid of Echternach justifies golden
containers for the saints as a way of preventing 'horrified'
responses to the material remains.[18] The saintly body is to be
understood as a shining body, whatever the physical remains
might look like. This special golden status appears in paintings,
too, with the use of the halo and sometimes floating crowns or
shining robes of gold.

The type of reliquary called 'speaking' or 'image' reliquar-
ies expressed in fuller form the fragment's identity as body
part. Thus a piece of skull might be encased in a life-sized

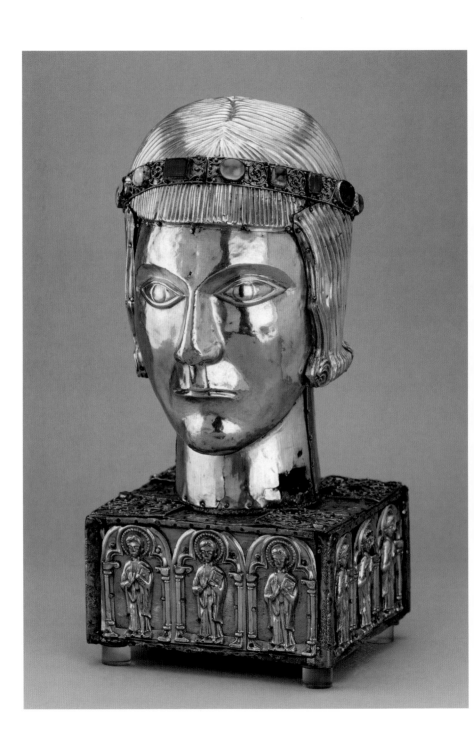

head fashioned from precious metal, like the reliquary head of St Eustace at the British Museum. A simple object relic might be encased in a more lavish version of itself, such as the bell-shaped shrine with gold filigree (fine wire soldered onto the surface in patterns) that houses the much simpler bell of St Patrick. As the art historian Cynthia Hahn writes of the St Eustace head (and the description can apply to many others): 'It is as if one sees ... the human figure giving off light, a stunning and oversaturated sensory experience.'[19]

One of the most famous Christian reliquaries made of gold is that of Ste-Foy (St Faith) at the church of Ste-Foy de Conques, a ninth-century statue just under 90 cm (3 feet) high. Seated in majesty, set with numerous gems, the statue incorporates an earlier head, possibly an imperial portrait from the later Roman Empire, with an impassive masklike face and disconcertingly staring eyes. In the flickering light of candles in the medieval church, one can imagine the shining surface coming to appear mobile, animating the figure. In the eleventh century Bernard of Angers, writing an account of Ste-Foy's miracles, first doubts the statue, comparing it to a pagan idol that would receive sacrifices to Jupiter or Mars. He finally concludes that 'the holy image is consulted not as an idol that requires sacrifices, but because it commemorates a martyr',[20] and goes on to collect accounts of the many miracles performed by the saint.

Would we be wrong to think Bernard's change of heart not altogether justified? Whether the statue 'required' sacrifices or not, it accumulated countless votive offerings as thanks for these miracles. Indeed, like an idol, the statue sometimes punished those who failed to supply them. And surely the distance between divine or semi-divine being and lifeless image was not always obvious to believers. This slippage would result in vehement critiques – sometimes physical acts of destruction – during the Protestant Reformation in the sixteenth century, when concerns arose both about the possibility that worshippers were giving their adoration to material things and also about the excessive wealth of the Catholic Church, embodied in costly ornamentation. The worry that golden objects of worship

Reliquary head of St Eustace, c. 1210, from Basel, Switzerland. Silver-gilt repoussé head surrounding wooden core with gem-set filigree circlet.

give priority to the economic value of gold did not emerge suddenly in the sixteenth century, however. It is a basic assumption of inscriptions sometimes found on medieval objects. On the back of a golden altar at the church of Sant'Ambrogio in Milan, an inscription cautions that 'more potent than all its gold is the treasure with which it is endowed by virtue of the holy bones within it.'[21] Similarly, a Bible commissioned by Theodulf, author of the *Opus Caroli*, contains a dedication noting that the cover

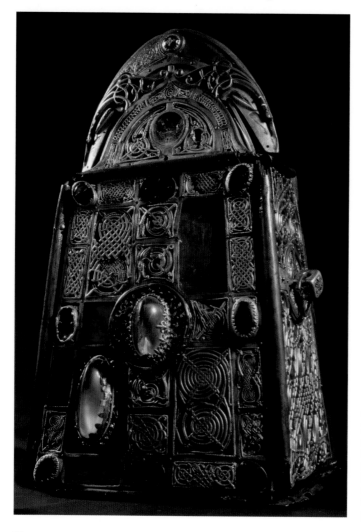

The shrine of St Patrick's bell, a reliquary made to hold the bell which had originally been placed in St Patrick's tomb, 1091–1105. Bronze with gold, silver and precious stones.

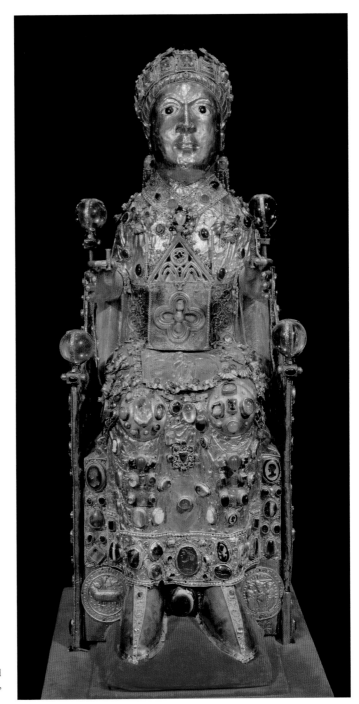

Reliquary of Ste-Foy,
9th century CE, with
Gothic additions.
Gilded silver, copper,
enamel, rock crystal and
precious stones, cameos,
wooden core.

of the book shines 'through precious stones, gold and purpure' but that 'its radiance within is even stronger . . . on account of its great glory.'[22] A gilded altar frontal in Denmark is inscribed: 'More than with the golden radiance by which you see it shine, this work shines by virtue of the knowledge it conveys about sacred history. Indeed, it unveils the marvelous story of Christ, whose glory surpasses gold.'[23] Here the gold is clearly prized as material, which makes all the more wondrous the fact that it is so decisively surpassed by divine glory.

One of the world's oldest and most impressive golden reliquaries is the Bimaran reliquary, an early Buddhist reliquary found in Afghanistan. On this golden casket adorned with sophisticated repoussé figures, the Buddha appears surrounded by the Indian gods Brahma and Sakra, each filling a niche with a pointed arch. The technique suggests Scythian goldsmithery, whereas the style is Hellenistic (the Greek style that developed after the classical period of the fifth century BCE). The dating of the object was long debated, but evidence suggests it was made around the time of the birth of Christ. If this is true, the object would be the earliest surviving artistic representation of the Buddha and precede any Christian visual imagery – an important point, since Buddhist art has sometimes been thought to have been created following the model of early Christian art.

Along with small casket reliquaries like that of Bimaran, the stupas (usually a large tower in a temple complex, shaped like a mound, bulb or bell, and often topped with a tapering pinnacle) of Buddhist temples can also be considered reliquaries: their function is to house funerary remains of the Buddha or monks. In East and Southeast Asia stupas have often been gilded. Although ancient China generally valued bronze and jade more highly than gold, the introduction of Buddhism to China seems to have opened the door to a new view of gold as a substance laden with meaning; it was during the Tang dynasty (618–907 CE), the peak of Buddhist influence in China, that an indigenous goldworking industry began to flourish. One of the legends that explain Buddhism's arrival directly mobilizes the significance of gold: after seeing a vision of a giant, golden god,

The Bimaran reliquary, a cylindrical relic container of gold set with almandine garnets, from the monument Stupa 2 at Bimaran, Gandhara (in modern Afghanistan), 1st century CE.

the Emperor Ming of the Eastern Han dynasty (who reigned in the first century CE) sent to India for representatives of the new religion and soon began constructing gilded temples. The sixth-century CE *Record of Buddhist Monasteries in Lo-Yang* (Luoyang, one of the ancient capital cities of China) tells of thousands of golden stupas. It also describes many golden statues of the Buddha, and temples adorned with many types of golden ornaments: bells, door knockers, nails, jars, plates. The *Record* claims that this dazzling display profoundly impressed Bodhidharma, a monk who arrived in China from Persia in the fifth century CE and became the founder of Zen Buddhism.[24]

Inside and out

Chinese visitors to India, such as the seventh-century Chinese monk Xuanzang, were also impressed by the golden statues of the Buddha they saw there.[25] Most Buddha statues that appear gold are actually made of other substances that have been gilt. As with the skin of the ancient Egyptian gods, it makes sense that Buddhists would also gild Buddha statues, for one of the 32 marks of the Buddha is that his skin is the colour and smoothness of gold; he is also described as bathed in radiant, sometimes golden, light. The largest solid gold statue in the world is the Golden Buddha, in Bangkok, Thailand, originally created in the Sukhothai period (the thirteenth to fourteenth century CE). At some point in its history, in a reversal of the more typical act of gilding, the statue's guardians covered it in plaster to protect it from thieves. Later it was adorned with paint and coloured glass. The precious metal core only re-emerged in 1955, when the ropes holding it as it was moved to a new location gave way and the statue dropped, chipping off some of its plaster coating and revealing the gold beneath.

Like other religions, Buddhism has an ambivalent relationship to gold. The Buddha renounced material wealth, and Buddhist monks are expected to maintain an ascetic lifestyle. But in Buddhist legends and practice, precious materials indicate spiritual worth and give honour to the Buddha. Buddhist

Golden Buddha. Sukhothai period, 13th–14th century, Bangkok, Thailand.

90

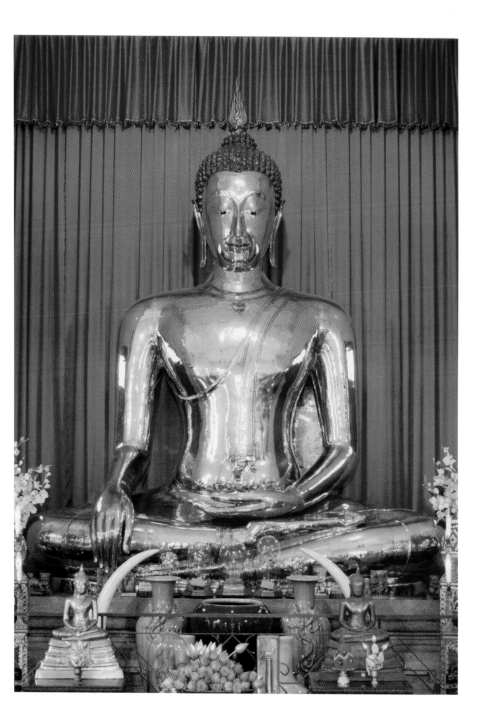

Montien Boonma,
*Melting Void: Molds for
the Mind* (1998), plaster,
gold foil and herbs.

stories told of paradisiac spaces laden with gold: the paradise of the Buddha Amith-aba has ground made of gold; the Maitreya Buddha was born in a city whose ground is gold sand. But Buddhism also prescribes the renunciation of material wealth. Although sacred texts told monks not to use alms bowls of gold, such bowls were regularly made as imperial gifts to high-ranking monks.[26] This apparent contradiction was not lost on critics.[27] In the ninth century, as part of a programme of suppression from which Buddhism in China never entirely recovered, Emperor Wuzong forbade Buddhists to use gold (or other precious materials) in the creation of religious images, not because he subscribed to the ascetic ideal, but because he believed the accumulation of wealth in temples was draining the money supply. Clay and wood, he declared, 'are sufficient to express respect'. He even ordered the gilding to be peeled off the statues and presented to him.[28] In 2014 the dome of the Mahabodhi Buddhist temple in Bihar, India, was covered in gold plate through a donation by the king of Thailand. Ironically the temple commemorates the spot where the Buddha is said to have renounced material possessions.

With a project entitled *Melting Void: Molds for the Mind* (1998), the modern Thai artist Montien Boonma alluded to the idea of gilding the Buddha statue, but by inviting viewers into a more private experience. He created moulds for statues – not the statues themselves, but their reverse, the void within which they would be created – and invited viewers to step inside them as a place of refuge and mindfulness. On the insides, not the outsides, he applied gold foil (along with herbs and cinnabar). This invisibility suggests a logic of modest spirituality like that of *bpìt tong lăng prá,* which does not seek the approbation of society. In a sense he places viewers within the mind of the Buddha, with honorific gold surrounding but not touching them in a darkened space displaying ephemerality more than permanence.[29]

3 Gold as Money

The name of Croesus, the fabulously wealthy king of Lydia, in what is now western Turkey, lives on in the phrase 'as rich as Croesus' largely because of the Greek writer Herodotus. Writing his *Histories* 100 years after Croesus' death, Herodotus detailed the king's opulence in order to demonstrate the platitude that money does not buy happiness. The historian recounts the Lydians' stupendous gifts to the oracle at Delphi, such as a lion of solid gold weighing ten talents (more than 227 kg/500 lb), but also describes a meeting in which Croesus asks the Athenian philosopher Solon who the happiest mortal is. Solon names an obscure dead Athenian, shocking the wealthy king, who expected to hear his own name mentioned. Solon explains that no mortal can be truly happy before his death because something awful might befall him. And in fact, as Herodotus hastens to tell his reader, that is exactly what happened to Croesus: he first lost his son and heir in a hunting accident, and then saw his empire destroyed by the Persians. Herodotus was not the first writer among the Greeks to disparage their wealthy neighbours. In the seventh century BCE Archilochus wrote of one of Croesus' ancestors, King Gyges, that 'These golden matters of Gyges and his treasuries are no concern of mine . . . Such things have no fascination for my eyes.'[1]

This may have been sour grapes. Gold was scarce in most of the Greek city-states, but running through Lydia was the River Pactolus, where the legendary King Midas had supposedly washed away his curse and left gold so plentiful that you could pick it up on the banks. Lydia received tribute from several

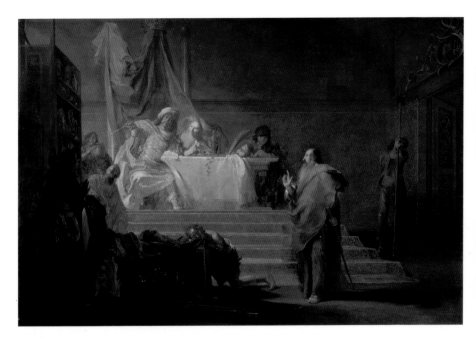

Ionian Greek city-states and had recently conquered others. And Croesus' defeat at the hands of Cyrus of Persia in 546 BCE brought the Persian Empire to Greece's front door – meaning that Lydia's legendary wealth failed not only to save it from defeat, but to buffer Greece from their mutual foes. But for our purposes, Croesus is the man who first created the bimetallic system of gold and silver coins, an honour that even Herodotus is willing to give him.

These were not the first coins – even his predecessors in Lydia had issued coins minted from electrum (a naturally occurring alloy of gold and silver, to which they added silver until it reached a consistent ratio), and the Zhou Dynasty in China had been producing bronze imitations of cowrie shells since around 900 BCE (although whether these count as 'coins' is a matter of debate). And they were certainly not the first use of gold in commerce, a practice that dates from at least twenty centuries earlier. But tantalizing evidence from the Harvard-Cornell Sardis Expedition – an ongoing excavation of Croesus' capital city – strongly suggests that the doomed king was indeed the

Nikolaus Knüpfer, *Solon Before Croesus*, c. 1650–52, oil on panel.

first ruler in history to issue gold and silver coins of standard weights and values. The proof comes not from the ruins of the treasury or the mint, but from several workshops where smiths processed grains and dust of gold, separating the yellow metal from the quartz, silver and copper that naturally occur with it. Goldworkers under Croesus were the first to be able to produce pure gold and silver coins, because they were the first to be able to separate the metals.[2]

It's important to remember, though, that gold coins are not the beginning or end of the concept of money. In fact, they represent only the merest blip in the history of human civilization and trade. Elementary economics tells us that money – whatever form it might take – serves as a medium of exchange and a standard unit to express prices and debt. Before there was gold coinage, there were other media of exchange, and anything of mutually recognizable value could be used. Cows and grain, which had inherent value as chief sources of food, were popular in early civilizations. But objects used as the basis for currency need not have an inherent material value: the most widespread currency in history was the cowrie shell, which unlike a cow has no obvious practical use. (And, of course, modern coins are worth far more than the metal they're made from.) Finally, a material can be a means of measuring value without being used as part of actual exchange: in mid-second-millennium BCE Egypt, if one party wanted to trade cattle and another party wanted to trade grain, they would determine how much each commodity was worth in silver or copper to ensure a fair exchange, without ever exchanging silver or copper. In the *Iliad* the Greek warrior Diomedes and the Lycian warrior Glaukos meet on the battlefield, discover that their grandfathers had been good friends and agree to exchange armour instead of trying to kill each other. But Zeus 'stole away the wits of Glaukos who exchanged with Diomedes . . . armor of gold for bronze, for nine oxen's worth the worth of a hundred'.[3] (Although perhaps Glaukos got the better of the deal, as gold armour would be too heavy to wear into battle.) This was not a practice that disappeared once coins came on

the scene, either – in the early twelfth-century CE Welsh tale *Culhwch and Olwen*, the anonymous author mentions a well-dressed youth as having 'precious gold of the value of three hundred kine [cattle] upon his shoes, and upon his stirrups, from his knee to the tip of his toe', suggesting a similar method of value storage and exchange.[4]

What kind of economic innovation did coins represent? Like cowrie shells, they are more readily portable than cows. Coins make a metal, such as gold, easier to use in trade because their standardized shape and weight indicate a set numerical value. Before coins existed, gold could be used for trade, but the receiver would have to weigh the gold to know how much value it had, and might have to know how to test it for its precious metal content. By creating a standard shape (for Croesus, a lumpy figure-of-eight stamped with the image of a lion) with standard markings, a government issuing a coin states that a hunk of metal of this size, shape and marking is worth a particular amount. There is still an element of trust involved: by accepting the coin, you are accepting the promise of the government that issued it.

Ancient gold coins

It makes sense, therefore, that issuing coinage is firmly tied to state-building. We can see a good illustration of this in another example from the ancient Mediterranean. Amid the chaos that erupted after Alexander the Great's death in 323 BCE, one of his generals, Ptolemy, was determined to consolidate his control of Egypt both militarily and governmentally. Key to the latter was his decision to introduce coinage to Egypt, a land whose history was awash in gold objects and lore but which had never had its own currency. By creating one, Ptolemy was able to achieve a new form of political integration of the Nile valley with his court at Alexandria as its symbolic centre. Ptolemy shored up his claim to rulership of Egypt by putting his predecessor Alexander's face on the coins. This, too, was a revolutionary step – some previous coins had borne the faces of

human individuals, but those coins were not meant for regular circulation. This indicated that daily economic transactions occurred under the aegis of a government symbolically linked to the famous emperor. When Ptolemy had himself proclaimed king in 306 BCE, he issued the first coins to bear the image of a living ruler – himself, of course.[5]

Coins only work as money if you use them, and Ptolemy made sure his would circulate by banning the use of foreign currency in Egypt. By law any foreign coins brought into Egypt had to be exchanged for Ptolemy's coins and melted down to make new coins. Before this, and elsewhere in the world, it was customary for coins to be used anywhere they might reach through trade networks; the coins were valued not so much for what was stamped on them as for the amount of metal they contained. Ptolemy's decree served the state-building function we mentioned earlier, as well as a financial function: Ptolemy's coins had less gold in them than the competition, so Egypt made a small profit each time a purer foreign coin was traded in for an Egyptian coin. This practice results in a phenomenon known as Gresham's Law – 'bad money drives out good' – wherein people circulate currency that is devalued by addition of base metals and keep the purer stuff under their mattresses. It was named for a sixteenth-century English financier, but it might as well have been named for the Greek playwright Aristophanes, whose *The Frogs* pre-dates Ptolemy by only 100 years:

Gold coin of Croesus, Lydia, 6th century BCE.

I'll tell you what I think about the way
This city treats her soundest men today:
By a coincidence more sad than funny,
It's very like the way we treat our money.
The noble silver drachma, which of old
We were so proud of, and the one of gold,
Coins that rang true (clean-stamped and worth their weight)
Throughout the world have ceased to circulate.
Instead the purses of Athenian shoppers
Are full of phoney silver-plated coppers.[6]

Rome, which was to be the next major power in the Mediterranean, adopted much of its culture from Greece, but came late to coinage, around 300 BCE. Typically using bronze or silver, the republic issued gold coins only in times of crisis, such as during the Second Punic War late in the third century BCE. It wasn't until the reign of Julius Caesar that Rome, having become an

Gold coin, Kingdom of Egypt, bearing Ptolemy I's image, 277–276 BCE.

Gold coin showing the head of Constantine I, and on the reverse a star above two interlaced wreaths, 326 CE.

Empire, began to mint gold coins. Caesar embraced the practice with gusto – by the middle of the second century CE, more than 60 per cent of Rome's coins were gold.

Every golden age must come to an end, and by the third century CE, the Roman monetary system collapsed, for reasons that are still the subject of debate. It was partly because of an almost complete failure of silver and gold mines, inflationary measures and the debasement of coins, which by the time of Claudius Gothicus (emperor from 268 to 270 CE) contained little precious metal. When Constantine became emperor in 312, he replaced the debased *aureus* with the *solidus*, which would remain the standard of Byzantine and European currency for 1,000 years. Its legacy remains with us today in several forms, notably the French word *solde*, which can variously mean salary, debt or sale, and the English word *soldier*, which traces its lineage back to this Roman coin used to pay mercenaries.[7]

Gold in China vs. Chinese money

Elsewhere in the world, China presents us with an interesting case of a fabulously wealthy empire that did not use gold as the centrepiece of its economic system. China certainly possessed a great deal of gold – the first-century BCE *Records of the Grand*

Historian of Sima Qian informs us that by 123 BCE Emperor Wu had distributed more than 42,500 kg (1.5 million ounces) of gold to his victorious soldiers, practically emptying the royal treasury.[8] The historian Ban Gu reports in the *Book of Former Han* that in 23 CE, the treasury under usurping emperor Wang Mang contained approximately 141,750 kg (5 million ounces) of gold. (For comparison, the Spanish imported around 6 million ounces of gold from the Americas between 1503 and 1660.)[9]

Wang Mang is of particular interest here primarily because he broke hundreds of years of Chinese monetary tradition by issuing gold coins (or at least attempting to). Early in Chinese history, individual states had produced their own currency, which ranged from imitation cowries made from bronze to knife- or axe-shaped proto-coins. Only the Chu state had produced gold coin-like objects – gold cowrie shells and small gold plates stamped with the name of the city where they were minted. When Qin Shi Huang unified China in 221 BCE, he abolished all of these local currencies in favor of 'cash', bronze ring-shaped coins with a square central hole whose name probably came from the Tamil word for coined money, *kāsu*.

Wang Mang had been a treasury minister under the last of the Han emperors, and as minister he decided to do what Ptolemy was doing thousands of miles away in Egypt – he required that all the gold in China be turned in at the palace and exchanged for bronze coins. Once he seized power, he took over the treasury and demonetized those bronze coins, leaving people with about 1 per cent of what their gold had been worth. He then issued nearly 30 different denominations of coin, one of which was a gold-inlaid knife-shaped coin, and tried to make everyone in the vast Chinese empire use them in place of the 'cash' coins. It was an abject failure: the array of denominations and shapes confused everyone, and this unfamiliarity made it easy for counterfeiters to produce fakes. He stubbornly stuck to his scheme, decreeing that anyone who opposed the new system 'should be thrown out to the four frontiers' to fight evil spirits, but he finally rescinded his plan when the financial system threatened to collapse.[10]

The failure of Wang Mang's gold-coin scheme does not mean that the Chinese did not place a great deal of value on gold. Wealthy landowners and nobles possessed it and used it for large exchanges, like the 12,100 kg (426,000 ounces) of gold that featured prominently in the dowry of Wang Mang's future empress.[11] The seventh-century author Yan Shigu recounts that 'anciently gold was counted in terms of its weight in catties and taels, it came in regular shapes laid down by official regulations, like the present gold ingots with luck-bringing inscriptions.'[12] Gold served as a measure of sheer wealth, but in the form of ingots that were weighed and stamped with their value, not as coins that could be used for purchases. For example, the royal tomb of Lui Kuan from around 87 BCE contained twenty large gold ingots, each of which was worth as much as a common labourer would earn in five and a half years.[13]

China also used gold in foreign trade. Early in the Han period, China sent eunuch interpreters who served the palace out in boats to ports in Southeast Asian countries, trading gold and silk for 'bright pearls, opaque glass, rare stones and strange things'.[14] In fact, so much gold left the country in trade with its neighbours that in 713 CE China banned the export of gold and iron to foreigners. Over the next several centuries, regulations about who could possess and use gold proliferated. By 1340 a Muslim commentator was shocked that it was impossible to purchase anything in Chinese markets with a gold coin – China had long required the use of paper currency, so prospective buyers had to trade in their gold for banknotes. In addition to stopping the outflow of gold from the empire, this requirement ensured the inflow of gold to the treasury.[15]

The gold standard

Before the nineteenth century, silver, not gold, was the closest thing to a worldwide standard currency. But the metal, not the denomination, was the real measure of value. A silver coin from one country was usable in another because of the silver in it, and silver coins travelled the globe. For example,

the most common currency used for trade in East Asia in the eighteenth century was not Chinese cash coins but the Mexican silver peso.

This is not to say that there weren't important gold coins before the dawn of the gold standard. During the Middle Ages European city-states began minting their own coins in an exercise of the state-building we discussed above. In 1252 Florence began minting the florin, which quickly became the standard gold coin of Europe. The first French gold coin, the *écu*, followed quickly in 1266, and Venice used the florin as the model for its gold ducat in 1284. Although the Spanish silver dollar (the eight-*real* coin, the 'pieces of eight' popular in pirate stories) was by far the most common denomination in Spain's globe-spanning empire, Spain also issued the gold *escudo* (worth twice as much as the dollar) for almost 300 years, and the *pistole* or double *escudo* was popular in world trade.

Over the course of the nineteenth century, most countries in the world adopted the gold standard – a commitment to fix their domestic currencies in terms of specific amounts of gold. By state decree, one franc equalled x ounces of gold, one dollar equalled y ounces of gold, and so on. Different countries went with the gold standard for different reasons. Great Britain did it because it had more or less done so already in the early eighteenth century, when Isaac Newton, as master of the Royal Mint, established policies that effectively drove silver out of circulation. Japan, quickly becoming a world power after defeating China in the first Sino–Japanese War of 1894–5, looked to gold for commercial and military growth: switching to a gold standard would depreciate the yen, likely encouraging exports and increasing foreign investment in industry; and the switch made it easier for Japan to borrow international money to fund a war chest in case of conflict with Russia (which came less than a decade later). That impending war helped push Russia to adopt the gold standard, as both nations had colonial designs on Korea and Manchuria and both believed that the gold standard would make it easier to bankroll military and industrial growth.[16]

Gold-inlaid knife coin of the Han Dynasty official Wang Mang, *c.* 7 CE.

The theory was that everything would balance worldwide – gold would flow out of a country that imported more than it exported, causing prices in that country to fall, which would make it easier for manufacturers and merchants to sell that country's goods abroad, which would mean more gold would flow in. As the economic historian Steven Bryan put it, 'English theory imagined a world in which central banks and state treasuries sat idly by and watched gold flow freely in and out of the country – inflating or deflating prices, filling central bank vaults, or being pulled out in financial panics.'[7]

Gold florin, 1252–1303.

But as with most things, the theory and practice were quite different. The subtleties of this worldwide economic balancing were often lost on the everyday citizens who experienced its effects. When a bad wheat harvest that caused financial ruin and depression in one country was offset by a financial bonanza in a country that had a good wheat harvest, economists might see worldwide equilibrium, but this didn't exactly

reassure the ruined wheat farmers. Central banks were supposed to let the standard work through 'automatic forces' that would mysteriously fix everything in the long run. Of course, banks meddled by raising or lowering interest rates to soften the blows of events like our bad wheat harvest, or raising interest rates sky-high to prevent overseas borrowers from taking gold out of the country, as the Bank of England did during a worldwide financial crisis in 1873.

It was by no means an uncontroversial move for a country to switch to the gold standard. The United States effectively switched in 1873 when the Coinage Act demonetized silver, but debate raged. Populist pundits decried the 'Crime of '73', arguing that a return to bimetallism would increase the money supply and bring prosperity, especially after the Panic of 1893 sent the u.s. economy into a deep depression. In 1896 William Jennings Bryan rode the issue to the first of three nominations for the Democratic Party's presidential ticket, thundering 'you shall not crucify mankind upon a cross of gold' at the Democratic National convention Address. He lost the election to William McKinley, who signed the Gold Standard Act in 1900, making the de facto situation official.

Eight-*escudo* gold coin, mint of Pamplona, 1652.

For the most part the system worked as long as everyone agreed to play by the same rules. But the First World War changed everything. After the assassination of Archduke Ferdinand in the summer of 1914, European countries experienced a series of banking panics. In Britain, whose economy and gold reserves were the de facto backbone of the gold standard – due to being the centre of world finance at the time – fears that the nation would become involved in the conflagration led to a stock exchange crash. The authorities reacted quickly with a series of costly measures that staved off disaster, including using some of their small gold reserve to pay creditors and issuing banknotes that could no longer be exchanged for gold. The cheap banknotes issued to keep money circulating caught on with the public, and more gold came into the treasury's war chest, making it easier to make vital military purchases overseas. This emergency unofficially but effectively ended Britain's 700 years of internal circulation of gold specie and the short-lived gold standard.

Internationally, warring countries abandoned the gold standard as they printed more money to finance their own war efforts. Even if countries had wanted to stick with gold, the practical obstacles of mines and u-boats prevented the system from working because it became impossible to safely transport gold overseas. Inflation was rampant, governments collapsed and debts piled up. After the fighting stopped in 1918, there was a halting attempt to return to the gold standard, but it was doomed to failure. The economic historian Glyn Davies says that Britain's plan to restore the gold standard through drastic deflation seemed 'calculated to . . . crucify the economy on an outdated cross of gold', echoing Bryan's famous speech.[18] Prices fell and British unemployment hit 18 per cent by the end of 1921. But Britain kept up its rush back to gold, despite economist John Maynard Keynes's prophetic warning in 1925 that 'the British Public will submit their necks to the golden yoke – as a prelude, perhaps, to throwing it off forever at not a distant date.'[19]

The world finally threw off that yoke with the Great Depression, which some economists believe was exacerbated

Louis Dalrymple, 'The Survival of the Fittest', *Puck*, 14 March 1900. The 'gold standard' gladiator triumphs over the 'silver standard'.

OL. XLVII. No. 1201.

PUCK BUILDING, New York, March 14th, 1900.
Copyright, 1900, by Keppler & Schwarzmann.

PRICE TEN CENTS.

Puck

Entered at N. Y. P. O. as Second-class Mail Matter.

THE SURVIVAL OF THE FITTEST.

by the gold standard because it prevented governments from issuing more banknotes to stimulate the economy. The manner in which the United States abandoned it brings us back to the central role that money plays in governmental power, and vice versa. Taking a page from the books of Ptolemy I and Emperor Wang Mang, in April 1933 President Franklin Delano Roosevelt issued Executive Order 6102, which prohibited private citizens from possessing gold except in small amounts, such as jewellery or historical coin collections. Citizens had to turn their gold in at the Federal Reserve in exchange for $20.67 an ounce (28.4 grams); the following year Congress passed the Gold Reserve Act, which set the price of gold at $35 an ounce, resulting in a $2.8 billion windfall for the government.[20] Roosevelt's order came as a shock to many, including the u.s. Mint, which produced nearly half a million $20 gold double eagles in 1933. These coins never circulated, and except for two coins given to the Smithsonian for posterity, the entire run was melted down in 1937 – or was it?

After the Second World War, world leaders desperate to avoid a return to the chaos of the interwar years established the Bretton Woods system, which created something like a gold standard, more accurately called a gold exchange standard. Member states of the International Monetary Fund agreed to peg the value of their currency against the u.s. dollar, and the United States agreed to set the value of its dollar at $35 per ounce of gold. Thus only the u.s. dollar was directly tied to gold. An increase in world trade and the expansion of the u.s. economy led to a familiar situation – there were more dollars in circulation by 1959 than there was gold to back them up, a situation that became so dire by 1971 that u.s. President Richard Nixon unilaterally ended the Bretton Woods gold exchange system.[21]

Although a 2012 survey by the University of Chicago's Initiative on Global Markets produced zero economists who recommended a return to the gold standard, the debate has raged on and will likely continue. Ron Paul, a former u.s. Representative and candidate for the 2012 Republican presidential

Franklin Delano Roosevelt, Executive Order 6102, 1933.

UNDER EXECUTIVE ORDER OF THE PRESIDENT

issued April 5, 1933

all persons are required to deliver

ON OR BEFORE MAY 1, 1933

all GOLD COIN, GOLD BULLION, AND GOLD CERTIFICATES now owned by them to a Federal Reserve Bank, branch or agency, or to any member bank of the Federal Reserve System.

Executive Order

FORBIDDING THE HOARDING OF GOLD COIN, GOLD BULLION AND GOLD CERTIFICATES.

By virtue of the authority vested in me by Section 5(b) of the Act of October 6, 1917, as amended by Section 2 of the Act of March 9, 1933, entitled "An Act to provide relief in the existing national emergency in banking, and for other purposes", in which amendatory Act Congress declared that a serious emergency exists, I, Franklin D. Roosevelt, President of the United States of America do declare that said national emergency still continues to exist and pursuant to said section do hereby prohibit the hoarding of gold coin, gold bullion, and gold certificates within the continental United States by individuals, partnerships, associations and corporations and hereby prescribe the following regulations for carrying out the purposes of this order:

Section 1. For the purposes of this regulation, the term "hoarding" means the withdrawal and withholding of gold coin, gold bullion or gold certificates from the recognized and customary channels of trade. The term "person" means any individual, partnership, association or corporation.

Section 2. All persons are hereby required to deliver on or before May 1, 1933, to a Federal reserve bank or a branch or agency thereof or to any member bank of the Federal Reserve System all gold coin, gold bullion and gold certificates now owned by them or coming into their ownership on or before April 28, 1933, except the following:

(a) Such amount of gold as may be required for legitimate and customary use in industry, profession or art within a reasonable time, including gold prior to refining and stocks of gold in reasonable amounts for the usual trade requirements of owners mining and refining such gold.

(b) Gold coin and gold certificates in an amount not exceeding in the aggregate $100.00 belonging to any one person; and gold coins having a recognized special value to collectors of rare and unusual coins.

(c) Gold coin and bullion earmarked or held in trust for a recognized foreign government or foreign central bank or the Bank for International Settlements.

(d) Gold coin and bullion licensed for other proper transactions (not involving hoarding) including gold coin and bullion imported for reexport or held pending action on applications for export licenses.

Section 3. Until otherwise ordered any person becoming the owner of any gold coin, gold bullion, or gold certificates after April 28, 1933, shall, within three days after receipt thereof, deliver the same in the manner prescribed in Section 2; unless such gold coin, gold bullion or gold certificates are held for any of the purposes specified in paragraphs (a), (b) or (c) of Section 2; or unless such gold coin or gold bullion is held for purposes specified in paragraph (d) of Section 2 and the person holding it is, with respect to such gold coin or bullion, a licensee or applicant for license pending action thereon.

Section 4. Upon receipt of gold coin, gold bullion or gold certificates delivered to it in accordance with Sections 2 or 3, the Federal reserve bank or member bank will pay therefor an equivalent amount of any other form of coin or currency coined or issued under the laws of the United States.

Section 5. Member banks shall deliver all gold coin, gold bullion and gold certificates owned or received by them (other than as exempted under the provisions of Section 2) to the Federal reserve banks of their respective districts and receive credit or payment therefor.

Section 6. The Secretary of the Treasury, out of the sum made available to the President by Section 501 of the Act of March 9, 1933, will in all proper cases pay the reasonable costs of transportation of gold coin, gold bullion or gold certificates delivered to a member bank or Federal reserve bank in accordance with Sections 2, 3, or 5 hereof, including the cost of insurance, protection, and such other incidental costs as may be necessary, upon production of satisfactory evidence of such costs. Voucher forms for this purpose may be procured from Federal reserve banks.

Section 7. In cases where the delivery of gold coin, gold bullion or gold certificates by the owners thereof within the time set forth above will involve extraordinary hardship or difficulty, the Secretary of the Treasury may, in his discretion, extend the time within which such delivery must be made. Application for such extension must be made in writing under oath, addressed to the Secretary of the Treasury and filed with a Federal reserve bank. Each application must state the date to which the extension is desired, the amount and location of the gold coin, gold bullion and gold certificates in respect of which such application is made and the facts showing extension to be necessary to avoid extraordinary hardship or difficulty.

Section 8. The Secretary of the Treasury is hereby authorized and empowered to issue such further regulations as he may deem necessary to carry out the purposes of this order and to issue licenses thereunder, through such officers or agencies as he may designate, including licenses permitting the Federal reserve banks and member banks of the Federal Reserve System, in return for an equivalent amount of other coin, currency or credit, to deliver, earmark or hold in trust gold coin and bullion to or for persons showing the need for the same for any of the purposes specified in paragraphs (a), (c) and (d) of Section 2 of these regulations.

Section 9. Whoever wilfully violates any provision of this Executive Order or of these regulations or of any rule, regulation or license issued thereunder may be fined not more than $10,000, or, if a natural person, may be imprisoned for not more than ten years, or both; and any officer, director, or agent of any corporation who knowingly participates in any such violation may be punished by a like fine, imprisonment, or both.

This order and these regulations may be modified or revoked at any time.

THE WHITE HOUSE, FRANKLIN D ROOSEVELT
April 5, 1933.

For Further Information Consult Your Local Bank

GOLD CERTIFICATES may be identified by the words "GOLD CERTIFICATE" appearing thereon. The serial number and the Treasury seal on the face of a GOLD CERTIFICATE are printed in YELLOW. Be careful not to confuse GOLD CERTIFICATES with other issues which are redeemable in gold but which are <u>not</u> GOLD CERTIFICATES. Federal Reserve Notes and United States Notes are "redeemable in gold" but are <u>not</u> "GOLD CERTIFICATES" and are <u>not</u> required to be surrendered

Special attention is directed to the exceptions allowed under Section 2 of the Executive Order

CRIMINAL PENALTIES FOR VIOLATION OF EXECUTIVE ORDER
$10,000 fine or 10 years imprisonment, or both, as provided in Section 9 of the order

Secretary of the Treasury.

U.S. Government Printing Office: 1933 2-16064

nomination, represents a fringe of the far right in the United States but convinced the Republican Party to commit to exploring a return to the golden past.

In a literary footnote to the debate over the gold standard, the high school history teacher Henry Littlefield suggested in 1964 that the beloved children's book author L. Frank Baum had embedded a parable of the gold standard in *The Wonderful Wizard of Oz*, with the yellow brick road playing the role of gold. It was an appealing proposition, but was most likely untrue, based as it was on a mistaken idea of where Baum stood on the issues of the day. Still, it remains in the popular imagination, serving as a useful thought exercise in economics classes, and a copy of the book, as of 2015, was included in the Citi-sponsored Money Gallery at the British Museum.[22]

And then there were those double eagles. As it turns out, not all of them were melted down after all. The aftermath of Roosevelt's executive order is a case whose twists, turns and international intrigue rival the most outlandish thrillers on the bestseller lists. A mild-mannered cashier named George McCann stole at least twenty of the doomed coins, replacing them with other double eagles from earlier years, so the books balanced. The theft wasn't discovered until 1944, when one of the coins was listed for auction. Frank Wilson, who had spearheaded the investigation that put Al Capone behind bars and had broken the Lindbergh Baby kidnapping case, was brought in to investigate. Over the next eight years, Wilson's investigation turned up eight more purloined double eagles, each of which the Secret Service seized as stolen property – except one.

That one had made it into the collection of King Farouk of Egypt, who refused diplomatic entreaties to give up the coin. When he was deposed in 1952 the coin appeared briefly for sale, but disappeared again when it became clear that the Secret Service intended to confiscate it. Decades later it surfaced again with a British coin dealer named Stephen Fenton, who brought it to the U.S. to sell – but the buyer was an undercover Secret Service agent. Fenton sued to recover the coin, and after years in litigation, he and the U.S. government agreed to

auction it and split the proceeds. It sold in 2002 for more than $7.5 million – plus $20 to reimburse the u.s. Mint for Gordon McCann's theft.[23]

That would seem to be the end of the story, but in 2001 the heirs of Israel Switt, to whom McCann had sold or given the stolen coins back in the 1930s, discovered ten more 1933 double eagles in a forgotten safety deposit box. They sent them to the Philadelphia mint to be authenticated, and the government seized them as stolen property. The family sued, but lost in federal court. As of this writing, no other 1933 gold double eagles have surfaced, but who knows what the future holds.[24]

4 Gold as a Medium of Art

For millennia specialized workers have crafted gold into objects of all kinds – for adornment, worship, symbolic power and currency. Gold as an ornament highlights other things, enhancing their glitter. Jewellers use it to create settings for gems and other precious things: in early modern Europe, jewellers mounted exotica – artefacts, coconuts, ostrich eggs – in gold to allow collectors to reinvent objects from other lands as their own. In the Japanese art of *kintsugi* gold adorns by serving as a cement to repair pottery, its joins making beauty out of brokenness. To glorify princes and gods, many cultures have sheathed buildings in gold, inside and out. Already in ancient Mesopotamia, goldworkers practised a form of gilding by engraving an underlying surface with grooves to grip a sheet of gold foil. Around the fourth century BCE Chinese goldworkers developed the 'fire-gilding' technique that involved chemically bonding gold leaf (thinner than foil) to bronze and other metals. Sculptors in the Roman Empire used this same technique to gild statues. An early modern example that draws on the Roman tradition is the Monument to the Great Fire of London, topped with an urn of gilded bronze.

Over the centuries gold has been applied to cloth, leather, glass and the pages of books. As we have seen, scribes and illuminators used it to make inks for writing and painting lavish manuscript books. Gold-splashed papers were made in China from early times.[1] Along with making golden thread into cloth of gold, and using it to sew jade suits for emperors, textile workers embroidered purses and vestments with it, and wove it into

Tea bowl repaired using the *kintsugi* method of fixing broken pieces with a mixture of powdered gold.

tapestries. Mosaics made from tesserae of glass bonded with gold adorn the interiors of churches and mosques. Glass vessels and other objects receive gilding as well. In gold sandwich glass, which has been made since antiquity, a thin layer of gold is sandwiched between two pieces of glass. Venetian glassmakers gilded vessels by placing pieces of gold leaf or even sprinkling granular gold on the molten glass before blowing it, or on the finished object once cooled. In the Islamic world tanners have long practised gold tooling on leather; Persian and North African artists introduced the technique to Italy in the fifteenth century and it became popular in Europe, especially for bookbinding. All these techniques expressed the honour and value (economic and otherwise) attached to the adorned object. Gold is scarcer and more expensive than many of the things it adorns, which may help explain why it is often used in this way; many people who can afford a little gold cannot afford an object made entirely out of the precious metal. But specialized artisans have also, through the millennia, fashioned objects entirely or mostly of gold.

The artistry of gold has had different meanings for different cultures and in different time periods. During the period of European conquest, stories abounded of indigenous peoples trading gold for glass beads and other items that the Spanish considered valueless. Some Europeans believed this demonstrated the naivety of American natives – they did not seem to value gold properly – or even used it to justify treating them as

less than human. Others, by contrast, idealized what they saw as a 'Golden Age' prior to the deadening and corrupting power of greed. But a story told about an episode in Panama suggests something different at work. Watching the Spanish melt down the handiwork of indigenous craftsmen, the son of the cacique (chief) Comogre reportedly exclaimed:

> What thing then is this, Christians? Is it possible that you
> set a high value upon such a small quantity of gold? You
> nevertheless destroy the artistic beauty of these necklaces,
> melting them into ingots ... We place no more value
> on rough gold than on a lump of clay, before it has been
> transformed by the workman's hand into a vase which
> pleases our taste or serves our need.[2]

The story of Comogre's son – if it isn't just the projection of a European observer intent on critiquing other Europeans

Sir Christopher Wren, Monument to the Great Fire of London (detail), 1677.

Two saints on the base of a glass cup, made with the *Zwischengoldglas* method. Roman, 4th century CE.

– shows how one group of indigenous Americans attached value to gold. They appreciated it as a material with the potential to convey symbolic values, but only when fashioned by the skill of sophisticated artists. This view stands at odds with the ideas about gold as a material of artistic production that Europeans brought with them to the Americas. In Europe the monetary value of gold trumped all but the most exquisite workmanship, and often even that. The labour and skill devoted to the working of golden objects might even be suspect. It took gold temporarily out of economic circulation; it was ephemeral, even wasteful, if the underlying material was eventually to be melted down; and it sometimes appeared to be merely a ruse by the artisan to charge more for the material than it was worth, especially in situations in which the market value of a precious metal might exceed its coinage value, regulated by law.

The artistic working of gold adds another element to the already complex relationship between the monetary value and

Emerald glass goblet with granular gilding and portrait of a betrothed man, late 15th century, Venice.

religious and political symbolism of gold. For Comogre's son, gold was apparently no more valuable than any other product of the earth until an artisan worked it. In Europe gold's economic value was so powerful that the value added by craft was often considered negligible by comparison. This wasn't always the case, but when artisans were able to enhance the value of gold it was seen as a special accomplishment, nothing short of miraculous. When the Italian Renaissance architect and writer Filarete described Piero de' Medici's collection of antique gold medals, he wrote with awe that, although nothing is more valuable than

Gold-tooled leather binding from a manuscript of the *Mantiq al-Tayr* (The Language of the Birds), by Farid al-Din Attar, made in Safarid Iran *c.* 1600.

gold, ancient craftsmen made gold 'worth more than gold by means of their skill'. The artifice involved 'appears to have come from heaven rather than to have been made by man'.[3] Rather than creating the value of gold through craftsmanship, European artists can at best enhance it.

Limbourg Brothers (fl. 1399–1416 CE), *January: The Feast of the Duke of Berry*, illuminated manuscript page from *Les Très Riches Heures du Duc de Berry*, 1416, pigment and gold on vellum.

Meaning and material in the early Americas

In the late medieval illuminated manuscript known as the *Très Riches Heures* of the Duc de Berry, gold leaf is used for haloes, borders, backgrounds and highlights, as was customary in such books. But gold was also used to depict gold. The gold objects and adornments on the famous January page express the wealth of a stylish French ducal court, including a 'nef' – a vessel shaped like a ship that contains cutlery or spices. This is a princely display of glitter with which an artist like Albrecht Dürer – trained as a goldsmith in the late fifteenth century – might have been familiar. But the German artist was rendered literally speechless by the gold objects brought from Mexico to Spain and displayed at the Habsburg court in Brussels:

> I saw the things that have been brought to the King from the new land of gold: a sun all of gold a whole fathom broad, and a moon all of silver of the same size, also two rooms full of armor of the people there, and all manner of wondrous weapons of theirs, harness and darts, very strange clothing, beds, and all kinds of wonderful objects of human use, much better worth seeing than prodigies. These things were all so precious that they are valued at 100,000 florins. All the days of my life I have seen nothing that rejoiced my heart so much as these things, for I saw amongst them wonderful works of art, and I marvelled at the subtle *ingenia* of men in foreign lands. Indeed I cannot express all that I thought there.[4]

The artisanal cultures the Spanish Conquest destroyed were producing sophisticated artworks whose technical prowess

and aesthetic qualities are apparent from works that have been excavated, largely from tombs, in more recent times. Goldworking began in South America thousands of years later than in Mesopotamia, but by the time the Europeans arrived, artisanal traditions had already existed there for millennia. As early as 1500 BCE, people in what is now south central Peru had begun hammering gold into very thin foil; along with fragments of gold foil from this period, archaeologists discovered a specialized toolkit for working gold.[5] Precious metals played a bigger role in South America than they did in Europe, whose metalworking crafts emphasized iron and bronze for tools and military uses. But in the Andes, because of the mountainous terrain, wheels were useless for transport, and the technology of warfare that Andean people developed emphasized cloth (using slings and quilted armour). Metals also did not serve as currency per se, so their importance was more symbolic than functional.[6]

The earliest known substantial caches of gold artefacts from Peru are from the Chavín culture. The name Chavín derives from a site in the northern Andean highlands whose importance as a religious pilgrimage destination dates to around 1500 BCE; as a stylistic label for artefacts, it designates a set of forms and techniques that flourished from around 900 to 200 BCE. Two main burial sites, Chongoyape and Kuntur Wasi, have yielded troves of sophisticated gold artefacts, consisting of personal adornments including pectorals, pendants, gorgets, ear spools, nose rings, headdresses, plaques to be sewn on clothing and such small implements of personal indulgence as golden nosehair tweezers and snuff spoons. Chavín metalworkers were highly skilled, using the techniques of alloying, burnishing, annealing, sweat welding (in which the edges to be joined were heated to their melting point in order to create the join) and soldering (in which additional molten metal was added to serve as the 'glue' that joined two pieces). A pair of Chavín armbands bear a repoussé design that may have been inspired by textiles. The central motif demonstrates Chavín 'anatropic' styles, by which elements of the central symbolic face rearrange themselves into a different creature when the design is turned 180 degrees.[7]

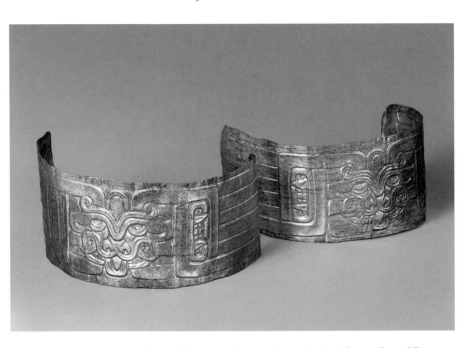

Pair of gold armbands from the prehistoric Chavín culture, Peru, 7th–5th century BCE.

One of the most impressive technical feats of pre-Hispanic American metallurgy is the working of platinum by artisans at La Tolita in Ecuador, who were active from around 600 BCE to 400 CE. Premodern people could not produce fires that burned hot enough to melt platinum, with its melting point of 1,768°C (3,214°F), but they could achieve gold's melting point of 1,064°C (1,947°F). La Tolita's metalworkers combined gold and platinum using powder metallurgy or 'sintering', an art unknown at the time in Europe. In order to create a metal of platinum appearance that could be melted, they created fine granules of each metal and alternately hammered and heated them together until the gold particles 'trapped' the platinum ones, eventually creating a homogeneous alloy that could be worked like gold.[8] La Tolita's artisans produced objects that deftly paired gold with the platinum-appearing alloy to create visual contrast. This technique was forgotten after the Spanish Conquest and was only revived in the nineteenth century; it forms the basis of modern powder metallurgy, which is used in many industries, especially electronics.

Following the Chavín culture in Peru, the Moche civili-
zation became dominant in the Andes from around the first
to the eighth century CE. Moche metallurgy employed copper,
silver and gold. In the Moche royal tombs at Sipán, excavated
beginning in the 1980s, the symbolic relationships between
metals become apparent by their placement in relation to male
and female bodies of varying status. The materials scientist and
archaeologist Heather Lechtman has combined metallurgical
analysis with cultural interpretation, showing that gold was
associated with maleness and the right side of the body, silver
with femaleness and the left. For example, a Moche necklace
made up of metallic peanuts – a key crop – was worn with gold
peanuts on the wearer's right side and silver peanuts on the
left. Copper, the third in the symbolic system of metals, was
generally worn by women, children and high-ranking atten-
dants.[9] In one myth collected after the Spanish Conquest, the
Sun sends three eggs – one of gold, one of silver and one of
copper – to the earth to create human beings, with the gold
representing male nobles, the silver their wives and the copper
the common people.[10]

The three metals were typically alloyed together. The
peanut necklace's 'gold' and 'silver' are actually both based on
ternary alloys of all three metals (a material called tumbaga).
These alloys have a lower melting (fusion) point and are thus
easier to work than pure versions of each metal. To create a
golden surface sheen, Andean goldsmiths used a technique
known as depletion gilding, in which the other metals are
removed from the surface chemically (perhaps using acids
made from plant juices or stale urine to remove the cop-
per, and salt or ferric sulphate to remove the silver), and the
resulting pitted gold surface is burnished to smooth it. Were
it merely a matter of presenting a golden appearance while
conserving the more valuable metal, they could simply have
made an object from the other metals and gilded it with a
thin coating of molten gold. Instead this process may have
reflected a particular value given to the idea of gold as inte-
gral to the object: the artisan does not conceal what is inside,

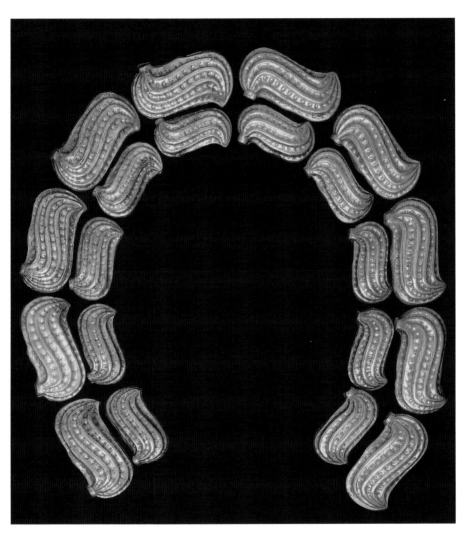

Moche peanut bead necklace, Tomb 1, Sipán, Peru, *c.* 300 CE. Gold, silver and copper.

but rather transforms it to bring out its virtues. As Lechtman puts it, 'Perhaps the notions of "technological essence" – of the visually apprehended aspect of an object as revealing its inner structure – are related to these fundamental Andean concepts of the divine animation of all material things.'[11]

By the late Inca period artisans brought from all over the empire's conquered territories were making huge quantities of precious metal objects – so much so that archaeologists have

found numerous discarded metal objects in excavated refuse pits.[12] The Inca possessed a sophisticated trade network and political structure. Though they had no written language that was recognizable as such by Europeans (unlike Nahuatl, the language of the Aztecs), they used knotted strings called quipu for record keeping, and these knots may have encoded words as well as numerical information. The Inca seem to have carried on the associations of the three metals developed by their predecessors in the Andes. While only traces of Andean gold survived the Spanish Conquest, we know from contemporary accounts that Inca temple walls were clad in gold and silver and endowed with life-sized golden statues and other objects.[13] Pedro de Cieza de León wrote in his seventeenth-century *Chronicle of Peru* that in the temple of the Sun god, Coricancha, in Cusco,

> They had also a garden, the clods of which were made of pieces of fine gold; and it was artificially sown with golden maize, the stalks, as well as the leaves and cobs, being of that metal ... Besides all this, they had more than twenty golden sheep [probably llamas] with their lambs, and the shepherds with their slings and crooks to watch them, all made of the same metal.[14]

Felipe Guamán Poma de Ayala, a Quechua-Spanish chronicler of the Inca born in the first generation after the conquest, depicted Coricancha (as 'curi cancha') prominently in a map of Cusco in his *Nueva corónica y buen gobierno*. According to the art historian Adam Herring,

> The Inca understood glittering light, the shining surfaces of gold, and spearlike instruments to operate as a set of metonymic equivalents, together with a final master term, sunlight. Across the Andes, the sharp, eye-catching visual effects of shine, gleam, glint, glitter, glow, and strong colours were all considered the phenomena of sacredness.[15]

Peruvians knew how to cast molten metals, but they preferred hammering their pieces and assembling them by soldering. Colombian goldsmiths, on the other hand, emphasized casting. The Muisca, a tribal confederation of central Colombia, produced numerous precious metal objects of varying sizes as offerings to the gods, called *tunjos*. The Muisca raft, depicting the ritual that gave rise to the name El Dorado, is one. Priests communicated the particulars of the objects to be created for a given purpose and placed the resulting objects in a clay offering vessel. Usually made from varying alloys of gold and copper, these artefacts at first glance appear to have been made with filigree by soldering thin decorative wires onto them (like the ornamental panels on the shrine of St Patrick's bell, see page 86). But the Muisca pieces were instead cast integrally using the 'lost-wax' method, and are thus sometimes called 'false filigree'. In the lost-wax method the artisan

Map of Cusco in Felipe Guamán Poma de Ayala, *El primer nueva corónica y buen gobierno* (1615).

created a wax model in the exact desired form of the final object, then coated it in a clay mould and heated it so that the wax would melt and run out through channels (called sprues) in the mould. The mould could then be used to cast an object from molten metal. In the case of the Muisca goldwork, wire-like pieces (originally made in wax) create linear definition and ornamentation. Interestingly the artisans do not seem to have been especially concerned with the finish of the metal objects – they are not burnished, and obvious mistakes and channel pieces remaining from the casting process are not removed – even though they must have lavished careful attention on the design of the wax models.[16] Many Colombian gold artefacts also have hanging pieces added to them that must have created a sense of animation, clinking and glinting as the object moved.

Goldworking came later to Mexico and the rest of Central America. The craft was most likely introduced to western Mexico by metalworkers from Ecuador via a maritime route in the seventh century CE.[17] In succeeding centuries the Tarascans, Maya, Mixtecs and Aztecs all practised some form of the craft. Some of the most beautiful gold objects surviving from the Maya culture of southern Mexico and Central America are gold discs with repoussé designs found in the Sacred Cenote at Chichen Itza (dating from around 800–1100 CE) and face ornaments, possibly belonging to a statue, with geometric eye and mouth holes and feathered serpent and cartouche adornments. The Mayans' neighbours in southern Mexico, the Mixtecs, developed the method of lost-wax casting to the fullest extent in pre-Hispanic America. Much of the gold that the Spanish found in the Aztec empire (which had subjugated portions of Mixtec territory) was actually made by Mixtec craftsmen whose use of false filigree recalls the Muisca artefacts of Colombia. The pectoral shown in Chapter One is a stunning example of Mixtec work produced during the period of the Aztec empire.

Mixtec and Aztec gold objects made as big an impression on Europeans as the Inca ones. We have already seen Albrecht

Muisca culture, 'Muisca
raft', made between 600
and 1600 CE.

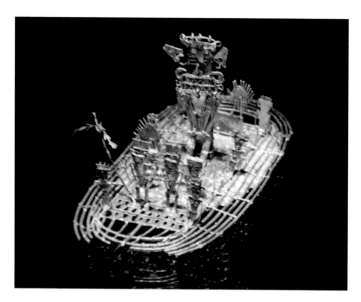

Dürer's reaction to Mexican goldwork. Fray Toribio de Motolinia,
who saw golden artefacts in Mexico, wrote that

> they took precedence over the goldsmiths of Spain, inasmuch
> as they could cast a bird with a movable head, tongue, feet,
> and hands, and in the hand put a toy so that it appeared to
> dance with it; and even more, they cast a piece, one-half silver,
> and cast a fish with all its scales, one scale of silver, one of
> gold, at which the Spanish goldsmiths would much marvel.[18]

Hernán Cortés himself agreed; in a letter to Charles V he
referred to the Aztecs' 'gold and silver . . . wrought so naturally
as not to be surpassed by any smith in the world.'[19] Most of the
gold and silver objects Motolinia, Cortés and Dürer saw have
vanished, literally liquidated for their monetary value; only a
few Central and South American objects brought to Europe
in the early years of contact remain in European collections,
and of these even fewer are gold.[20] The physical properties of
gold rendered the form of fashioned gold objects precarious,
since they can be remade indefinitely by melting and recasting

with little loss of material value. It wasn't only Europeans who saw golden objects this way. In the kingdom of Ghana a royal decree required owners of gold ornaments to melt them down and refashion them every year before the annual Yam Festival. This served the political function of erasing potentially troublesome past symbolic meanings; it also allowed the king to extract a tax on the recasting. In Europe, too, rulers constantly subjected finely fashioned gold objects to financial exigencies (often the result of warfare). Not a single one of the exquisite objects fashioned by the master goldsmith Gusmin of Cologne survives, according to Lorenzo Ghiberti, who wrote in his *Commentaries* that Gusmin, on seeing his work melted down, retired in despair to a hermitage.[21] Even sacred functions did not protect objects from being melted down. The Benna Cross in Mainz, Germany, a crucifix cast from 272 kg (600 lb) of gold around 983, lost first a foot and then an arm to the expenses of two bishops before finally being melted down entirely in 1161.[22] In 1673 the shrine of the Madonna of Loreto melted down most of its gold ex-votos (objects given to the church in thanks for miracles performed by the Madonna): these 'useless monuments and superfluous testimonies to the holiness of the place' were converted 'to a more useful purpose'.[23]

If early modern Europeans didn't mind melting down their own gold objects for currency, it was with all the more enthusiasm that they melted down the objects they found in the Americas. They also had an interest in obliterating their subject-matter – they considered many of the objects they found to be pagan idols. And perhaps they understood all too well the symbolic connection of artistic styles with local sovereignty. By destroying culture, conquerors were more readily able to assert their dominion. The destruction went on for centuries: as late as the middle of the nineteenth century, the Bank of England was melting down thousands of pounds sterling worth of pre-Columbian gold artefacts every year.[24] It is hard to tell whether the destruction resulted from lingering prejudice against the style of the objects or simply the fact that gold's financial value trumped all else.

Skill and value in Europe

Dürer looked at the Mexican objects he saw with a practised eye. Like many European artists of his time, he had originally trained as a goldsmith. For a printmaker in particular, who worked with metallurgy to create plates and used styluses to incise designs into metal surfaces, the crafts were especially closely related. But

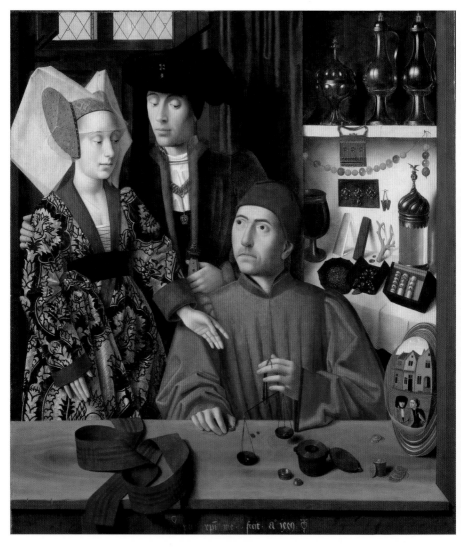

Petrus Christus, *A Goldsmith in His Shop, Possibly Saint Eligius*, 1449, oil on wood.

the field of goldsmithery attracted talented artists because gold objects were so sought after by elites (a lavish portrait medal of Isabella d'Este provides one example). This might seem to contradict the idea that the craft devoted to making gold objects was expendable. But the fashioning of gold objects can be thought of as ephemeral, virtuoso performance, like a lavish theatrical event or feast – even as a form of potlatch or conspicuous waste.

Goldsmiths were also among the most learned artists, because their work involved the study of ancient objects and could require wide-ranging knowledge in order to identify forgeries.[25] Among the Renaissance artists better known as painters, sculptors or printmakers who began their careers apprenticed to goldsmiths are Luca della Robbia, Lorenzo Ghiberti, Andrea del Sarto, Sandro Botticelli, Filippo Brunelleschi, Donatello and Andrea Verrocchio. The great sixteenth-century Florentine biographer of artists, Giorgio Vasari, wrote that in the fifteenth century 'there was a very close connection – nay, almost a constant intercourse – between the goldsmiths and the painters.'[26] For him this explained how Botticelli, appropriately trained in the art of design (meaning drawing) as an apprentice goldsmith, was able so readily to switch to painting.

In late medieval Europe goldsmiths convened in guilds that typically had a fixed number of members, so that new spots only opened when a master artist died or moved away. To become a full member of the guild, one had to execute a 'masterpiece' – literally the work that demonstrated one's fitness to become a 'master' craftsman of the guild. Each master – as is still the case today – had a specific 'trademark' registered with the guild: a mark stamped on his products that identified their authorship. (His or occasionally her; although women could rarely if ever become 'masters' in their own right, widows could take over their deceased husband's marks.) This and other aspects of the trade were heavily regulated in order to maintain the quality of precious metals. This was no small matter, since gold and silver objects were often melted to make coinage and if they were adulterated could conceivably be vastly overvalued. In some cities goldsmiths' movements were also regulated; in fifteenth-century Nuremberg, for example, goldsmiths were prohibited from both travelling out of the city without official permission and sharing secrets with outsiders.[27]

According to one estimate, less than half of 1 per cent of goldsmiths' works from medieval Europe survive.[28] Renaissance goldwork has not fared much better. Where gold is strongly associated with economic value, artistic use of gold was suspect

because it took the metal out of circulation. Sumptuary laws attempted to prevent goldsmiths from putting too much effort into their workmanship, because it risked making the gold in the objects harder to extract, or perhaps encouraged hoarding. Artworks made of gold were at risk of being melted down for their material value by impecunious owners or by thieves or conquerors. Seen from this vantage point, the craft of the master goldsmith can be considered not an act of creation but a performance of skill – creating exquisite but ephemeral stylings poignantly slated for destruction.

No goldsmith was as much a performer as Benvenuto Cellini, whose sixteenth-century golden salt cellar – one of the lucky few objects to survive – is one of the most famous pieces of secular goldwork from Western Europe. It made news once again when it was stolen from the Kunsthistorisches Museum in Vienna in 2003 (then recovered in 2006). Originally designed for Ippolito d'Este, the cardinal of Ferrara, the Salt Cellar was finally executed for Francis I of France. It holds both salt and pepper, and its figures symbolically represent the sources of salt and pepper as the sea and earth respectively (the sea god Neptune, the earth goddess Berecynthia, and their various products). Today, salt and pepper seem like incongruously humble commodities to be housed in such a luxurious vessel, but at the time they were potent symbols. Table salt represented the wealth of France, which profited from salt harvesting on the Atlantic coast, and was essential to preserving foods during winter and lean times, whereas pepper was an exotic commodity from the east, representing foreign luxury trade.

As we saw with manuscript illumination, gold was a medium for the arts of writing and painting on parchment as well as for creating three-dimensional objects. In the Middle Ages paintings made on wood panels also gleamed with gold. Byzantine artists used gold highlights on icons (portrait-style paintings of the saints) to create a sense of relief or movement, to emphasize important visual elements, and to lend honour to holy figures. According to the art historian Jaroslav Folda, the practice of endowing icons with gold highlights was 'part of

Simone Martini, *Annunciation with Saints Ansano and Margaret*, 1333, tempera and gold on wood.

Overleaf: Benvenuto Cellini, *Saltcellar*, 1543, gold, niello work and ebony base.

the important new concept of the icon' developed in the second half of the ninth century CE when supporters of icons (iconodules) won out against their detractors (iconoclasts).[29] Western European artists who saw examples of the Byzantine work quickly adopted the use of gold in religious panel painting.

The gold that formed the background of many such paintings was typically gold leaf, made by hammering high-quality gold coins.[30] Like illuminators, panel painters also applied powdered shell gold as a pigment. They decorated their panels' gold backgrounds by incising or punching designs into them, and created sculptural elements by building up the surface before gilding, typically with a clay mixture called bole and then with a gesso paste called pastiglia. Certain golden elements such as haloes, crowns, belts and angels' wings thus project from the

surfaces. Simone Martini's *Annunciation* of 1333 is an excellent example of the use of gold as a background where golden haloes appear as thickly textured objects, not just flat paint. But a century later, taste had changed. Leon Battista Alberti, an art theorist concerned with the precise depiction of geometric space, criticized the use of gold in paintings. Alberti describes 'painters who use much gold in their pictures, because they think it gives them majesty,' and says bluntly, 'I do not praise this.'

> Even if you were painting Virgil's Dido – with her gold quiver, her golden hair fastened with a gold clasp, purple dress with a gold girdle, the reins and all her horse's trappings of gold – even then I would not want you to use any gold, because to represent the glitter of gold with plain colours brings the craftsman more admiration and praise.[31]

Rather than using materials to dazzle, Alberti asks the painter to create the illusion of fine gold with ordinary materials. We can explain his focus in a number of different ways. It suggests a certain satisfaction with modest means and a distaste for overt magnificence; it might also reflect a concern that the 'special effect' of glittering gold counteracted the realism of the representation. Finally, in a time when artists strove to raise the profile of their profession, insisting on its learned character, Alberti focused on the value added by the artist's skilled hand rather than the value inhering in the material.

Gold in modern art

The Symbolist painter Gustav Klimt flew in the face of Alberti's pronouncements with the paintings of his 'golden phase', during which he was inspired by the gold mosaics and painted backgrounds of Byzantine and Western medieval art. In paintings like the *Portrait of Adele Bloch-Bauer*, *The Kiss* and *Danaë* Klimt liberally used gold leaf to flatten the space of the painting, blending figures and background into a shining, hallucinatory surface design. As with other painters of the legend of Danaë

(impregnated by Zeus, who used the shape of a shower of gold to infiltrate the tower that imprisoned her, Danaë gave birth to the hero Perseus), the Austrian artist used the story as an excuse for undisguised eroticism. Several versions by the Renaissance painter Titian also played with an equivocation between the rain of gold as divine presence and as gold coins, suggesting something pecuniary about Danaë's acceptance of her godly visitor. In Klimt's case, however, the gold that envelops Danaë seems to comment on the artist's own sensual gold-infused practice as a painter.

The issues Alberti's critique raises are still at work today, as contemporary artists use gold itself as a medium to comment, sometimes ironically, on questions of intrinsic and artistic value. In 1959 the French conceptual artist Yves Klein created an art piece called *Zone de sensibilité picturale immatérielle* in which he printed receipts that claimed to give title to one 'zone of immaterial pictural sensitivity' in return for a certain amount of solid gold. Should the buyer choose, he or she could burn the receipt, accomplishing the 'immateriality' of the work's title, and Klein would throw half the corresponding gold into the River Seine; the rest of the gold found its way into one of his 'Monogold' gold leaf paintings. Carl Andre's *Gold Field* of 1966 was simply a flat square of gold that he paid a jeweller $600 to make, the same price he charged the collector, Vera List, who had commissioned it. The literalism of the gesture seems to erase the artist's labour, possibly also commenting ironically on the relationship between patron, artist and fabricator.[32] The sculptor Roni Horn played on Andre's title with her 1980–82 piece *Forms from the Gold Field*, in which she flattened 900 grams (2 lb) of gold into a crinkly rectangular floor mat; Félix González-Torres, inspired by the piece, created one of his characteristic 'candy spill' pieces in response, with all the pieces of candy wrapped in gold-coloured foil. In the early 2000s the American artist Lisa Gralnick, a metalsmith by training, created *The Gold Standard*, a tripartite set of unusual small objects designed to prompt reflections on gold, value and history. The first group consists of portraits of objects in plaster with a smaller portion in gold

that represents the value in gold, by weight, of the object rep-
resented. The objects are generally everyday items without any
great monetary value, which means that plaster predominates.
A book, for example, has just a tiny corner in gold; a hand-
gun has a somewhat larger inset piece on the side of its grip.

Detail of Gustav Klimt,
Danaë, 1907, oil and
gold leaf on canvas.

Lisa Gralnick,
Rhinoplasty, 2003,
plaster and gold.

The piece called *Rhinoplasty* (the technical term for a plastic surgeon's 'nose job') is a plaster cast of a human face with the nose – and a bit more – in gold. A second group consists of plaster casts of objects Gralnick had to purchase and melt down in order to obtain gold for her other pieces. The third group contains imagined objects placed within a surreal, fictionalized history of goldwork.[33]

El Anatsui, *Fresh and Fading Memories*, exhibition installation at Palazzo Fortuny, Venice, 2007, aluminium and copper wire.

The ephemerality of the form of gold objects reappears in the work of the British artist Richard Wright, who paints delicately intricate designs, like Baroque inkblots, in gold leaf on monumental walls of contemporary exhibition spaces (for example, his *no title* at the Tate Britain in 2009–10). Wright thus creates an immersive viewing experience in which the shimmering piece changes constantly with the position of the viewer, with the gold leaf 'glorious in sunlight and invisible in shade', as Sarah Lowndes puts it.[34] The process is traditional – the design is transferred by cartoon to the wall, first size (adhesive) is applied, and then the small squares of gold leaf.

Yves Klein, *Le silence est d'or* (Silence is Golden), 1960, gold leaf on wood.

The artwork is painted over when the exhibition run is finished. Wright is interested in value but not in 'things': 'These paintings may take several weeks to make and often do not survive as long after they are completed. Perhaps there is an

element of sacrifice in this but really this approach stemmed more from other thoughts: from the feeling that there are too many things and from the desire that painting should become part of everything else.'[35] The Ghanaian sculptor El Anatsui also responds to the glut of things in the global consumer society: he fashions glittering, monumental tapestries out of cast-off bottlecaps and aluminium cans. The power of art appears in this almost alchemical transmutation of everyday waste into a kind of gold. Incidentally, Anatsui practices something very much like what Alberti argued for in the fifteenth century: to create the appearance of gold artfully, using ordinary materials rather than the precious substance itself.

5 From Alchemy to Outer Space: Gold in Science

Mammon. Now, Epicure,
Heighten thy self, talk to her all in gold;
Rain her as many showers as Jove did drops
Unto his Danae; shew the god a miser,
Compared with Mammon. What! the stone will do't.
She shall feel gold, taste gold . . . I will be puissant,
And mighty in my talk to her.

Ben Jonson, *The Alchemist*

Ben Jonson's play *The Alchemist* mocks the pursuit of alchemical knowledge – often equated with the desire to synthesize gold from other metals. As we will see, he was far from the first to make the alchemist into a figure of derision. But throughout much of history, alchemy has been serious business. In the early fourteenth century Western Europe experienced a shortage of silver as mines became depleted, and rulers turned to alchemists to attempt to enlarge their treasuries. Pope John XXII in 1317 responded with a Papal Bull entitled *Spondent pariter quas non exhibent* (They Promise That Which They Do Not Produce), which criminalized alchemy. Soon after, the Dominican order excommunicated all the alchemists within its number, and the Italian astrologer and alchemist Cecco d'Ascoli was burned at the stake – his position as professor at the University of Bologna notwithstanding. Those who opposed alchemy had religious concerns, but also economic and political ones. 'Alchemy' could be used for forgery, extending metallic coinage by alloying

precious metals with less valuable ones; critiques of alchemy were often critiques of the avarice of alchemists as much as dismissals of the likelihood of success or condemnations of black magic. And as warfare and its costs burgeoned in the fourteenth and fifteenth centuries, the need to produce more cash led rulers to protect alchemists in the hope of reaping benefits from the practice. Although in 1404 Henry IV of England banned the multiplication of precious metals, later in the same century Henry VI was curious enough about the practice to provide immunity to certain trusted men to investigate it.

Very early, practitioners of the art developed a bad reputation. As with Jonson, many observers have seen them as obsessed, mad scientist types impoverishing themselves in the fruitless quest to attain perfection in their art. In Philips Galle's 1558 print based on a painting by Pieter Bruegel the Elder, we see a chaotic scene of an alchemist's workshop, at the centre of which the alchemist's wife gestures toward her empty purse. Alchemy was famous for the perverse effect of impoverishing its practitioners. A later publisher added the title 'Al-Gemist', a play on the word 'alchemist', but literally meaning 'all mixed up'. A similar but more subtly disordered scene is typical of many paintings of alchemists' workshops, such as one in which the mad scientist appears with a monkey (a mocking symbol of imitation and fakery).

Others have viewed alchemists as charlatans, hoaxers and quacks. In the Enlightenment alchemy became the target of fulsome ridicule, and the modern field of history of science imbibed this prejudice as it sought to winnow its history of past practices down and emphasize direct precedents for modern, objective, rational methods and their findings.

But the chemical and physical ambitions of alchemy are based on assumptions that are, in a way, not that different from modern science: alchemists believed in a kind of atomic theory – a connection not lost on devotees of occult lore as they observed the new sciences of atomic physics and radiochemistry emerge at the turn of the twentieth century.[1] Underlying all alchemical theories was a view of the material world as based upon a Prime

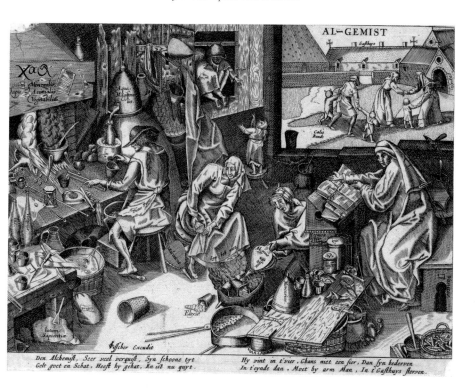

Copy after Philips Galle, *The Alchemist*, after painting by Pieter Bruegel the Elder, 17th-century engraving.

Matter that expressed itself in basic elements (air, fire, water, earth) and qualities (hot, wet, cold, dry) in varying proportions. Earthly matter as we experience it was composed of these elements and qualities, and could, presumably, be both decomposed into them and recombined in different proportions. While some of the claims of alchemy seem fantastical, in an abstract way this is not so different from modern atomic theory. Alchemists also held that transformation occurred naturally (minerals grow in the earth; some animals are born from the degeneration of others; human beings become ill and then regain health) and nature could be helped along by the proper application of 'art'. It was not really magic as we understand it, in the sense that it wasn't considered to operate outside natural laws.

Overleaf: Alchemist with Monkey, 17th–18th century. In the manner of David Teniers II, oil on canvas.

The alchemical view, indeed, looked a lot more foolish from the point of view of the eighteenth or nineteenth centuries than it does from that of the twentieth or twenty-first. While it

147

might be too much to say that alchemists prefigured the many uses of gold in modern science, they were, with their tinctures and solvents, their processes of combustion, fermentation, crystallization, calcination and distillation, practising a form of experimental science, making discoveries that later served science proper. Many of the seventeenth-century European writers of what we now call the Scientific Revolution distanced themselves from alchemy – but this does not distinguish them from the alchemists of earlier centuries, who distanced themselves as proper alchemical practitioners from the charlatans and quacks who were not to be trusted. Some of the same seventeenth-century scientists who disparaged alchemy were also involved in it. Robert Boyle, one of the founders of modern chemistry, and Isaac Newton were both disciples of the American alchemist George Starkey (also known as Eirenaeus Philalethes, or 'peaceful lover of truth'), and Boyle sought the alchemical Philosopher's Stone until the end of his life. Alchemical experimentation produced usable knowledge, such as the discovery of phosphorus. Chemists, too, sought basic principles that could be used to explain many different chemical processes. For example, the 'acid/alkali' theory placed these characteristics at the basis of matter just as alchemists had imagined mercury, sulphur and salt to be basic principles of matter. As Francis Bacon wrote in his *Advancement of Learning*, already in 1605, 'the search and stirre to make gold hath brought to light a great number of good and fruitfull inventions and experiments.'[2] The experimental practices of the alchemists prepared the way for modern experimental science.

Alchemy and the fabrication of gold

The desire to fabricate 'artificial' gold and other substances (such as porcelain, pigments and various elixirs) was at the heart of the development of experimental science in early modern Europe. It was also closely connected to art practices. When Cennino Cennini refers, in his early Renaissance treatise on art techniques, to pigments made using 'alchemy', he is just talking

about pigments made with minerals through chemical or physical processes: for example, vermilion, a red pigment made from powdered cinnabar, a compound of mercury and sulphur (not-ably, the two most symbolically significant elements in Western alchemy), or orpiment (*auripigmentum*, meaning 'gold pigment' in Latin, a sulphide of arsenic), with its brilliant yellow colour that attracted the attention of painters, alchemists and physicians, despite its highly poisonous nature.

It is often hard to tell the difference between alchemy (which we now think of as fantastical) and simple practical knowledge. Consider the medieval European writer Theophilus' description of the process of painting in gold on manuscripts. When painting with powdered gold, one starts with a ground made of red pigments and egg white, applied wherever the artist plans to embellish the manuscript page with gold. Then, gold that has been milled into a powder is mixed with heated glue, painted onto the page and then burnished with 'a tooth or a bloodstone that has been carefully cut and polished on a smooth, shining horn tablet'. Glue can be made from a sturgeon's or eel's bladder, from calf vellum (the prepared skin used as the writing surface for manuscripts) or by cooking the bones of the head of a dried pike three times.[3] To modern ears the ingredients sound like the makings of a magic potion, but it was a matter of practical expertise based on naturally occurring materials.

Knowledge of practical metallurgical tasks – gilding, distilling and fabricating compounds and alloys – dates back thousands of years. The 'making' of gold in many cases simply involved various forms of gilding or alloying to make metallic substances that looked like gold. The more esoteric connotations of what we now know as alchemy date back at least to the first centuries of the Common Era, possibly earlier. It is hard to know how literally to take the many references of lost texts and mysterious ancient authorities, including both human practitioners and quasi-divine figures such as Hermes Trismegistus, an avatar of the Greek god Hermes whose name gives us the word 'hermetic'. True to this term's meaning, alchemical

texts often appear intentionally obscure, designed to reveal their secrets to the initiated without exposing them to a broader circle of readers. They often purport to speak not of ordinary minerals but of mystical, ethereal substances bearing the same names. A number of writers in the late Roman Empire claimed that the emperor Diocletian, who ruled at the turn of the fourth century CE, had all the books of the alchemists in Egypt burned so that they would not produce gold to finance rebellions against him. This would then explain why the earliest alchemical texts come from around 300 CE. The accounts of censorship begin appearing a century later, and it is not clear whether they are reliable. However, an attack on alchemy might easily have been part of an effort to reform currency, discouraging the forms of knowledge necessary to counterfeit and clip coins.[4]

The earliest 'alchemical' papyrus manuscripts (for example, the *Papyrus Graecus Holmiensis* and the *Leyden Papyrus x*) are practical guides to various chemical preparations, containing matter-of-fact recipes for purifying, assaying, fabricating and 'increasing' metals, dyeing and colouring gems and metals, and making gold and silver inks. Some of these practices certainly involved fraud; others possess what may be a conveniently loose definition of metallic gold, encompassing 'white, dry, yellow, and gilded things . . . pyrite [fool's gold], cadmium, and sulphur . . . all the fragments and flakes yellowed and divided and brought to perfection'.[5] Zosimos of Panopolis, an alchemist born in Egypt in the third century CE, wrote what may be the earliest treatise that can be called properly alchemical in its focus on genuine metallic transmutation and its mystical tone. Zosimos claims to be working in a long tradition dating back to pharaonic Egypt, conjures the language of Hermetic and Gnostic wisdom, and, recounting a mystical vision, associates the purification of metals with moral purification. While the conjunction of sulphur and mercury does not figure as prominently in his system as it would for later alchemists (who believed that the marriage of these two elements was the key to producing gold), he does describe the process of compounding them. He describes the 'Philosopher's Stone', a chief

component of later alchemical works, thought to be a pure substance possessing the property of turning other metals into gold. Zosimos also provides information about earlier practitioners about whom we otherwise know little, such as Maria the Jewess, a woman living in Egypt several generations earlier whom he credits with inventing a number of alchemical instruments. (Her name survives in the French term for a double boiler, 'bain-marie'.) By the time of Proclus, who wrote in

Maria the Jewess, in Michael Maier, *Symbola aureae mensae duodecim nationum* (1617), etching.

the fifth century, the quest to fabricate gold was an established cultural topos; he writes disparagingly of 'those claiming to make gold out of the mixture of certain species'. His own views don't sound much less mystical to modern ears; along with other authors from late antiquity to the early modern period, he believed that 'gold and silver [grew] in the earth under the influence of the celestial gods and their emanations.'[6]

It was the Arabic language that gave us the word alchemy (along with numerous related terms: elixir, alkali, alcohol and algebra). 'Alchemy' derives from the Arabic translation of the Greek word *chymeia* (meaning a mixture). After the Rashidun Caliphate's conquest of Alexandria in 640, Arabic alchemists had access to manuscripts that transmitted the Hellenistic knowledge of the Egyptian alchemists. They also drew on Indian practical knowledge of chemical science and metallurgy, and lent their own scientific rigour to the tradition. Jābir ibn Hayyān, born in Persia in the eighth or ninth century, was perhaps the most important of the Islamic world's alchemists. Arabic texts attributed to him propound the idea that all metals originate from mercury and sulphur, which was to become a key theory of medieval and early modern alchemy. He (or others writing under his name) details the processes of preparation of the Philosopher's Stone – for Jābir, equivalent to the 'elixir of life' – that would turn base metals into gold. But the transformation of base (less precious) metals into gold was but one part of the elements of a practice emphasizing experimentation that would continue to inform alchemy for a millennium. Jābir purified chemical compounds like sal ammoniac, prepared steel, dyed cloth and leather, and distilled acetic acid from vinegar. It is also thought that he produced what became known in the west as *aqua regia*, a mixture of nitric and hydrochloric acids capable of dissolving gold and platinum. (Nitric acid alone cannot dissolve gold, though it does dissolve silver and other metals, the origin of the 'acid test' to determine the purity of the metal.)

Even the Arabic texts attributed to Jābir cannot be definitively connected to a single historical figure. In Europe the

problem multiplied. Jābir came to be known as 'Geber', a name
spuriously attached to hundreds of alchemical texts composed
long after his death, after alchemy arrived in Western Europe
in the twelfth century. Using a pseudonym may have been less
a matter of forgery than self-protection, in situations where
owning up to alchemical practices might be politically danger-
ous. It did of course lend authority to the texts presented under
a famous name, as may also have been the case for those who
attributed alchemical texts to the early Buddhist philosopher
Nagarjuna or the Catalan physician Ramon Llull. Writers
using Llull's name propounded the mercury theory, a view
that competed with Jābir's: according to this one, the goal of
alchemy was to distil the 'quintessence' (or 'fifth essence'), a
material form of the heavenly mercury, and then to further
purify it to attain the prime matter itself. European alche-
mists proposed and debated a variety of systems. Roger Bacon,
the English friar and scholar, emphasized animal substances
like blood, milk and urine, transformed through processes of
combustion, distillation and fermentation. Later alchemists
believed the Philosopher's Stone could be produced from vit-
riol (sulphuric acid) or nitre (potassium nitrate, or saltpetre).
Paracelsus, as we will see, added salt as a key ingredient.

In alchemical symbolism across the world, from Chi-
nese Daoist alchemy to Indian Tantric alchemy to Arabic
writings to Europe, substances have symbolic genders and
the production of metals is understood as a kind of sexual
reproduction. In the Jābirian tradition, sulphur (like the sun)
was considered male and mercury (like the moon) was female,
and their union was understood as a sexual one. Joined in an
acid bath, they created a hermaphrodite body that was then
destroyed and resurrected. Many alchemical writings are so
abstruse, complicated and metaphorical – bristling with eggs,
flasks, homunculi, dragons, hermaphrodites and toads – that
they appear to have more symbolic than practical meaning.
'Take the egg', instructs one illustration from Michael Maier's
Atalanta fugiens of 1618, in which alchemical learning was even
set to music, 'and hit it with a fiery sword'. This symbolism

Hermaphrodite in a landscape, from the *Splendor Solis* codex (1582), an alchemical text by Salomon Trismosin.

may have been a strategy to hide the practical methods of alchemical laboratories from the uninitiated. But its allusive imagery suggests that alchemical processes themselves could be understood in a more spiritual than practical light. The purification of metals might represent the purification of the soul: alchemical teachings drew upon philosophies of microcosm and macrocosm that assumed that the human, natural and divine worlds were joined together materially as well

'Accipe Ovum', etching in Michael Maier's *Atalanta fugiens* (1618).

EMBLEMA VIII. *De secretis Naturæ.*

Accipe ovum & igneo percute gladio.

EPIGRAMMA VIII.

*Est avis in mundo sublimior omnibus, Ovum
Cujus ut inquiras, cura sit una tibi.
Albumen luteum circumdat molle vitellum,
Ignito (ceu mos) cautus id ense petas:
Vulcano Mars addat opem : pullaster & inde
Exortus, ferri victor & ignis erit.*

Mul.

as symbolically. In an engraving from Heinrich Khunrath's *Amphitheater of Eternal Wisdom*, the alchemist's workshop forms the pupil of a giant eye, expressing the view that alchemical knowledge depended upon – among others – the maxim 'know thyself'. More surprising might be the fact that church reformer Martin Luther saw no contradiction between alchemy and Reformation theology:

The science of alchemy I like well, and, indeed, 'tis the philosophy of the ancients. I like it not only for the profits it brings in melting metals, in decocting, preparing, extracting, and distilling herbs, roots; I like it also for the sake of the allegory and secret signification, which is exceedingly fine . . . For, as in a furnace, the fire extracts and separates from a substance the other portions, and carries upward the spirit, the life, the sap, the strength, while the unclean matter, the dregs, remain at the bottom,

Etching attributed to Peter van der Doort, after Hans Vredeman de Vries, *The Alchemist's Laboratory* from Heinrich Khunrath, *Amphitheatrum sapientiae aeternae* (Ampitheatre of Eternal Wisdom, 1595).

like a dead and worthless carcass; even so God, at the
day of judgment, will separate all things through fire, the
righteous from the ungodly.[7]

Gold and medicine

In ancient times alchemy represented a broad philosophical
outlook connected to medical practice and cosmology – it
wasn't just about increasing wealth. Gold and pharmacology
had long held a close relationship. The purported 'nobility' of
gold led to its use as an agent of immortalization in burials. In
the Late Period of ancient Egypt, the seventh to fourth cen-
turies BCE, mummies were covered in gold – that is, their skin
was gilded in its entirety, or they were sealed with gold on the
principal orifices or vital spots of the body. This was thought to
protect the dead from decomposition and even to regenerate
them as immortal beings composed entirely of gold.[8]

Alchemy's healing functions were especially stressed in
Asian practices that were probably known – one way or another
– to the Arabic writers who became so influential in Europe.
Even if gold was not central to the Chinese economic system, it
was a routine component of the Chinese pharmacopoeia. Chi-
nese alchemical practice possessed a dizzying panoply of elixirs
made from herbs, flowers, grains and fruit as well as animal
and mineral ingredients. Elixirs in a Ming Dynasty alchemical
text range from the poetic 'Scarlet Snow and Flowing Pearl' or
'Crimson-coloured Empyrean-roaming' elixirs to the more pro-
saic 'Fine Day' or 'Eight Mineral' elixirs. Gold was ostensibly an
ingredient of many elixirs, though few are named for it; 'Liquid
Gold and Jade Flower' elixir is an exception.[9] Cinnabar and
the arsenic compounds orpiment and realgar were also favourite
ingredients, though they were probably more poisonous than
healthful. (In the Qing dynasty glass vessels were tinted to look
like realgar – conveying its brilliant orange-red colour without
the toxicity.) If a preparation did not have its intended effect,
one could always find some imperfection in the adept's comple-
tion of the requisite ritual steps. For example, the elixir known

Hanging scroll, alchemist with charcoal basket, Ming dynasty, after Zhang Sheng, 1351–1400 CE.

as 'Nine-crucible Cinnabar', which according to Jin dynasty alchemist Ge Hong enabled the Yellow Emperor to ascend into the sky, required a recipient to purify himself ritually for 100 days, keep his practice secret and then 'throw a golden human statuette . . . and a golden fish . . . into an eastward-flowing stream as a pledge and take an oath by smearing his lips with blood of a victim (white chicken)'.[10]

At the origins of their practice, Chinese alchemists may have derived ideas from ancient Indo-Iranian religious texts that linked gold with the liturgy surrounding the use of *soma*, a plant-based Vedic ritual drink described as golden in colour and associated with immortality. It may in fact have been a psychotropic mushroom.[11] Along with drinking potable gold, eating from gold plates and utensils was thought to help attain longevity.[12] It was likely in China, in the fourth century BCE, that practitioners first connected the idea of artificially creating and perfecting gold with the notion of an elixir of immortality. The origins of Chinese alchemy are inseparable from the religious and philosophical movement known as Daoism, emerging in

Hexagonal mould-blown glass vases made in imitation of realgar, Qing dynasty, Beijing, c. 1723–50 CE.

this same period. By the second century BCE the confluence of alchemical ideas – artificial gold and the elixir of life – was well established in China.[13] It would eventually spread worldwide. Chinese alchemists touted artificial gold as superior to the natural mineral: in the *Nei P'ien* of Ge Hong, a master alchemist asserts, to the narrator's evident surprise, that the qualities of artificial gold exceed those of natural gold for rendering the practitioner immortal. (It's also a factor, he admits, that alchemists are poor – so if they want it, they have to make it.)[14] If you don't believe gold can be fabricated, Ge tells us, well, some people don't believe in dragons or unicorns either, but just because they haven't seen them doesn't mean they're not real![15]

As with many Western alchemical texts, the metaphorical language of Chinese alchemy often makes it difficult to tell whether the instructions for chemical processes in Chinese texts are to be interpreted in spiritual or practical terms. Ge Hong's *Baopu zi* explicitly invites a distinction between public and private knowledge, dividing his work into Inner (Daoist) and Outer (Confucian) teachings. The latter give advice on practical matters of daily life; the Inner teachings give instructions on chemical processes, but also philosophical concepts, placing equal priority on 'internal alchemy' (processes of self-transformation through meditation) and 'external alchemy' (the fabrication of elixirs). Ge also wrote *Scripture of the Golden Liquid of the Divine Immortals, by the Master Who Embraces Spontaneous Nature*, in which he describes the process of making a series of elixirs that culminate with the production of gold and the conferral of immortality.

Ge Hong and others described both alchemy and meditation as superior to other means of cultivating the self (gymnastics, herbal medicine, breathing and sexual techniques, and diet) and to magic and divination.[16] Alchemists often received favour at imperial courts, and their ranks included women as well as men: Mistress Kêng, a court alchemist during the T'ang Dynasty, could, among other feats, reportedly turn snow into silver. But as in the West, alchemy was sometimes classed with the shady practices of magicians and hoaxers (one can only imagine that

the snow-to-silver transformation was simply a magician's trick). Popular Daoism was the province of practitioners known as Fang-shih, a term that can be translated as magicians or diviners, artisans whose expertise included medicine and metallurgic transmutations as well as various forms of prognostication. According to a detractor, Ku Yung,

> All those occultists ... who are brimming with claims about the strange and the marvelous, about spirits and ghosts ... who rotate the planting of grain in mysterious conjunction with the Five Powers, and who sow and reap in cadence with the daily sun, who rival the mountains stones in longevity, who have mastered transformations of base metal into gold, who have made whole the five colours and five stores within their bodies – those occultists cheat people and delude the masses. They hold in their grasp the black arts and in their embrace all manner of false and faked means in order to deceive the ruler of our world.[17]

Alchemical gold also came to be associated with longevity in Europe, although the dream of earthly immortality through a golden elixir could not find easy expression in Christian contexts. But many European alchemists were also physicians – the most famous, perhaps, being the sixteenth-century Swiss doctor Paracelsus. In Mary Shelley's *Frankenstein* the early modern scientist epitomizes the shady realms of antiquated belief into which Victor Frankenstein delves as he attempts to create artificial life. Paracelsus did pursue alchemy (he extended the theoretical dyad of mercury and sulphur into a triad by adding salt), but he did so as part of the practice of medicine. His empirical approach to the medical arts also included the observation that cleaning wounds could be more effective than cauterizing them, and experiments with the use of metallic compounds in treating illness (such as gold compounds for the treatment of epilepsy and mood disorders), essentially inventing chemotherapy. He also invented something called laudanum, later a popular medicine involving a solution of opium in

alcohol, though for Paracelsus the term could refer to several different types of elixir and might include such ingredients as gold and pearls. He also praised gold as a noble metal and general elixir, a routine treatment for ordinary mortality. He was by no means alone in this view, and the fashion for potable gold among the nobility led to some tragic consequences. In small doses gold can be safely consumed – as it is in modern fad drinks like Goldschläger and occasionally in haute cuisine – but in larger quantities it is poisonous. Diane de Poitiers, the mistress of the French king Henri II, was known to drink gold as

Anonymous French painter, *Portrait of Diane de Poitiers*, red and black chalk drawing, 17th century.

an elixir of youth. When her body was exhumed in 2009, high concentrations of gold – a toxic level – were found in her hair.[18] The quest for youth may have been what killed her.

Before the twentieth century gold was used to treat conditions as varied as syphilis, heart disease, smallpox and melancholia. Gold compounds have been used (in injectable and oral forms) since the early twentieth century to alleviate the symptoms of rheumatoid arthritis and lupus. These compounds have an anti-inflammatory effect, but long-term treatment with gold can discolour the skin and damage the internal organs. Current studies are attempting to understand the mechanism at work and to address concerns about toxicity. Some veterinary acupuncturists use gold bead implants to treat epilepsy, hip dysplasia and other conditions in animals – a method not generally used in human patients.

One of the best-known modern medical uses of gold is as crowns and fillings in teeth. The use of gold in dentistry has a long history; the ancient Etruscans appear to have used gold for dental crowns and bridges. Although the first u.s. president, George Washington, is commonly (and incorrectly) thought to have worn wooden teeth, at least one of his sets of dentures contained far more valuable substances: gold and ivory![19]

Electronics and high-tech uses of gold

If the premodern world found gold desirable as a container of value precisely because it was not useful for tools, modern science has found numerous uses for the metal. Gold is now used as a toner in photography, as a reflective coating to protect equipment and astronauts from electromagnetic radiation in space technology, as a coating in some catalytic converters, and as a heat conductor to de-ice aircraft cockpit windows. The *Voyager 1* and *2* space probes, launched in 1977 to study Jupiter and now forging ahead into interstellar space, carry golden LP records bearing sound and images that document Earth cultures in the late twentieth century. More recently, NASA's James Webb Space Telescope, scheduled for launch in 2018, was

Voyager 1 golden record cover.

designed with mirrors coated with a microscopic gold film that reflects infrared light from space to allow it to be studied by the telescope's instruments.

Gold's imperviousness to humidity and corrosion and its ductility are especially prized in high-tech applications. The physical properties of gold have enabled it to play a supporting role in numerous technological innovations. In 1786 the provincial English clergyman Abraham Bennet published his invention of a gold-leaf electroscope, in which gold enabled more sensitive measurements of electrical charge than had previously been possible. In Bennet's electroscope, two slips of gold leaf hung in a large glass cylinder, separating in a 'V' shape when a charge was applied to a contact connected to them.[20] In 1909 when Hans Geiger (of Geiger counter fame) and Ernest Marsden established that atoms are composed of positively charged nuclei surrounded by electrons, gold was the element they initially studied. The thinness that could be achieved with gold foil made it an apt

In September 2011 NASA engineers completed coating of the James Webb Space Telescope's 21 mirror segments with microscopic layers of gold.

substance to bombard with alpha particles and observe their scattering, which enabled measurements of the negative and positive charges associated with atomic gold. This in turn enabled scientists to establish the principle of ordering the periodic table of elements by atomic number (the number of protons in the nucleus of an element) rather than by atomic weight.

Gold foil was also crucial to the development of the transistor – a device that underlies all modern electronic technology – in the years immediately following the Second World War, when scientists turned from military applications to basic research. Transistors work by amplifying and switching on and off the charge passing through a semiconductor. Semiconductors

– silicon is the best known – are a class of substance essential to modern electronic devices because their ability to carry a charge can be manipulated. By definition, their conductivity falls between that of conductors (of which gold is one) and insulators (such as glass), but it can be varied by 'doping' with impurities or 'gating' with electric fields. Scientists at Bell Telephone Laboratories, in search of methods to amplify sound for telecommunications, developed the transistor in 1947. They coated a plastic wedge with gold foil which was then slit with a razor to create two separate contact points that were very close together. They then pushed the gold-sheathed wedge into a piece of germanium, a semiconductor. When a positive charge was applied to the germanium, it sucked away electrons at one point of contact with the gold foil, opening up a pathway for more electrons to move through the germanium from one side of the slit foil to the other. With one side acting as the 'emitter' and the other as the 'collector', a charge could be conducted and amplified.[21]

The first transistor: Bardeen and Brattain's 'point-contact semiconductor amplifier' made of germanium and gold.

Starting in the late 1950s, scientists also used very thin gold wire as bonding wire for complex circuitry. At 10–200 microns, thinner than a strand of human hair, gold wire was well suited to connect the components of an integrated circuit – transistors, resistors, capacitors and diodes – on a microchip. Because of its high cost, gold is now rapidly being replaced by copper, which (although it corrodes more readily) is cheaper and a better conductor.

The modern alchemy of seawater and fraud

When Hernán Cortés and his conquistadors landed in Mexico they believed they had found a land as abundant in gold 'as in that from which Solomon is said to have taken the gold for the temple'.[22] But the precious stuff was not always easy to

find. When Cortés first inquired about Moctezuma's gold, he justified his request by telling the Aztecs that he and his men suffered from a sickness of the heart that gold could cure.[23] Perhaps he had in mind the purported medicinal properties of gold within the alchemical tradition; perhaps he was just inventing a persuasive fable. The story is told only later, so perhaps it was embroidered. But the metaphor is an especially evocative one. The heartsickness Cortés and his men suffered was, in the end, just their longing for gold.

That particular longing has led people throughout history to do irrational things, like pursue alchemy long after it had been discredited by all reputable scientists. Since the lust for gold survived unabated, alchemy could still, on occasion, excite the imaginations of people in need of cash (and those who would exploit that need). Late in the seventeenth century, the naturalist Johann Joachim Becher claimed to be able to turn sand into gold, and persuaded the Dutch assembly to go so far as to pay him an initial advance to set up his equipment. Ostensibly he succeeded twice in demonstrating his technique to witnesses. He certainly succeeded admirably in extracting silver from the government – before being forced to flee for his life when he was unmasked as a fraud.[24] The scientific reputation of alchemy was already on the decline by Becher's time, but it did not die: in London in 1891, an American by the name of Edward Pinter, claiming to have discovered the Philosopher's Stone, used his purported discovery as the basis of a con game. In a familiar form of con, he used a small-scale demonstration in which he appeared to triple a small quantity of gold, thus persuading people (including one member of the famous Rothschild banking family) to hand over a much larger quantity of gold into his keeping.[25]

By this time, however, the thirst for gold had set its sights on a different form of transmutation. In the second half of the nineteenth century scientists proposed and debated theories about the presence of gold in seawater. Some believed gold might be extracted from the oceans, though it was unclear whether profitable methods could ever be devised given the

extremely small concentration of the metal. Inspired by the scientific findings, a Baptist minister from Martha's Vineyard set up an elaborate hoax using an actual factory building in a remote part of Maine. He concocted fake machinery and hid small amounts of gold that could be presented to curious visitors as the product of his new method of extraction. Investors who bought shares in the Electrolytic Marine Salts Company were sorely disappointed when he absconded with their life savings.

In spite of this debacle, the possibility of gold extraction from seawater continued to excite imaginations at the dawn of the twentieth century, and other inventors pressed on. Gold extraction schemes popped up in England, Malta and Australia. In the Australian scheme seawater filled a large reservoir. Mineral contents were allowed to settle, the water was drawn off, and the resulting sludge was subjected to the newly invented cyanide process – now a key component of mining – to extract the gold. The project was not, apparently, a hoax, but a sincere effort; however, the amounts produced were apparently so negligible that the project quickly collapsed.[26]

Lively scientific debate surrounded these attempts – as did social and ethical speculation. What would happen to modern economies were it to become possible to produce synthetic gold cheaply and easily? Jean Finot, a French sociologist and ardent anti-racist, warned in 1912 that the world economic system was in jeopardy due to future massive increases in the supply of gold, an occurrence he felt was near at hand thanks to modern technology – whether from seawater extraction, new discoveries of gold deposits or the actual fabrication of synthetic gold. The *New York Times* paraphrased: 'If gold, which is the sole base of economic stability, were to suffer such violent fluctuations, what would be the position of those whose fortune is only symbolical as representing merely a certain quantity of this metal?' But Marie Curie, whom the *Times* queried on the topic, dissented on scientific grounds, finding it such a remote possibility that it was 'unprofitable' to 'consider the possible consequences of the fabrication of gold'.[27]

In the twentieth century the alchemists' dream finally culminated in the scientific capacity to make gold. Scientists in the 1920s claimed to have synthesized gold by bombarding mercury with helium nuclei, but other scientists had difficulty repeating the experiment – a key standard for scientific knowledge. In 1941, as part of the war effort, scientists produced radioactive isotopes of gold from mercury by neutron bombardment. In 1980 a research group at Lawrence Berkeley Laboratory – headed by the Nobel Prize-winning chemist Glenn Seaborg, who also discovered plutonium – transmuted bismuth into the only stable isotope of gold (also the only one found naturally, ^{197}Au) through nuclear collision. These methods of synthesizing gold have not made a huge impact on the scientific community, even if they have stirred some imaginations. None, so far, can be carried out in a way that would make gold synthesis profitable.

6 Dangerous Gold

The myths and literature of the world contain countless warnings about the dangers of lust for gold, but few people – mythical, historical or present-day – heed the warnings. The *Prose Edda*, the thirteenth-century CE compilation of Norse mythology that finds parallels in the Germanic *Nibelungenlied*, tells us that the dwarf Andvari had a magical ring that could make gold (he could also turn into a fish). The mischievous god Loki captured the dwarf in fish form and demanded all of his wealth, including the wealth-creating ring. The dwarf gave up the ring, but not before cursing it, saying that it would bring ruin to anyone who possessed it. The ever-practical Loki handed the ring over to Odin, who gave it to Hreidmarr, whose sons killed him for his riches – and Andvari's curse lives on. In the oral history of the Coloma people of northern California, where the discovery of gold at Sutter's Mill in 1848 sparked the California Gold Rush, a chief with whom Sutter tried to negotiate a treaty warned him that the gold he sought 'belonged to a demon who devoured all who searched for it'.[1] The demon is still devouring, and this chapter details how those myths of the destructive power of the lust for gold play out in the real world on real people.

The curse of gold seems to have a twisted sense of humour, and quite often in mythology and fiction, nobody profits from greed. For example, the first-century Roman poet Ovid added a unique episode to the story of Perseus in his *Metamorphoses*. Fresh from slaying Medusa, Perseus stops for a rest in the kingdom of the giant king Atlas and mentions his famous father,

Fafnir the dragon, who got Andvari's gold but was killed for it. Illustration by Arthur Rackham for *Siegfried and the Twilight of the Gods* (1924).

The helmeted Perseus bringing to Atlas the head of Medusa. Cherubino Alberti, after Polidoro da Caravaggio, 1570–1615, engraving.

Zeus (he of the rain of gold). Atlas remembers a prophecy that a child of Zeus would steal the precious golden apples that grow in his magical garden, the garden of the Hesperides, so he attacks Perseus. The annoyed hero uses Medusa's head to turn the gigantic Atlas into stone, and the gods decide to place the heavens on his rocky shoulders. Perseus departs without the golden fruit, and presumably nobody benefits.[2]

This theme resurfaces in B. Traven's novel *The Treasure of the Sierra Madre* (1927), which was adapted into an award-winning film starring Humphrey Bogart in 1948. In it, three destitute American miners strike it rich in post-Revolutionary Mexico, but greed and paranoia lead one miner to believe that his partners are going to rob him. He robs them first, but as with Atlas, his preemptive violence backfires: he's ambushed by bandits who don't realize that his saddlebags are filled with gold dust, and it blows away as he expires. Frank Norris's novel *McTeague* (1899) ends on a similar note: McTeague, having murdered his miserly wife for the $5,000 in gold coins that she refused to share with him, attempts to escape to Mexico but is cornered in Death Valley by his erstwhile friend Marcus. The two fight, first over their last few drops of water and then over the gold. McTeague kills Marcus, but his hard-won riches won't prevent

him from dying of thirst. When Erich von Stroheim filmed the novel in 1924 as *Greed*, it clocked in at eight hours and cost the studio more than $600,000 (about $8 million today). Studio head Irving Thalberg removed von Stroheim from the project and had it cut to just over two hours. The excised footage was then rendered for its silver content.

Sometimes, after suitable punishment, the greedy are allowed to see the error of their ways. In the King Midas legend as recounted in Ovid's *Metamorphoses*, Dionysus rewards Midas for his kindness to the satyr Silenius by granting one wish. The king requests that everything he touches turn into gold. The blessing quickly reveals itself to be a curse – Midas realizes he can no longer eat or drink, as food and drink turn to gold as soon as he touches them. In Nathaniel Hawthorne's *A Wonder-Book for Girls and Boys* of 1851, Midas' daughter turns to gold when he touches her. He repents his greed and begs Dionysus to withdraw the gift. Dionysus tells him to wash in the river Pactolus, which transfers the golden touch to the waters that would later make the real King Croesus very rich. Midas retires to the woods to worship Pan.

Midas is not the only legendary king whose greed and hubris led him to the brink of disaster. In the tenth- to eleventh-century CE *Shāhnāmeh* (book of kings), the national epic of the Persian-speaking world, the poet Ferdowsi tells us of a powerful and capricious king named Kay Kāvus. Goaded by an evil spirit disguised as a handsome youth, the king has a golden throne built for himself (illustrated on page 180), which is carried aloft by four hungry eagles lured into flight by chunks of meat tied to the throne. His goal is to fly into the heavens and learn their secrets; the king manages to fly all the way to China before the eagles are too exhausted to continue. The contraption crashes, but miraculously Kay Kāvus survives and repents.[3]

Another kind of myth about dangerous gold comes to us in the form of legends of lost mines and buried treasure. Among the most famous is the Lost Dutchman's Mine, purportedly located in Arizona's Superstition Mountains (although geologists doubt there is any gold in the area). The story goes that

Walter Crane, 'King Midas with his Daughter', from *A Wonder-Book for Girls and Boys* by Nathaniel Hawthorne (1851).

·MIDAS'·DAUGHTER·TURNED·TO·GOLD·

French-language film poster for *Treasure of the Sierra Madre* (1948).

in the 1880s or '90s, a German prospector named Jacob Waltz discovered a rich vein of gold but was attacked by Apaches (or by his greedy partner; the story has many different versions). He survived long enough to tell his tale to at least one person and left a crude map that unfortunately wasn't accurate enough to pinpoint the mine's location. There's something to the legend – there was a real German immigrant named Jacob Waltz who actually did some prospecting in the general vicinity of

the Superstition Mountains, and a gravestone helpfully but somewhat inaccurately identifies him as 'the Lost Dutchman' (he wasn't lost; his mine was). And he just might have related the story of a lost mine on his deathbed, although he had given up mining nearly twenty years before. At any rate, it's tempting to see the story as a harmless legend that helps drive tourism to the area; indeed, several thousand people a year head out into the mountains in search of the mine, and there's a Lost Dutchman State Park for the less adventurous. But it can be deadly, too: several treasure hunters have died while searching, some under rather mysterious circumstances, including a 1930s adventurer whose skull was found with two bullet holes in it.[4]

Oak Island, off the coast of Nova Scotia, is home to another mythical treasure trove, although what exactly is supposed to be there is unclear – the leading theory is that it is pirate booty, perhaps even Captain Kidd's (probably mythical) lost treasure, which was advertised in the song 'Captain Kid's Farewell to the Seas; or, the Famous Pirate's lament' in 1701 as containing 'two hundred bars of gold'. Other, even less plausible, theories include Marie Antoinette's jewels and secret documents proving that Francis Bacon wrote the plays of Shakespeare. Treasure hunters have been digging on the island in a location known as the Money Pit for more than 200 years, discovering inexplicable signs of human workmanship like flagstones, layers of logs and, in some reports, stones bearing mysterious symbols. Each attempt has been more elaborate and costly than the previous one, and each attempt ends with the pit filling with seawater and the treasure hunters bankrupt – or, in at least six cases over the years, dead – all for a treasure that probably doesn't exist.

A modern-day Money Pit was the Bre-x gold mining scandal in the mid-1990s. Bre-x was a mining company that claimed to have discovered an enormous gold deposit in Indonesia. Their stock price went through the roof, investors flocked to get a piece and it all came tumbling down when it emerged that Bre-x had fabricated the core samples by 'salting' them with gold. The company collapsed overnight, and investors lost billions of dollars.[5]

For as long as gold has been coveted, it has been stolen. The annals of the American West are full of tales of daring masked men stealing gold at gunpoint from horse-drawn carriages and then trains, but these were mostly small potatoes. In the biggest such theft, desperado Sam Bass and his Black Hills Bandits robbed a Union Pacific train of about U.S.$60,000 in newly minted $20 gold pieces in 1877, which would be worth a little more than U.S.$1 million today. On the other side of the Atlantic, the Great Gold Robbery of 1855 saw enterprising thieves steal 91 kg (200 lb) of gold from a heavily guarded train shipment; the thieves, who included guards and railway employees, had secured copies of the keys to the strongboxes containing the gold, and had replaced the loot with lead shot so nobody would notice a difference in weight. They were caught anyway.[6]

More sensational was the Brink's-MAT heist of 1983, when a gang of thieves who had thought they were robbing a Brink's warehouse of cash discovered £26 million in gold bullion. Although it was quickly obvious to authorities what had happened – like most big robberies, it was an inside job – none of the gold has been recovered. In 1984 the gang's ringleader was sentenced to 25 years in prison, and in 1995 the High Court ordered him to pay back the missing £26 million. He was released from prison in 2000. Police suspect that much of the gold was melted down, and 'it is claimed in some quarters that anyone wearing gold jewellery bought in the UK after 1983, is probably wearing Brinks Mat.'[7] One might be tempted to believe that the gold was cursed – the deaths of as many as twenty people are linked to this fateful robbery, including several unsolved murders of suspected gang members and the death by stabbing of a policeman who was investigating the robbery. The most famous is Charlie Wilson, one of the thieves in the infamous Great Train Robbery of 1963, who was engaged in laundering some of the proceeds from the Brink's-MAT job. An unknown hitman shot him and his German Shepherd outside his home in Spain in 1990.[8]

Slavery, war and the environmental costs of gold mining

These gold-fever tragedies tend to be small, affecting only a few people (at least physically). But the reality of gold extraction is much more frightening. Gold mining at any level beyond simple panning leads to environmental damage, and the great amount of resources necessary to reach veins deep beneath the surface means that mining companies may be less interested in the welfare of their employees.

Mining, especially underground, is a dirty, dangerous job. The u.s. Bureau of Labor Statistics warns that even in strictly controlled, modern settings, 'unique dangers include the possibility of cave-in, mine fire, explosion, or exposure to harmful gases. In addition, dust generated by drilling in mines still places miners at risk of developing either of two serious lung diseases: pneumoconiosis, also called "black lung disease," from coal dust, or silicosis from rock dust.' In less controlled settings, it can be a lot worse.[9]

One of the earliest accounts of the hardships of mining comes from first-century BCE Greek historian Diodorus Siculus. In his massive *Bibliotheca historica*, he describes the doomed slaves who worked Nubian gold mines in Ptolemaic Egypt:

> And those who have been condemned in this way – and they are a great multitude and are all bound in chains – work at their task unceasingly both by day and throughout the entire night, enjoying no respite . . . All without exception are compelled by blows to persevere in their labours, until through ill-treatment they die in the midst of their tortures. Consequently the poor unfortunates believe, because their punishment is so excessively severe, that the future will always be more terrible than the present and therefore look forward to death as more to be desired than life.[10]

Shah Kay Kāvus Attempts to Fly to Heaven, in a *Shāhnāmah* manuscript, Iran, Il-Khanid period, gold and ink on paper, opaque watercolour.

Using slaves to mine gold was not an uncommon occurrence: in the 1770s the Tokugawa shogunate in Japan sent vagrants to work as water carriers at the gold mine in Sado province.

The discovery in 1886 of immense goldfields in the Witwatersrand region of Transvaal in present-day South Africa set off decades of strife. The area had been colonized by fiercely individualistic Boers (from the Dutch word for farmers), a mix of Dutch settlers and French Huguenots and Calvinists who had fled religious persecution in Europe. The Boers lacked the population necessary to work their new gold mines, so they reluctantly allowed 'outlanders', mostly British miners, to be hired. The outlanders quickly outnumbered the Boers and began demanding political and economic rights, which the Boers were reluctant to grant since they would lose control of the state they had founded earlier in the century to escape British rule. A British-backed attempt to overthrow the Boer government failed in 1895, and when negotiations collapsed in 1899, the Boers demanded that Britain withdraw the troops that had massed on the borders of Transvaal, while the British demanded that the Boers immediately grant full citizenship to British settlers in Transvaal. War broke out, a costly, bloody conflict in which the outnumbered Boer army used guerrilla tactics against the much larger British army, to which the British under Lord Kitchener responded with a scorched-earth policy of destroying Boer farms and placing civilians in concentration camps where more than 25,000 Afrikaner women and children died of disease and malnutrition.[11]

Between 1904 and 1907, almost 64,000 indentured Chinese men on three-year contracts travelled to the goldfields to work in mines as part of a short-lived experiment to jump-start the ailing industry, which was still reeling from war. By 1910 the last of these workers were repatriated. During this short time, they suffered horrific living and working conditions (such as being underground for ten hours of the day), physical abuse by the white mine owners and brutal treatment by Chinese mine police hired ostensibly to keep order but more likely to deal opium, run prostitution and gambling rings, and either kill or drive to suicide their unfortunate debtors.[12]

The California Gold Rush of 1849 survives in popular history as a wild festival of boom and bust, pitting hardy and

enterprising (white) men against fate and nature in a microcosm of Manifest Destiny personified. Beloved tales by Mark Twain and Bret Harte romanticized the squalor of the mining camps and made folk heroes of the plucky and individualistic miners, even though the bulk of the gold was extracted by mining companies. And until relatively recently, historians tended to glamorize it as a historic event, an unprecedented mass movement of people, without addressing the consequences. Although some people did get rich, most people's reality was much grimmer, poorer and more violent.

"THE USED-UP MAN"—See page 36.

'The Used-up Man', wood engraving, 1853, caricature of a failed California gold miner.

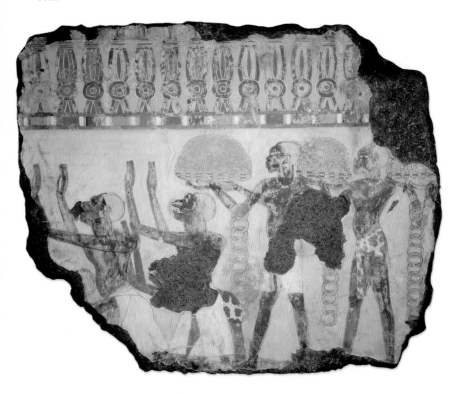

One in twelve Forty-niners died on the way to the gold-
fields, while there or on the way back. Death could come
through illness, accident or violence. In an environment where
most of the population was male and armed, the murder rate
skyrocketed to as high as 500 per 100,000 inhabitants, or almost
100 times the current murder rate in the United States. One
physician observer estimated that between 1851 and 1853, one-
fifth of the people who arrived in California died within six
months of arrival. In the absence of police or courts, vigilant-
ism ruled: between 1849 and 1953 there were more than 200
lynchings in the goldfields.[13]

Miners of all races faced hardships, but non-white min-
ers fared much worse than whites. Miners born outside the
United States had to pay a steep tax to work, but payment did
not mean freedom from violence. Mexican miners were beaten
and robbed of their holdings, and in one camp sixteen Chilean

Part of a tomb wall
with a painted
representation of
Nubians offering gold
nuggets and rings to
the (unseen) king,
c. 1400 BCE.

Utagawa Hiroshige,
*Gold Mine, Sado
Province*, September
1853, ukiyo-e print.

THINGS AS THEY ARE.

miners were executed on trumped-up charges. Chinese min-ers were barred from testifying against whites in criminal and civil trials, forcibly evicted from their claims and sometimes murdered. A committee of the California state legislature acknowledged in 1862 that 'it is a well known fact that there has been a wholesale system of wrong and outrage practiced upon the Chinese population of this state, which would disgrace the most barbarous nation upon earth.'[14]

The worst treatment was reserved for Native Americans, who numbered about 120,000 in California in 1844 but only around 30,000 by 1870. (During the first ten years of the rush, the white population jumped by 2,000 per cent.) Native Americans died from disease, violence and starvation as their traditional lands were overrun by white hunters and then farmers. They were even left out of the story entirely – it was probably workers from the Maidu tribe, not their white over-seers, who discovered the first nuggets of gold at Sutter's Mill in

'Things as they Are', picture of the gold rush in California, 1849, by Henry Serrell and S. Lee Perkins, lithograph on wove paper.

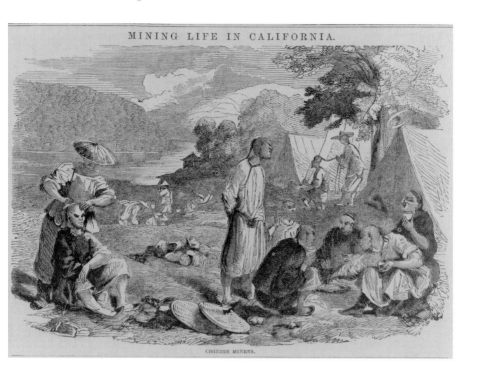

MINING LIFE IN CALIFORNIA.

CHINESE MINERS.

Mining Life in California – Chinese Miners, from *Harper's Weekly*, 1/40 (3 October 1857), p. 632.

January 1848, sparking the gold rush. The woeful story of what one tribe, the Wintu of northern California, suffered at the hands of white settlers in just three years serves to enscapulate the Native experience during the gold rush. In 1850 whites gave a 'friendship feast' where they served poisoned food, killing 100 Wintu; in 1851 miners burned a Wintu council house, killing 300; and in 1852, in the Bridge Gulch Massacre, whites attacked a Wintu camp, killing 175. Peter Burnett, the first governor of California, reflected the opinions of many white Californians when he said 'That a war of extermination will continue to be waged between the races, until the Indian race becomes extinct, must be expected.'[15] Speaking of this policy of extermination, the historians Robert Hine and John Faragher concluded, 'It was the clearest case of genocide in the history of the American frontier.'[16] This was par for the course for gold rushes – in the decade after the discovery of gold in Victoria and New South Wales, Australia, the white population rose more than 400 per

cent while the aboriginal population fell to less than half of what it had been.[17]

Although California outlawed slavery, thousands of Native Americans were virtually enslaved under the Act for the Government and Protection of Indians of 1850. This act enabled white employers to lease Native American convict workers, indenture free Native Americans overcome by personal debt, and kidnap Native children into private homes as exploited 'apprentices' who could legally remain bonded into their late twenties. An illegal slave trade quickly emerged to provide sufficient Native American children to work as domestics or farmworkers, making up for the shortage of women and children in the male-dominated gold rush.[18]

Native American groups in other parts of North America suffered at the hands of whites lusting after gold. The 1868 Fort Laramie Treaty between the United States and the Cheyenne and Sioux tribes of the Great Plains recognized the ownership by the Lakota of the Black Hills of South Dakota. But an exploratory survey by General George Armstrong Custer found large gold deposits, and President Ulysses S. Grant decided not to enforce the terms of the treaty. When white miners poured into the Black Hills and inevitably came into conflict with the Lakota, the u.s. Government attempted to purchase the land; when that failed, the u.s. resorted to military force. The best-known episode of this war was the battle of the Little Bighorn, where a confederation of Lakota, Northern Cheyenne and Arapaho led by Sitting Bull and Crazy Horse wiped out Custer and his 7th Cavalry, but the victory was short-lived, and the u.s. took control of the land.[19]

Gold rushes devastate the natural environment for years, even centuries. In California the influx of hundreds of thousands of people meant that the human population overran natural areas, leading to the near-extinction of species like the grizzly bear, the golden beaver, the tule elk, the pronghorn and many others. The miners needed to eat, and cattle and sheep quickly numbered in the millions, devouring native grasses and denuding vast swathes of land. (This is typical of mining:

GENERAL CUSTER'S DEATH STRUGGLE.
The Battle of the Little Big Horn.

H. Steinegger after
S. H. Redmond,
*General Custer's Death
Struggle: The Battle of
the Little Big Horn*, 1878,
lithograph on paper.

a recent study of western Ghana found that surface mining has resulted in the loss of almost 60 per cent of its forests and almost half of its farmland.)[20]

After 1860, when larger mining companies adopted hydraulic mining, entire hillsides were washed away. The resulting silt and debris washed downstream, clogging rivers and causing massive flooding, such as a flood in 1862 that inundated the grounds of the state capitol building in Sacramento. Still, it wasn't until 1884 that hydraulicking was banned in California, a testament to the lobbying power of the mining companies.

The devastation didn't end when the hydraulicking ended. Mining during the California Gold Rush introduced as much as 36.3 million kg (8 million lb) of mercury into the environment, and there are lakes and rivers where the fish remain unsafe for

consumption. And mercury use is still common among arti-
sanal gold miners around the world, leading to continuing
health problems. For example, the use of mercury in small-scale
gold rushes in the Amazon basin has led to mercury poisoning
among indigenous peoples who eat fish from polluted waters,
as well as among the miners who lack proper safety equipment
and breathe in mercury fumes. Mercury is linked to impaired
cognitive and neurological development in children – and the
children in a recent sample of the indigenous population in one
section of Peru notorious for illegal mining had mercury levels
three times higher than what is considered safe. In 2013, 140
countries signed the Minamata Convention on Mercury, which
sought to limit mercury use internationally. The treaty prohibits
new mercury mines, mercury-containing batteries and certain
other electrical items – but does not require the banning of
mercury in small-scale gold mining.

It is important to remember that gold rushes aren't a thing
Not every gold rush leads to such awful consequences. In
the so-called Automobile Gold Rush during the Great Depres-
sion of the 1930s, non-professional gold-seekers picked over the
areas that had been depleted during the California Gold Rush
almost a century earlier. The federal government encouraged the
activity, printing booklets advising amateurs on how to build
and operate basic gold-panning equipment and rationalizing
that it was better for people to be roughing it in the wilderness
than waiting on a bread line.[21] However, misery-free rushes are
the exceptions to the rule.

It is important to remember that gold rushes aren't a thing
of the past. As the price of gold continues to rise, the search
for new, untapped goldfields continues. Even small-scale gold
rushes that quickly peter out can cause human and environ-
mental harm. In 2007 a Brazilian math teacher posted on his
website about miners in Apui scooping up handfuls of surface
gold. Within weeks thousands of prospectors arrived and the
boomtown of Eldorado do Juma sprang up, where the bar own-
ers and hardware dealers made more money than the miners.
Some did strike it rich, including one elderly miner who dug up
$19,000 in gold in a little over two weeks. But as in most rushes,

most miners went away discouraged – or contracted malaria, which made a resurgence in the area.[22]

Although mercury is (mostly) outlawed, other chemicals used in industrial mining can wreak havoc on the environment and the people who live there. On 30 January 2000, approximately 100,000 cubic metres of wastewater burst through a dam into the Someş River at the Aurul gold mine in Baia Mare, Romania. The water was contaminated with an estimated 100 tonnes of cyanide, the byproduct of a process called gold cyanidation, which is used to extract gold from low-grade ore. As it travelled more than 3,000 kilometres (1,865 miles) downstream to the Tisza River in Hungary and thence to the Danube and out into the Black Sea, it polluted the drinking water of 2.5 million people and killed more than 1,400 tonnes of fish.

The Aurul mine had been in operation less than a year, but gold mining had been going on for more than 2,000 years – since the time of the Romans – in Baia Mare. But it wasn't until the twentieth century that the area became hopelessly polluted. The World Health Organization reports that some adult residents' lead levels are more than twice as high as what is considered safe, and some children's lead levels are six times as high. The Săsar River, which flows through Baia Mare, had already been known as a 'dead river', with arsenic and lead levels hundreds of times higher than permissible.[23]

These environmental and health issues have plagued the gold-mining industry since its inception, but the adoption of a process known as cyanide heap leaching in the 1960s raised the environmental stakes. In this process a mining company creates a heap of crushed low-grade ore and pours a cyanide solution over it. The cyanide binds to the gold in the ore, making it soluble in water; the water is collected at the bottom of the heap and the gold removed by one of several chemical processes. Extracting enough gold to fashion a single wedding ring can produce as much as 20 tonnes of waste material.

That waste material is stored in ponds, behind dams and in caves and other natural sites. Leaks are distressingly

common. A dam break in Guyana in 1995 sent 2.5 billion litres of cyanide-tainted water into the Essequibo River, the country's primary waterway. A tunnel collapse in the Philippines in 1996 filled a 26-kilometre (16-mile) river with 4 million tonnes of gunk containing cyanide, cadmium, lead and mercury. In Papua New Guinea an American company dumps tailings into a deep trench in the ocean via a pipe – which broke in July 1997. And even when it's not broken, it leaves hundreds of millions of tonnes of waste in the ocean, smothering life around it.[24]

Efforts to ban cyanidation have been largely unsuccessful, although there are exceptions. In 1998 a voter-initiated ban passed in Montana and was upheld by the state supreme court, but voters in several Colorado counties and one South Dakota city, who approved similar measures, were not so lucky, as courts ruled that the measures violate state and federal laws, respectively. Large entities like the European Union declined to ban cyanidation outright, but individual countries such as the Czech Republic and Costa Rica have outlawed it.[25]

So why is gold cyanidation still being used? As dangerous as it is, it's safer than mercury, which had previously been the most common method of extracting gold from ore. It's also the cheapest and most efficient method known thus far. But hope sometimes springs from surprising places, like a test tube in a chemistry lab at Northwestern University in Evanston, Illinois. In 2013 the postdoctoral fellow Zhichang Liu mixed a solution of gold salts with a solution of alpha-cyclodextrin (derived from cornstarch) and was shocked to discover that the process isolated the gold more efficiently and less toxically than cyanide. As of this writing, his team, led by the Scottish chemist Sir Fraser Stoddart, is in the process of developing a practical system for separating gold from scrap alloys safely.[26]

Dangerous gold at the dawn of the twenty-first century

The price of gold has skyrocketed in the past few decades for a few related reasons. Not much new gold enters the market, so

any increase in demand for the limited supply means that the price goes up. In uncertain economic times like the worldwide financial crisis that hit in 2008, investors turn to gold in the belief that it will retain value even if currencies devalue. And the exponential growth in economies like China and India means that more people have more money to invest. India has tried to crack down on gold importation by placing punishingly high import duties on it, but this has just led to an increase in smuggling – leading to recent amusing cases like $1.1 million in gold being discovered in an aeroplane toilet, or the traveller who was caught with 467 grams (16.5 ounces) of gold hidden in brassieres.

Conservative U.S. commentators including Glenn Beck and Sean Hannity have been urging viewers to put their money in gold for the past several years. Beck's investment of choice was antique gold coins sold by Goldline International, which happened to be one of the sponsors of his TV and radio shows. In 2012 the company was ordered by a California court to refund $4.5 million to defrauded customers, who were misled about the relative value of the coins versus bullion.[27]

Playing the gold markets can make investors rich, but it can also backfire. Between 1999 and 2002, British Chancellor of the Exchequer (and later Prime Minister) Gordon Brown infamously auctioned off more than half of Britain's gold reserves when gold was at a historic low. When the price shot up, it left Brown open to charges that he had 'lost' Britain billions of pounds. It's easy to criticize Brown in hindsight, as the gold he sold *is* now worth billions more than it was when he sold it. But the situation is more complicated than that. The securities Britain invested in with the proceeds of the sale are worth a great deal today, albeit less than the gold would have been. There are rumours that Brown did it to stave off a bank failure, and it's possible to argue that he did the right thing – Alan Beattie of the *Financial Times* writes, 'Let speculators go gambling on a shiny metal, if they want to. For most governments in rich countries, holding gold remains a largely pointless activity.' He argues that expecting governments to play the market,

especially one as volatile as the gold market, is foolish. The debate will likely continue to rage.[28]

The increase in demand for gold has real consequences. These are evident in three regions that help us understand the human and environmental cost of the lust for gold in the twenty-first century: Peru, Papua New Guinea and the Democratic Republic of Congo.

A gold rush has been underway since 2000 in the Madre de Dios region of Peru, and illegal gold mining has destroyed more than 40,000 hectares of Amazon forest. There are an estimated 30,000 illegal miners in the region; most of them came because mining or providing services to miners is the only way they can make enough to feed their families. A u.s.-based research group reported incidences of forced labour, child labour, disregard for workers' health and safety, and sex trafficking of young girls forced into prostitution.[29]

The Porgera gold mine in Papua New Guinea dumps 6 million tons of waste a year into the Porgera River, sending heavy metals downstream in quantities that would be illegal in more developed countries. More than 50,000 people have flocked to the area since the mine opened in 1990, most of them to pick through the mine's tailings. For years, local residents have charged that mine security personnel have killed and physically abused these 'illegal' miners.

The Canadian mining giant Barrick Gold bought the mine in 2006, but little changed. Human Rights Watch charges Barrick's security forces with widespread abuses including frequent gang rapes of illegal miners, charges corroborated by research teams from Harvard University, New York University and the United Nations. Tellingly, even after the Harvard/NYU team presented similar findings to the Canadian government, in October 2010, under intense pressure from Canadian gold mining companies, the House of Commons failed to pass a law that would have required a modest level of monitoring of the overseas human rights records of Canadian companies. Although Barrick took steps to rein in the abuse, riots broke out as recently as December 2013 after private security forces and government police killed four local residents.[30]

Conditions in the Democratic Republic of Congo (DRC) are even worse. Three and a half million people died through violence, exposure, hunger and lack of medical assistance in the Second Congo War of 1998, in which Rwandan and Ugandan forces fought the Congolese dictator they had installed in 1996. After a series of treaties in 2002 ended most of the fighting, violent conflict persisted in the northeastern Ituri region, home to one of the world's richest goldfields. Large-scale massacres were common, and the BBC estimates that between 1998 and 2006 more than 60,000 people died violently in Ituri alone.

The conflict wasn't just fuelled by local rivalries. Multinational corporations seeking the rich gold deposits negotiated with armed groups with records of war crimes and human rights abuses: the corporations provided financial and logistical support for the militias, and the militias provided access to the gold. This set the stage for a pipeline of 'conflict gold' from the war-torn area, which funnels millions of dollars' worth of Congolese gold through Uganda to European refineries. These European companies choose to look the other way, ignoring the fact that their refusal to investigate the source of the gold means that war criminals can continue to exploit the people of the DRC.[31]

Wealthy nations are taking steps to reduce the amount of harm that gold mining causes. In 2013 Swiss authorities launched a criminal probe of Swiss refiner Argor-Heraeus, charging that in 2004 and 2005, the company had processed three tons of ore that came from armed groups in the DRC. In the U.S. the Dodd-Frank Wall Street Reform and Consumer Protection Act of 2010 requires companies to publicly disclose any use of conflict minerals from the DRC or adjoining countries, imposing a deadline of 2016 for companies to conduct a thorough independent inspection of their supply chain for conflict minerals. Mining companies can subscribe to the Voluntary Principles on Security and Human Rights, an initiative by governments, non-governmental organizations and industry to guide extractive companies on how to maintain the safety of their operations, observe human rights and respect fundamental freedoms.

Protestors outside Barrick's annual general meeting, Toronto, 2008.

Since 2005 more than 400 jewellery companies have pledged not to buy gold from companies with poor environmental and human rights records after pressure from activist groups including Earthworks and Oxfam. Members of this voluntary Responsible Jewellery Council vow to track where their gold comes from. But because it's voluntary, there's no enforcement if companies fail to comply, and critics charge that compliance is minimal.

Public opinion might be the most effective tool in getting companies to take more responsibility for where they get their gold. The global consulting firm PricewaterhouseCoopers surveyed almost 700 companies about their efforts to comply with the new Dodd-Frank rules in July 2013. A large portion of the companies stated that they were concerned about negative consequences on their revenues – through loss of customers, boycotts and harm to their brand's reputation – if they failed to comply.[32]

However, none of these efforts by industry associations, governments and non-governmental organizations get at the

heart of the problem – gold mining is inherently bad for the environment and the people doing the mining, and as long as some people are willing to pay premium prices for gold, other people will do the dirty work of digging up more of it.

We opened this book with a chapter on humanity's first use of gold – wearing it. Even after millennia of our inter-action with gold, and all the uses that we've found for it, the vast majority of the gold mined each year goes to ornament; indeed, some estimates suggest that all the gold required for industry could come from recycling unwanted jewellery and defunct electronics. Thus it is our continuing desire to wear gold that leads to essentially the entire environmental and human price. As Stephanie Boyd wrote in her *New Yorker* profile of Madre de Dios, 'If the real cost of gold is environmental destruction, teen-age prostitution, and forced labor, maybe the gold wedding band isn't such a great symbol of love and trust.'[33]

REFERENCES

Introduction: In Search of Gold

1 Erin Wayman, 'Gold Seen in Neutron Star Debris', *Science News*, CLXXXIV/4 (24 August 2013), p. 8.

2 Anne Wootton, 'Earth's Inner Fort Knox', *Discover*, XXVII/9, p. 18.

3 Frank Reith et al., 'Biomineralization of Gold: Biofilms on Bacterioform Gold', *Science* New Series, CCCXIII/5784 (14 July 2006), pp. 233–6; Chad W. Johnston et al., 'Gold Biomineralization by a Metallophore from a Gold-associated Microbe', *Nature Chemical Biology*, IX/4 (2013), pp. 241–3.

4 Máirín Ní Cheallaigh , 'Mechanisms of Monument-destruction in Nineteenth-century Ireland: Antiquarian Horror, Cromwell and Gold-dreaming', *Proceedings of the Royal Irish Academy. Section c: Archaeology, Celtic Studies, History, Linguistics, Literature*, CVIIC (2007), pp. 127–45; Frank Thone, 'Nature Ramblings: The Gold Rush', *Science News-Letter*, XLIII/10 (6 March 1943), p. 157.

5 *Thomson Reuters GFMS Gold Survey* (2014), p. 53, available at https://forms.thomsonreuters.com/gfms/

6 Strabo, *Geography*, trans. Howard Leonard Jones (Cambridge, MA, 1924), II.2.19.

7 Otar Lordkipanidze, 'The Golden Fleece: Myth, Euhemeristic Explanation and Archaeology,' *Oxford Journal of Archaeology*, XX/1 (2001), pp. 1–38.

8 Juan Rodriguez Freyle, *El Carnero: conquista y descubrimiento de el Nuevo Reino de Granada* (1638), vol. I, p. 21.

9 Walter Raleigh, *The Discovery of Guiana* (1596).

10 Joyce Lorimer, 'Introduction' to *Sir Walter Ralegh's Discoverie of Guiana* (Aldershot, 2006), p. lii.

11 Francisco Vazquez de Coronado, *The Journey of Coronado*, ed. and trans. George Parker Winship (New York, 1904), p. 174.

12 Timothy Lim, *The Dead Sea Scrolls: A Very Short Introduction* (Oxford, 2005).

13 James A. Harrell and V. Max Brown, 'The World's Oldest Surviving

Geological Map: The 1150 BC Turin Papyrus from Egypt', *Journal of Geology*, C/I (January 1992), pp. 3–18.

14 Yvonne J. Markowitz, 'Nubian Adornment', in *Ancient Nubia: African Kingdoms on the Nile*, ed. Marjorie M. Fisher (Cairo, 2012), pp. 186–99, 193.

15 John W. Blake, *West Africa: Quest for God and Gold, 1454–1578* (London, 1937/1977).

16 Quoted in Malyn Newlitt, *A History of Portuguese Overseas Expansion, 1400–1668* (London, 2004), p. 27.

17 Herbert M. Cole and Doran H. Ross, *The Arts of Ghana*, exh. cat., Frederick S. Wight Gallery at the University of California, Los Angeles (1977), p. 134.

18 P. E. Russell, *Prince Henry 'the Navigator': A Life* (New Haven, CT, 2001).

19 Herodotus, *Histories* 3.23.4, trans. George Rawlinson (London, 1859).

1 Wearable Gold

1 Jan Wisseman Christie, 'Money and Its Uses in the Javanese States of the Ninth to Fifteenth Centuries AD', *Journal of the Economic and Social History of the Orient*, XXXIX/3 (1996), pp. 243–86, 249.

2 Ivan Ivanov, *The Birth of European Civilization* (Sofia, 1992). The Copper Age, a fluid designation generally associated with the fifth millennium BCE, was an early stage of the Bronze Age during which copper smelting was practised but without alloying copper with tin to make the more durable bronze. Gold mining generally followed copper mining and goldsmithing generally followed coppersmithing.

3 *Thomson Reuters GFMS Gold Survey* (2014), p. 53, https://forms. thomsonreuters.com/gfms, p. 8.

4 Colin Renfrew, 'Varna and the Social Context of Early Metallurgy', *Antiquity*, LII (1978), pp. 199–203.

5 Ivan Ivanov and Maya Avramova, *Varna Necropolis: The Dawn of European Civilization* (Sofia, 2000), pp. 46–50.

6 Hans Wolfgang Müller and Eberhard Thiem, *Gold of the Pharaohs* (Cornell, NY, 1999), p. 60.

7 'Behind the Mask of Agamemnon', *Archaeology*, LII/4 (July/August 1999), pp. 51–9.

8 Bernabé Cobo, *Inca Religion and Customs*, trans. and ed. Roland Hamilton (Austin, TX, 1990), p. 250.

9 Ralph E. Giese, *The Royal Funeral Ceremony in Renaissance France* (Geneva, 1960), p. 33.

10 *Epic of Gilgamesh*, Tablet VIII, column ii.

11 André Emmerich, *Sweat of the Sun and Tears of the Moon: Gold and Silver in Pre-Columbian Art* (Seattle, WA, 1965), p. xxi.

12 Ibid., p. 128.
13 Pliny the Elder, *Natural History*, trans. H. Rackham (Cambridge, MA, 1924), 33.8, available at https://archive.org.
14 Tertullian, *Apologeticus*, trans. Jeremy Collier (London, 1889), 6, available at www.tertullian.org.
15 Clara Estow, 'The Politics of Gold in Fourteenth Century Castile', *Mediterranean Studies*, VIII (North Dartmouth, MA, 1999), pp. 129–42.
16 Oviedo, *Historia general y natural de los Indios* (Madrid, 1853), p. 118.
17 Rebecca Zorach, *Blood, Milk, Ink, Gold: Abundance and Excess in the French Renaissance* (Chicago, IL, 2005), p. 118.
18 Joycelyne G. Russell, *The Field of the Cloth of Gold: Men and Manners in 1520* (London, 1969).
19 Xinru Liu, *Silk and Religion: An Exploration of Material Life and the Thought of People, AD 600–1200* (Oxford, 1998), p. 21.
20 Procopius, *History of the Wars,* VIII.xvii:1–7.
21 See for example *Lettres patentes de declaration du roy, pour la reformation du luxe . . .* (Rouen, 1634).
22 See N. B. Harte, 'State Control of Dress and Social Change in Pre-Industrial England', in *Trade, Government and Economy in Pre-Industrial England*, ed. D. C. Coleman and A. H. John (London, 1976), pp. 132–65.
23 Michel de Montaigne, *Essais*, trans. Charles Cotton (London, 1870), p. 183.
24 Martin du Bellay, *Mémoires de Martin du Bellay* (Paris, 1569), p. 16.
25 John Fisher, *Here After Ensueth Two Fruytfull Sermons . . .* (London, 1532), f. B2r.
26 On the development of modern gold cloth, see J.P.P. Higgins, *Cloth of Gold: A History of Metallised Textiles* (London, 1993).
27 Marcel Proust, *A La Recherche du temps perdu* (Paris, 1987–9), vol. III, pp. 895–6.
28 Deborah Nadoolman Landis, *Dressed: A Century of Hollywood Costume Design* (New York, 2007), p. 244.
29 See Krista Thompson, 'The Sound of Light: Reflections on Art History in the Visual Culture of Hip-hop', *Art Bulletin*, XCI/4 (December 2009), pp. 481–505.

2 Gold, Religion and Power

1 Thanapol (Lamduan) Chadchaidee, *Thailand in my Youth* (Bangkok, 2003), pp. 59–68.
2 David Lorton, trans., *The Gods of Egypt* (Ithaca, NY, 2001), p. 44; Sydney Hervé Aufrère, *L'Univers minéral dans la pensée egyptienne* (Cairo, 2001), vol. II, p. 380.

3 David Gordon White, *The Alchemical Body* (Chicago, IL, 1996), pp. 189–91.

4 Adam Herring, 'Shimmering Foundation: The Twelve-angled Stone of Inca Cusco', *Critical Inquiry*, XXXVII/1 (Autumn 2010), pp. 60–105, p. 97; Gordon McEwan, *The Incas: New Perspectives* (New York, 2008), p. 156.

5 Herodotus, *History*, IV. See also Michael L. Walter, *Buddhism and Empire* (Leiden, Boston and Tokyo, 2009), pp. 287–91.

6 V. N. Basilov, *Nomads of Eurasia*, exh. cat. (Natural History Museum of Los Angeles County, 1989).

7 A. Kyerematen, 'The Royal Stools of Ashanti', *Africa: Journal of the International African Institute*, XXXIX/1 (January 1969), pp. 1–10, 3–4.

8 Dominic Janes, *God and Gold in Late Antiquity* (Cambridge, 1998), pp. 55–60.

9 Ibid., pp. 110–12.

10 Ibid., pp. 74–5.

11 St Jerome, Letter XXII.

12 Alain George, *The Rise of Islamic Calligraphy* (London, 2010), p. 91.

13 Ibid., pp. 74–5.

14 Christopher De Hamel, *The British Library Guide to Manuscript Illumination: History and Techniques* (Toronto, 2001), pp. 69–70.

15 Peter T. Struck, *Birth of the Symbol: Ancient Readers at the Limits of their Texts* (Princeton, NJ, 2009), p. 231.

16 Erwin Panofsky, trans., *Abbot Suger on the Abbey Church of St Denis and its Art Treasures* (Princeton, NJ, 1946), pp. 101, 107.

17 Susan Solway, 'Ancient Numismatics and Medieval Art: The Numismatic Sources of Some Medieval Imagery', PhD dissertation, Northwestern University, Evanston, Illinois (1981), pp. 70–71.

18 Thiofrid of Echternach, *Flores epytaphii sanctorum*, quoted in Martina Bagnoli, 'The Stuff of Heaven: Materials and Craftsmanship in Medieval Reliquaries', in *Treasures of Heaven: Saints, Relics and Devotion in Medieval Europe*, ed. Martina Bagnoli (London, 2011), pp. 137–47 (p. 137).

19 Cynthia Hahn, 'The Spectacle of the Charismatic Body: Patrons, Artists, and Body-part Reliquaries', in *Treasures*, ed. Bagnoli, p. 170.

20 Pamela Sheingorn, ed. and trans., *The Book of Sainte Foy* (Philadelphia, PA, 1995), p. 78.

21 Erik Thunø, 'The Golden Altar of Sant'Ambrogio in Milan', in *Decorating the Lord's Table: On the Dynamics Between Image and Altar in the Middle Ages*, ed. Søren Kaspersen and Erik Thunø (Copenhagen, 2006), pp. 63–78, 67.

22 Ibid., p. 70.

23 Ibid.

24 Yi-t'ung Wang, trans., *The Record of Buddhist Monasteries in Lo-Yang* (Princeton, NJ, 1984), pp. 16, 20–21.

25 Richard H. Davis, ed., *Images, Miracles, and Authority in Asian Religious Traditions* (Boulder, CO, 1998), p. 25.

26 John Kieschnick, *The Impact of Buddhism on Chinese Material Culture* (Princeton, NJ, 2003), p. 108.

27 Ibid., p. 12.

28 Eric Robert Reinders, 'Buddhist Rituals of Obeisance and the Contestation of the Monk's Body in Medieval China', PhD dissertation, University of California at Santa Barbara (1997), p. 65.

29 Apinan Poshyananda, *Montien Boonma: Temple of the Mind* (New York, 2003), p. 35.

3 Gold as Money

1 Herodotus, *Histories,* trans. A. D. Godfrey (Cambridge MA, 1920), 1.29–45, 1.85–9, available at www.perseus.tufts.edu; Archilochus, fragment 14.

2 Andrew Ramage and Paul Craddock, *King Croesus' Gold: Excavations at Sardis and the History of Gold Refining* (Cambridge, MA, 2000).

3 Homer, *The Iliad*, trans. Richmond Lattimore (Chicago, IL, 1951), 6.234–6.

4 Lady Charlotte Guest, *The Mabinogion* (London, 1838–49).

5 Sitta von Reden, *Money in Ptolemaic Egypt: From the Macedonian Conquest to the End of the Third Century BC* (Cambridge, 2007).

6 Aristophanes, *The Frogs*, trans. David Barrett (New York, 1964), pp. 19–24.

7 *The Monetary Systems of the Greeks and Romans,* ed. W. V. Harris (Oxford, 2008).

8 Cited in Homer Dubs, 'An Ancient Chinese Stock of Gold', *Journal of Economic History*, XX/1 (May 1942), pp. 36–9.

9 Ban Gu, *The History of the Former Han Dynasty*, trans. Homer Dubs, vol. III (Baltimore, MD, 1955), chapter 99, p. 458.

10 Homer Dubs, 'Wang Mang and His Economic Reforms', *T'oung Pao* (second series), XXXV/4 (1940), pp. 219–65.

11 Ban Gu, *The History of the Former Han Dynasty*, vol. III, chapter 99, p. 437.

12 Quoted in Joseph Needham and Lu Gwei-Djen, *Science and Civilisation in China* (Cambridge, 1974), vol. V, part 2, p. 259.

13 China Institute Gallery, New York, *Providing for the Afterlife: 'Brilliant Artifacts' from Shandong*, exh. cat. (2005).

14 Ban Gu, *The History of the Former Han Dynasty*, quoted in Robert Wicks, *Money, Markets, and Trade in Early Southeast Asia: The*

Development of Indigenous Monetary Systems to AD 1400 (Ithaca, NY, 1992), p. 22.

15 Wicks, *Money, Markets, and Trade in Early Southeast Asia*, p. 25.

16 Steven Bryan, *The Gold Standard at the Turn of the Twentieth Century: Rising Powers, Global Money, and the Age of Empire* (New York, 2010).

17 Ibid., p. 45.

18 Glyn Davies, *A History of Money: From Ancient Times to the Present Day* (Cardiff, 2002), p. 376.

19 Quoted in ibid., p. 380.

20 Davies, *A History of Money*, p. 516.

21 Ibid., p. 523.

22 Bradley A. Hansen, 'The Fable of the Allegory: The Wizard of Oz in Economics', *Journal of Economic Education*, XXXIII/3 (Summer 2002), pp. 254–64.

23 David Tripp, *Illegal Tender: Gold, Greed, and the Mystery of the Lost 1933 Double Eagle* (New York, 2013).

24 Susanna Kim, 'Judge Says 10 Rare Gold Coins Worth $80 Million Belong to Uncle Sam', *ABC News* (online), 6 September 2012, http://abcnews.go.com.

4 Gold as a Medium of Art

1 'China, §XIII, 20: Paper', *Grove Dictionary of Art*.

2 Francis Augustus MacNutt, *De Orbe Novo: The Eight Decades of Peter Martyr D'Anghera* (New York and London, 1912), vol. I, p. 220.

3 Antonio Averlino (Filarete), *Treatise on Architecture,* trans. John R. Spencer (New Haven, CT, and London, 1965), p. 320 (187r). Cited in Luke Syson and Dora Thornton, *Objects of Virtue* (Los Angeles, CA, 2001), p. 89.

4 Thomas Sturge Moore, *Albert Durer* (London and New York, 1905), p. 147.

5 Joel W. Grossman, 'An Ancient Gold Worker's Tool Kit: The Earliest Metal Technology in Peru', *Archaeology*, XXV/4 (1972), pp. 270–75.

6 Heather Lechtman, 'Andean Value Systems and the Development of Prehistoric Metallurgy', *Technology and Culture*, XXV/1 (January 1984), pp. 1–36.

7 Richard L. Burger, 'Chavín', in *Andean Art at Dumbarton Oaks*, ed. Elizabeth Hill Boone (Washington, DC, 1996), pp. 45–86, 50, 67–70.

8 André Emmerich, *Sweat of the Sun and Tears of the Moon: Gold and Silver in Pre-Columbian Art* (Seattle, WA, 1965), p. xix. See also M. Noguez et al., 'About the Pre-Hispanic Au-Pt "Sintering" Technique for Making Alloys', *Journal of the Minerals, Metals and*

Materials Society, V/5 (2006), pp. 38–43.

9 Heather Lechtman, 'The Inka, and Andean Metallurgical Tradition', in *Variations in the Expression of Inka Power*, ed. R. Matos, R. Burger and C. Morris (Washington, DC, 2007) pp. 314–15.

10 Ibid., pp. 322–3.

11 Lechtman, 'Andean Value Systems', p. 32.

12 Lechtman, 'The Inka', pp. 319–20.

13 Ibid., p. 313.

14 Pedro de Cieza de León, *The Second Part of the Chronicle of Peru*, ed. Sir Clements Robert Markham (London, 1883), pp. 85–6.

15 Adam Herring, 'Shimmering Foundation: The Twelve-angled Stone of Inca Cusco', *Critical Inquiry*, XXXVII/1 (Chicago, IL, 2010), p. 89.

16 María Alicia Uribe Villegas and Marcos Martinón Torres, 'Composition, Colour and Context in Muisca Votive Metalwork (Colombia, AD 600–1800)', *Antiquity*, LXXXVI (2012), pp. 772–91, p. 777.

17 Dorothy Hosler, 'West Mexican Metallurgy: Revisited and Revised', *Journal of World Prehistory*, XXII/3 (2009), pp. 185–212.

18 Emmerich, *Sweat of the Sun*, p. xx, citing F. T. de Benavete Motolinía, *Historia de los Indios de la Nueva España*, Colección de documentos para la historia de México, vol. I (Mexico City, 1858), vol. I, ch. xiii.

19 Hernán Cortés, *Despatches of Hernando Cortés, the Conqueror of Mexico, Addressed to the Emperor Charles V*, trans. and ed. George Folsom (New York, 1843), p. 10.

20 Christian F. Feest, 'The Collecting of American Indian Artifacts in Europe, 1493–1750', in *America in European Consciousness, 1493–1750*, ed. Karen Ordahl Kupperman (Williamsburg, VA, 1995), pp. 324–60.

21 John Cherry, *Goldsmiths* (Toronto, 1992), pp. 68–9.

22 Martina Bagnoli, 'The Stuff of Heaven: Materials and Craftmanship in Medieval Reliquaries', in *Treasures of Heaven: Saints, Relics and Devotion in Medieval Europe*, ed. Martina Bagnoli (London, 2011), p. 138.

23 R. W. Lightbown, 'Ex-votos in Gold and Silver: A Forgotten Art', *Burlington Magazine*, CXXI/915 (1979), pp. 352–7, 359, 353. Canonico Pietro Paolo Raffaelli, '*Brevissima indicatio potius quam descriptio donorum quibus alma domus olim Nazarena, nunc lauretana deiparae virginis decoratur*', in *Lauretanae historiae libri quinque*, ed. Orazio Torsellini (Venice, 1727), p. 387.

24 Emmerich, *Sweat of the Sun*, p. xxi, citing E. G. Squier, 'More about the Gold Discoveries of the Isthmus', *Harper's Weekly*, 20 August 1859.

25 Syson and Thornton, *Objects of Virtue*, pp. 102–8.

26 Giorgio Vasari, *The Lives of the Most Excellent Painters, Sculptors, and Architects*, trans. Gaston du C. de Vere (New York, 2007), p. 187.

27 Jeffrey Chipps Smith, *Art of the Goldsmith in Late Fifteenth-century Germany* (New Haven, CT, 2006), p. 25.

28 Ibid., p. 27.

29 Jaroslav Folda, 'Sacred Objects with Holy Light: Byzantine Icons with Chrysography', in *Byzantine Religious Culture: Studies in Honor of Alice-Mary Talbot*, ed. Denis Sullivan, Elizabeth Fisher and Stratis Papaioannou (Leiden, 2012), p. 155.

30 See Irma Passeri, 'Gold Coins and Gold Leaf in Early Italian Paintings', in *The Matter of Art*, ed. Christy Anderson, Anne Dunlop and Pamela Smith (Manchester, 2015), pp. 97–115.

31 Leon Battista Alberti, *On Painting*, trans. John Spencer (New Haven, CT, 1966), p. 85.

32 Julia Bryan Wilson, *Art Workers: Radical Practice in the Vietnam War Era* (Berkeley, CA, 2009), pp. 65–6.

33 Lisa Gralnick, *Lisa Gralnick, The Gold Standard*, exh. cat., Bellevue Arts Museum, Bellevue, Washington (2010).

34 Sarah Lowndes, 'Learned By Heart: The Paintings of Richard Wright', in *Richard Wright*, exh. cat., Gagosian Gallery, London (New York, 2010), p. 59.

35 Richard Wright, 'Artist Richard Wright on How He Draws', www.theguardian.com, 19 September 2009.

5 From Alchemy to Outer Space: Gold in Science

1 Mark S. Morrisson, *Modern Alchemy: Occultism and the Emergence of Atomic Theory* (Oxford, 2007).

2 Francis Bacon, *The Two Bookes of the Proficience and Advancement of Learning Divine and Humane* (Oxford, 1605), 22v.

3 Theophilus, *On Divers Arts*, trans. John G. Hawthorne and Cyril Stanley Smith (Mineola, NY, 2012), pp. 36–8.

4 See Lynn Thorndike, *A History of Magic and Experimental Science* (1958), vol. I, p. 194, and Jack Lindsay, *Origins of Alchemy in Graeco-Roman Egypt* (London, 1970), p. 54.

5 M. Berthelot, *Introduction à l'étude de la chimie des anciens et du Moyen Âge* (Paris, 1899), p. 20.

6 Lindsay, *Origins of Alchemy in Graeco-Roman Egypt*, pp. 60–61.

7 Stanton J. Linden, ed., *The Alchemy Reader: from Hermes Trismegistus to Isaac Newton* (New York, 2003), p. 22.

8 Sydney Hervé Aufrère, *L'Univers minéral dans la pensée egyptienne* (Cairo, 2001), pp. 377–9, 389–91.

9 Nathan Sivin, *Chinese Alchemy: Preliminary Studies* (Cambridge, MA, 1968), pp. 151–8.

10 James Ware, *Alchemy, Medicine and Religion in the China of AD 320: The 'Nei Pien' of Ko Hung* (Mineola, NY, 1981), p. 74.

11 Joseph Needham and Lu Gwei-Djen, *Science and Civilization in China* (Cambridge, 1974), vol. V, part 2, section 33, part 1, pp. 115–20.

12 Sivin, *Chinese Alchemy*, p. 25. Needham and Lu, *Science and Civilization in China*, p. 13.

13 Ibid., pp. 12–13.

14 Ware, *Alchemy, Medicine and Religion in the China of AD 320*, pp. 267–8; Needham and Lu, *Science and Civilization in China*, pp. 68–71.

15 Ware, *Alchemy, Medicine and Religion in the China of AD 320*, p. 50.

16 Fabrizio Pregadio, *Great Clarity: Daoism and Alchemy in Early Medieval China* (Stanford, CA, 2006), p. 125.

17 Ku Yung, 'History of the Former Han', in *Doctors, Diviners, and Magicians of Ancient China*, ed. and trans. Kenneth J. DeWoskin (New York, 1983), p. 38.

18 Philippe Charlier et al., 'A Gold Elixir of Youth in the 16th Century French Court', *British Medical Journal*, 339 (16 December 2009).

19 Frank E. Grizzard, *George Washington: A Biographical Companion* (Santa Barbara, CA, 2002), p. 105.

20 See Paul Elliott, 'Abraham Bennet, FRS (1749–1799): A Provincial Electrician in Eighteenth-century England', *Notes and Records of the Royal Society of London*, LIII/1 (January 1999), pp. 59–78.

21 Michael Riordan and Lillian Hoddeson, *Crystal Fire: The Invention of the Transistor and the Birth of the Information Age* (New York, 1998), pp. 1–6, 132–42.

22 Hernán Cortés, *Letters from Mexico*, trans. Anthony Pagden (New Haven, CT, 2001), p. 29.

23 Francisco López de Gómara, *La Conquista de México*, ed. José Luis Rojas (Madrid, 1987), p. 187, cited in Hugh Thomas, *The Conquest of Mexico* (London, 1993), p. 178.

24 A. G. Debus, 'Becher, Johann Joachim', in *Dictionary of Scientific Biography*, ed. C. C. Gillispie, vol. I (New York, 1970), pp. 548–51.

25 'American Swindler in London: One of the Rothschilds Said to have been a Victim', *New York Times*, 13 May 1891.

26 Brett J. Stubbs, '"Sunbeams from Cucumbers": An Early Twentieth-century Gold-from-seawater Extraction Scheme in Northern New South Wales', *Australasian Historical Archaeology*, XXVI (2008), pp. 5–12.

27 'What Would Result if Gold were Made?', *New York Times*, 6 October 1912.

6 Dangerous Gold

1 Clifford E. Trafzer and Joel R. Hyer, eds, *Exterminate Them: Written Accounts of the Murder, Rape, and Slavery of Native Americans during the California Gold Rush, 1848–1868* (Lansing, MI, 1999), p. ix.
2 Ovid, *Metamorphoses*, IV:604–62.
3 Firuza Abdullaeva, 'Kingly Flight: Nimrūd, Kay Kāvus, Alexander, or Why the Angel Has the Fish', *Persica*, 23 (2010), pp. 1–29.
4 Curt Gentry, *The Killer Mountains: A Search for the Legendary Lost Dutchman Mine* (New York, 1968).
5 Sam Ro, 'Bre-x: Inside the $6 Billion Gold Fraud that Shocked the Mining Industry,' *Business Insider* (online), 3 October 2014, www.businessinsider.com.
6 Michael Robbins, 'The Great South-eastern Bullion Robbery', *Railway Magazine*, CI/649 (May 1955), pp. 315–17.
7 BBC News, 'Brinks Mat Gold: The Unsolved Mystery', 15 April 2000, http://news.bbc.co.uk.
8 Matt Roper, 'Fool's Gold: The Curse of the Brink's-Mat Gold Bullion Robbery', *Mirror*, 12 May 2012, www.mirror.co.uk.
9 U.S. Bureau of Labor Statistics, 2010–11 Career Guide to Industries, available at bls.gov.
10 Diodorus Siculus, *Bibliotheca historica*, trans. C. H. Oldfather (Cambridge, MA, 1935), 5.38.
11 Bill Nasson, *The War for South Africa: The Anglo-Boer War, 1899–1902* (Cape Town, 2010).
12 Gary Kynoch, '"Your Petitioners Are in Mortal Terror": The Violent World of Chinese Mineworkers in South Africa, 1904–1910', *Journal of South African Studies*, XXXI/3 (September 2005), pp. 531–46.
13 Kevin Starr, *California: A History* (New York, 2005).
14 Quoted in Sucheng Chan, 'A People of Exceptional Character: Ethnic Diversity, Nativism, and Racism in the California Gold Rush', *California History*, LXXIX/2 (2000), pp. 44–85.
15 Trafzer and Hyer, eds, *Exterminate Them*.
16 Robert Hine and John Faragher, *The American West: A New Interpretive History* (New Haven, CT, 2000), p. 249.
17 David Goodman, *Gold Seeking: Victoria and California in the 1850s* (Stanford, CA, 1994).
18 Michael Magliari, 'Free State Slavery: Bound Indian Labor and Slave Trafficking in California's Sacramento Valley, 1850–1864', *Pacific Historical Review*, LXXXI/2 (May 2012), pp. 155–92.
19 The Sioux never accepted U.S. ownership of the Black Hills, though, and in 1980 the U.S. Supreme Court found that the U.S. government had violated the terms of the Fort Laramie Treaty and failed to pay the Sioux for the land. The bill, factoring in 100 years of interest,

came to more than $100 million. The Sioux refused to accept the
award and demanded the return of their land. The award remains
in a Bureau of Indian Affairs account, accruing compound interest,
and as of 2010 it was worth $570 million.

20 Vivian Schueler, Tobias Kuemmerle and Hilmar Schröder, 'Impacts
of Surface Gold Mining on Land Use Systems in Western Ghana',
Ambio, XL/5 (July 2011), pp. 528–39.

21 Charles Wallace Miller, *The Automobile Gold Rushes and Depression
Era Mining* (Moscow, ID, 1998).

22 Tom Phillips, 'Brazilian Goldminers Flock to "New Eldorado"',
The Guardian (online), 11 January 2007, www.theguardian.com.

23 United Nations Environmental Programme, 'The Cyanide Spill at
Baia Mare, Romania: Before, During, After' (Szentendre, 2000).

24 Scott Fields, 'Tarnishing the Earth: Gold Mining's Dirty Secret',
Environmental Health Perspectives, CIX/10 (October 2001): A474–
A481.

25 Jan Laitos, 'The Current Status of Cyanide Regulations',
Engineering and Mining Journal, 24 February 2012, www.e-mj.com.

26 James Urquhart, 'Sugar Solution to Toxic Gold Recovery',
Chemistry World (online), 15 May 2013, www.rsc.org.

27 *Coinweek* (online), 'Goldline International Placed Under
Injunction, Ordered to Change Sales Practices', 22 February 2012,
www.coinweek.com.

28 For an explanation of the theory that Brown was preventing
the failure of a major bank, see Thomas Pascoe, 'Revealed: Why
Gordon Brown Sold Britain's Gold at a Knock-down Price', *The
Telegraph* (online), 5 July 2012, http://blogs.telegraph.co.uk. For a
defence of Brown's sale, see Alan Beattie, 'Britain Was Right to Sell
Off Its Pile of Gold', *Financial Times* (online), 4 May 2011,
www.ft.com.

29 Stephanie Boyd, 'Who's to Blame for Peru's Gold-mining
Troubles?', *New Yorker* (online), 28 October 2013, www.newyorker.
com.

30 Human Rights Watch, *Gold's Costly Dividend: Human Rights
Impacts of Papua New Guinea's Porgera Gold Mine* (Human Rights
Watch, 2011), available at www.hrw.org.

31 Human Rights Watch, *The Curse of Gold: Democratic Republic of
Congo* (Human Rights Watch, 2005), available at www.hrw.org.

32 PricewaterhouseCoopers, 'Dodd-Frank Section 1502: Conflict
Minerals', accessed 8 October 2015.

33 Boyd, 'Who's to Blame for Peru's Gold-mining Troubles?'

SELECT BIBLIOGRAPHY

Bagnoli, Martina, ed., *Treasures of Heaven: Saints, Relics and Devotion in Medieval Europe* (London, 2011)

Basilov, V. N., *Nomads of Eurasia* (Seattle, WA, 1989)

'Behind the Mask of Agamemnon', *Archaeology*, LII/4 (July/August 1999), pp. 51–9

Blake, John W., *West Africa: Quest for God and Gold, 1454–1578* (London, 1937/1977)

Boyd, Stephanie, 'Who's to Blame for Peru's Gold-mining Troubles?', *New Yorker*, 28 October 2013

Bryan, Steven, *The Gold Standard at the Turn of the Twentieth Century: Rising Powers, Global Money, and the Age of Empire* (New York, 2010)

Cherry, John, *Goldsmiths* (Toronto, 1992)

Cole, Herbert M., and Doran H. Ross, *The Arts of Ghana*, exh. cat., Frederick S. Wight Gallery at the University of California, Los Angeles (1977)

Craddock, Paul, *Early Metal Mining and Production* (Washington, DC, 1995)

Davies, Glyn, *A History of Money: From Ancient Times to the Present Day* (Cardiff, 2002)

De Hamel, Christopher, *The British Library Guide to Manuscript Illumination: History and Techniques* (Toronto, 2001)

Emmerich, André, *Sweat of the Sun and Tears of the Moon: Gold and Silver in Pre-Columbian Art* (Seattle, WA, 1965)

Fields, Scott, 'Tarnishing the Earth: Gold Mining's Dirty Secret', *Environmental Health Perspectives*, CIX/10 (October 2001), pp. A474–A481

Gentry, Curt, *The Killer Mountains: A Search for the Legendary Lost Dutchman Mine* (New York, 1968)

George, Alain, *The Rise of Islamic Calligraphy* (London, 2010)

Goodman, David, *Gold Seeking: Victoria and California in the 1850s* (Stanford, CA, 1994)

Gralnick, Lisa, *Lisa Gralnick, The Gold Standard*, exh. cat., Bellevue Arts
 Museum, Bellevue, Washington (2010)
Grossman, Joel W., 'An Ancient Gold Worker's Tool Kit: The Earliest
 Metal Technology in Peru', *Archaeology*, xxv/4 (1972), pp. 270–75
Harris, W. V., ed., *The Monetary Systems of the Greeks and Romans*
 (Oxford, 2008)
Higgins, J.P.P., *Cloth of Gold: A History of Metallised Textiles* (London,
 1993)
Human Rights Watch, *The Curse of Gold: Democratic Republic of Congo*
 (New York, 2005)
——, *Gold's Costly Dividend: Human Rights Impacts of Papua New
 Guinea's Porgera Gold Mine* (New York, 2011)
Ivanov, Ivan, and Maya Avramova, *Varna Necropolis: The Dawn of
 European Civilization* (Sofia, 2000)
Janes, Dominic, *God and Gold in Late Antiquity* (Cambridge, 1998)
Kaspersen, Søren, and Erik Thunø, eds, *Decorating the Lord's Table:
 On the Dynamics Between Image and Altar in the Middle Ages*,
 (Copenhagen, 2006)
Kieschnick, John, *The Impact of Buddhism on Chinese Material Culture*
 (Princeton, NJ, 2003)
Kupperman, Karen Ordahl, ed., *America in European Consciousness,
 1493–1750* (Williamsburg, VA, 1995)
Kyerematen, A., 'The Royal Stools of Ashanti', *Africa: Journal of the
 International African Institute*, xxxix/1 (January 1969), pp. 1–10
La Niece, Susan, *Gold* (London, 2009)
Landis, Deborah Nadoolman, *Dressed: A Century of Hollywood Costume
 Design* (New York, 2007)
Lechtman, Heather, 'Andean Value Systems and the Development of
 Prehistoric Metallurgy', *Technology and Culture*, xxv/1 (January
 1984), pp. 1–36
Linden, Stanton J., ed., *The Alchemy Reader: From Hermes Trismegistus to
 Isaac Newton* (New York, 2003)
Magliari, Michael, 'Free State Slavery: Bound Indian Labor and Slave
 Trafficking in California's Sacramento Valley, 1850–1864', *Pacific
 Historical Review*, lxxxi/2 (May 2012), pp. 155–92
Markowitz, Yvonne J., 'Nubian Adornment', in *Ancient Nubia: African
 Kingdoms on the Nile*, ed. Marjorie M. Fisher (Cairo, 2012),
 pp. 186–93
Matos, R., R. Burger and C. Morris, eds, *Variations in the Expression of
 Inka Power* (Washington, DC, 2007)
Müller, Hans Wolfgang, and Eberhard Thiem, *Gold of the Pharaohs*
 (Cornell, NY, 1999)
Nasson, Bill, *The War for South Africa: The Anglo-Boer War, 1899–1902*
 (Cape Town, 2010)

Needham, Joseph, and Lu Gwei-Djen, *Science and Civilization in China*, vol. V (Cambridge, 1974)

Newlitt, Malyn, *A History of Portuguese Overseas Expansion, 1400–1668* (London, 2004)

Panofsky, Erwin, trans., *Abbot Suger on the Abbey Church of St Denis and its Art Treasures* (Princeton, NJ, 1946)

Raleigh, Walter, *Sir Walter Ralegh's Discoverie of Guiana* [1596], ed. Joyce Lorimer (London, 2006)

Ramage, Andrew, and Paul Craddock, *King Croesus' Gold: Excavations at Sardis and the History of Gold Refining* (Cambridge, MA, 2000)

Riordan, Michael, and Lillian Hoddeson, *Crystal Fire: The Invention of the Transistor and the Birth of the Information Age* (New York, 1998)

Russell, P. E., *Prince Henry 'the Navigator': A Life* (New Haven, CT, 2001)

Sheingorn, Pamela, ed. and trans., *The Book of Sainte Foy* (Philadelphia, PA, 1995)

Starr, Kevin, *California: A History* (New York, 2005)

Syson, Luke, and Dora Thornton, *Objects of Virtue* (Los Angeles, CA, 2001)

Thorndike, Lynn, *A History of Magic and Experimental Science* (New York, 1958)

Trafzer, Clifford E., and Joel R. Hyer, eds, *Exterminate Them: Written Accounts of the Murder, Rape, and Slavery of Native Americans during the California Gold Rush, 1848–1868* (Lansing, MI, 1999)

Tripp, David, *Illegal Tender: Gold, Greed, and the Mystery of the Lost 1933 Double Eagle* (New York, 2013)

Vázquez de Coronado, Francisco, *The Journey of Coronado*, ed. and trans George Parker Winship (New York, 1904)

Venable, Shannon, *Gold: A Cultural Encyclopedia* (Santa Barbara, CA, 2011)

von Reden, Sitta, *Money in Ptolemaic Egypt: From the Macedonian Conquest to the End of the Third Century BC* (Cambridge, 2007)

Walter, Michael L., *Buddhism and Empire* (Leiden, Boston and Tokyo, 2009)

Wardwell, Allen, exh. cat., Museum of Fine Arts, Boston (Greenwich, CT, 1968)

Weston, Rae, *Gold: A World Survey* (London and Canberra, 1983)

White, David Gordon, *The Alchemical Body* (Chicago, IL, 1996)

Zorach, Rebecca, *Blood, Milk, Ink, Gold: Abundance and Excess in the French Renaissance* (Chicago, IL, 2005)

ASSOCIATIONS AND WEBSITES

The Alchemy Website
www.levity.com/alchemy

American Numismatic Association
www.money.org

American Numismatic Society
www.numismatics.org

British Museum's Citi Money Gallery
www.britishmuseum.org/explore/themes/money.aspx

British Numismatic Society
www.britnumsoc.org

California State Mining and Mineral Museum
www.parks.ca.gov

Field Museum (Chicago): Gold
archive.fieldmuseum.org/gold

Institute of Materials, Minerals and Mining (IOM3)
www.iom3.org

Leaves of Gold Learning Center
www.philamuseum.org/micro_sites/exhibitions/leavesofgold/learn

Mining History Association
www.mininghistoryassociation.org

MiningWatch Canada
www.miningwatch.ca

Museo del Oro (Gold Museum)
www.banrepcultural.org/gold-museum

National Mining Association
www.nma.org

Oriental Numismatic Society
www.onsnumis.org

Protest Barrick
www.protestbarrick.net

Royal Numismatic Society
www.numismatics.org.uk

Underground Gold Miners Museum
www.undergroundgold.com

World Gold Council
www.gold.org

ACKNOWLEDGEMENTS

Research assistants Kate Aguirre and Anna-Claire Stinebring both worked on this project for an extended period and contributed enormously to its completion. Alex Marraccini and Nancy Thebaut also provided excellent research assistance. For expert advice, we are grateful to Suzanne Preston Blier, Claudia Brittenham, Julia Cohen, Holly Edwards, William Etter, Robert S. Nelson and Brian Robinson. We thank the many rights holders who furnished images for the book with efficiency. We also thank Williams College and its graduate programme in Art History, the Williams College Library and the Clark Art Institute Library for providing pleasant surroundings and abundant resources for the work on this book.

This book would have been finished more quickly, and without so many delightful distractions, had Jesse Oliver Zorach-Phillips not entered our lives in 2012. This book is dedicated to him, in the hope that he will grow up in a world in which peace and justice are valued more than gold.

PHOTO ACKNOWLEDGEMENTS

The author and publishers wish to express their thanks to the below sources of illustrative material and/or permission to reproduce it. (Some information not placed in the captions for reasons of brevity is also given below.)

Aga Khan Museum, Toronto, On. (photos © AKM): pp. 75, 180; photo David S. Aguirre: p. 66 (readers are free to share – to copy, distribute and transmit the work, and to remix – to adapt the work - under the following conditions – you must attribute the work in the manner specified by the author or licensor (but not in any way that suggests that they endorse you or your use of the work) and – 'share alike' – if you alter, transform, or build upon this work, you may distribute the resulting work only under the same or similar license to this one); courtesy of the artist (El Anatsui) and Jack Shainman Gallery, New York, photo by Giovanni Pancino: p. 142; photo Anónimo s. XVII public domain: p. 107; courtesy of AT&T Archive and History Center: p. 168; photo Bayerische Staatsbibliothek, Munich: p. 153; Bibliothèque nationale de France, Paris: pp. 29, 72 (photo © BnF, Dist. RMN-Grand Palais / Art Resource, NY), 77 (photo © BnF, Dist. RMN-Grand Palais / Art Resource, NY), 79; courtesy the artist (Montien Boonma) and Numthong Gallery, Bangkok, Thailand: p. 92; photo © The British Library Board: p. 21; British Museum, London (photos © The Trustees of the British Museum): pp. 43, 44, 69, 84, 89, 91, 99, 100, 101, 104, 118, 147, 156, 160, 161, 174, 184; Byzantine Museum, Athens: p. 50 (photo Erich Lessing / Art Resource, NY); Cathedral, Cologne: p. 83 (photo Erich Lessing / Art Resource, NY); Central State Museum, Almaty, Kazakhstan: p. 40; Chemical Heritage Foundation Collections, Philadelphia (gift of Fisher Scientific International, photograph by Will Brown): pp. 148–149; The Egyptian Museum, Cairo: p. 37; photo credit Jim Escalante: p. 141; Freer Gallery of Art, Smithsonian Institution, Washington, DC (photo Bridgeman Images): p. 78; Galerie Würthle, Vienna: p. 140; Galleria degli Uffizi, Florence: p. 135 (photo Erich Lessing / Art Resource, NY); Gold Museum, Bogota, Colombia: p. 129 (photo Mariordo [Mario Roberto Durán Ortiz] – this file is licensed under the

Creative Commons license – readers are free to share – to copy, distrib-
ute and transmit the work, and to remix – to adapt the work - under
the following conditions – you must attribute the work in the manner
specified by the author or licensor (but not in any way that suggests that
they endorse you or your use of the work), and – 'share alike' – if you
alter, transform, or build upon this work, you may distribute the result-
ing work only under the same or similar license to this one); courtesy
Lisa Gralnick: p. 141; courtesy The J. Paul Getty Museum, Los Angeles
(photos Getty Open Content): pp. 12, 96; photo Adam Jones: p. 60 (this
file is licensed under the Creative Commons Attribution-Share Alike
2.0 Generic license – readers are free to share – to copy, distribute and
transmit the work, and to remix – to adapt the work, under the following
conditions – you must attribute the work in the manner specified by the
author or licensor (but not in any way that suggests that they endorse
you or your use of the work) and – 'share alike' – if you alter, transform,
or build upon this work, you may distribute the resulting work only
under the same or similar license to this one); Jordan Museum, Amman:
p. 25 (foot); Kunsthistorisches Museum, Vienna: pp. 117 (photo Andreas
Praefke), 131, 136–7 (photos Erich Lessing / Art Resource, NY); photo
Ralf-André Lettau: p. 63; Library of Congress Prints and Photographs
Division, Washington, DC: pp. 14, 18, 109, 183, 186, 187, 189; photo by Allan
Lissner/ProtestBarrick, reproduced by permission of the photographer:
p. 196; Metropolitan Museum of Art: pp. 16 (Harris Brisbane Dick Fund,
1934, Accession Number 34.11.7), 56 (purchase, Friends of The Costume
Institute Gifts, 2007), 77 (H. O. Havemeyer Collection, Gift of Horace
Havemeyer, 1929 [29.160.23]), 94, 119 (Fletcher Fund, 1963 [63.210.67]), 123
(purchase, Jan Mitchell Gift, 2003), 132 (Robert Lehman Collection,
1975 [1975.1.110])]), 158 (Accession Number: 2011.302 – purchase, C. G.
Boerner Gift, 2011); photo Minneapolis Institute of Arts: p. 185; Musée
Condé, Chantilly: pp. 121 (Ms. 65, fol. IV. – photo René-Gabriel Ojéda,
© RMN-Grand Palais / Art Resource, NY), 164 (photo Erich Lessing /
Art Resource, NY); Musée du Louvre, Paris: p. 47 (photo Erich Less-
ing / Art Resource, NY); Musée National de la Renaissance, Écouen: pp.
54-55 (photo Stéphane Maréchalle, © RMN-Grand Palais / Art Resource,
NY); Museo Nacional de Antropologia, Mexico: p. 42; Museo Tumbas
Reales de Sipán, Lambayeque, Peru: p. 125 (photo courtesy Museo Tumbas
Reales de Sipán); Museum of Fine Arts, Boston: p. 28; photo NASA/Chris
Gunn: p. 167; photo NASA/JPL: p. 166; National Archaeological Museum,
Athens: p. 39; National Museum of Ireland, Dublin: p. 86 (photo Werner
Forman / Art Resource, NY); photo by Nicholas (nichalp), reproduced
by permission of cc-by-sa-2.5-self: p. 64 (this file is licensed under the
Creative Commons Attribution-Share Alike 2.5 Generic license – readers
are free to share – to copy, distribute and transmit the work, and to remix
– to adapt the work, under the following conditions – you must attribute

the work in the manner specified by the author or licensor (but not in any way that suggests that they endorse you or your use of the work) and – 'share alike' – if you alter, transform, or build upon this work, you may distribute the resulting work only under the same or similar license to this one); courtesy PD-Australia: p. 9; Pierrepont Morgan Library and Museum, New York: pp. 80–81; private collection: p. 143 (© 2014 Artist Rights Society (ARS), NY; ADAGP, Paris. MG 1 – Photo Credit: Banque d'Images, ADAGP/ Art Resource, NY); Royal Collection: pp. 48–9 (RCIN 405794); photo Sächsische Landesbibliothek – Staats- und Universitäts-bibliothek Dresden: p. 157; photo Scala/Ministero per i Beni e le Attività culturali / Art Resource, NY: p. 73; Treasury, Abbey Ste. Foy, Conques: p. 87 (photo Erich Lessing / Art Resource, NY); courtesy U.S. National Library of Medicine, Bethesda, Maryland: p. 10; photo © Vanni Archive/ Art Resource, NY: p. 65; Varna Archaeological Museum, Varna, Bulgaria: p. 34; photo Yelkrokoyade: p. 34 (this file is licensed under the Creative Commons Attribution-Share Alike 3.0 Unported license – readers are free to share – to copy, distribute and transmit the work, and to remix – to adapt the work, under the following conditions – you must attribute the work in the manner specified by the author or licensor (but not in any way that suggests that they endorse you or your use of the work) and – 'share alike' – if you alter, transform, or build upon this work, you may distribute the resulting work only under the same or similar license to this one); Walters Art Museum, Baltimore, Maryland: p. 7; photo Xuan Che: p. 39 and front cover (this file is licensed under the Creative Commons Attribution 2.0 Generic license – readers are free to share – to copy, distribute and transmit the work, and to remix – to adapt the work, under the following conditions – you must attribute the work in the manner specified by the author or licensor (but not in any way that suggests that they endorse you or your use of the work) and – 'share alike' – if you alter, transform, or build upon this work, you may distribute the resulting work only under the same or similar license to this one).

INDEX